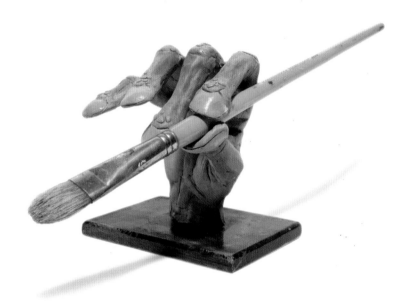

IMAGINATIVE REALISM

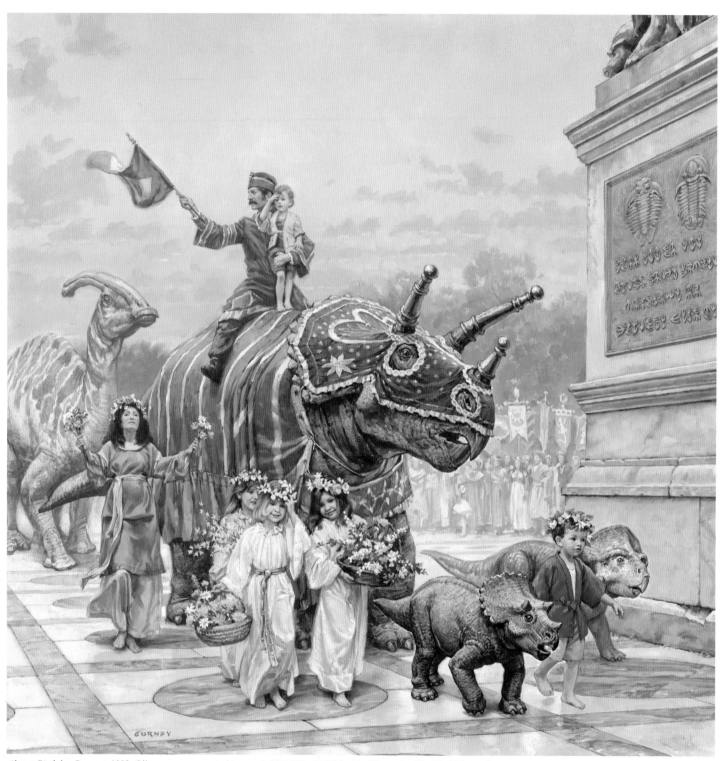

Above: *Birthday Pageant*, 1992. Oil on canvas mounted to panel, 29 × 29 in. Published in *Dinotopia: The World Beneath*.

JAMES GURNEY

IMAGINATIVE REALISM
How to paint what doesn't exist

Andrews McMeel
Publishing, LLC

Kansas City • Sydney • London

09 10 11 12 13 SDB 10 9 8 7 6 5 4 3 2 1

Library of Congress Cataloging-in-Publication Data

Gurney, James, 1958-
 Imaginative realism : how to paint what doesn't exist / by James Gurney. — 1st ed.
 p. cm.
 ISBN-13: 978-0-7407-8550-4
 ISBN-10: 0-7407-8550-8
 1. Painting--Technique. 2. Realism in art. I. Title.
 ND1505.G87 2009
 709.03'43--dc22

 2009015708

www.andrewsmcmeel.com
gurneyjourney.blogspot.com

ATTENTION: SCHOOLS AND BUSINESSES
Andrews McMeel books are available at quantity discounts with bulk purchase for educational, business, or sales promotional use. For information, please write to: Special Sales Department, Andrews McMeel Publishing, LLC, 1130 Walnut Street, Kansas City, Missouri 64106.

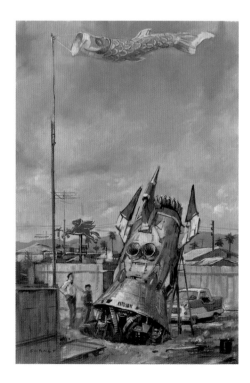

Right: *Digging Leviathan Sketch*, 1983. Oil on board, 11 × 7½ in.

Opposite: *Phineas and the Harpies*, 1984. Pastel and charcoal, 6 × 11 in.

CONTENTS

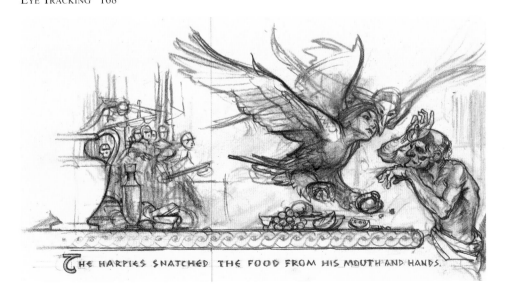

THE HARPIES SNATCHED THE FOOD FROM HIS MOUTH AND HANDS.

INTRODUCTION

This book explores the question of how to paint a realistic picture of something that doesn't exist. It is intended not only for artists interested in fantasy and science fiction but also for anyone who wants to recreate history, visualize extinct wildlife, or simply tell a story with a picture.

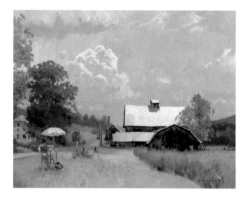

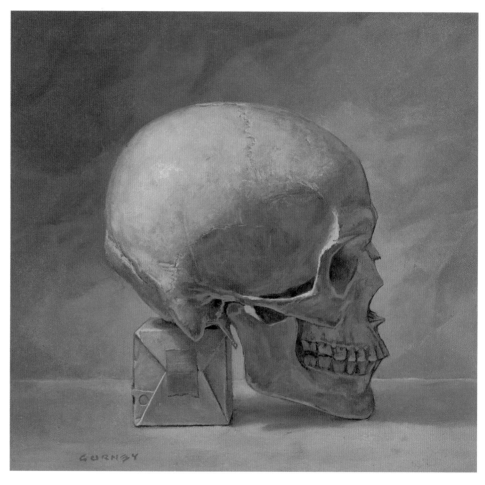

Most methods of art instruction assume that you're drawing or painting directly from observation. When you make a still life, a portrait, or a landscape, you generally begin with the subject in front of you.

That's how I painted the skull and the plein-air landscape on this page. The task is to learn to observe the subject accurately and arrange it into a pleasing design. Even if you're painting from a photograph, the challenge is essentially the same. You learn first how to see and then how to paint what you see. This kind of observational art training enables you to capture a likeness or to render a landscape.

But it doesn't help you much if you want to paint a mermaid, a *Tyrannosaurus rex,* or a Civil War battle. For that, you need a whole different approach. You can't just go out in your backyard and sketch a spaceship or a scene from the *Odyssey.* You might find some images on an Internet search, but those are just other people's notions of what your scene should look like.

This problem always puzzled me as a young artist. I liked to sketch from observation, but I couldn't find many books that explained how to develop my imaginative muscles. For a while I kept two separate sketchbooks, one from life and the other from imagination, and I felt as if they were done by two different people.

The first instructional book I cowrote was called *The Artist's Guide to Sketching* (1982). Around the same time I got a job as a background painter in the film industry. Later I painted science fiction paperback covers and illustrated for *National Geographic* magazine. All the while in my spare time I was sketching and painting from life outdoors. I started to discover that my separate skills of observation and imagination were beginning to grow together and to reinforce each other. I embarked on writing and illustrating *Dinotopia: A Land Apart from Time* (1992), which is an imaginary but realistic world shared by humans and dinosaurs, presented in the form of an explorer's sketchbook.

Along the way, I have researched the art instruction methods from fifty and one hundred years ago, when imaginative art was taught more systematically. I have taken those lessons to heart in my professional approach and have shared them with art students across the country. What this book contains is a distillation of the time-tested methods that I've found to be most helpful for achieving realism in imaginative pictures. They apply equally to professionals and to beginning art students.

This is not a book about figure drawing, anatomy, or perspective. It's not a step-by-step guide on how to draw dinosaurs. It's also not a recipe book for a particular paint technique, although all these topics are addressed in passing. You might use a traditional technique such as watercolor, gouache, oil, or acrylic. Or you might prefer a digital program such as Photoshop. My own art media are traditional: pencil, paper, pens, paint, brushes, cardboard, and modeling clay. Regardless of your medium, there are no shortcuts to research and planning. The methods in this book will save you time in the long run and yield much better results.

This book is designed to show you how by taking you behind the scenes. You'll see the preliminary steps, the blind alleys, and the adventures that went into the making of various imaginative paintings. Every page spread covers a separate topic that builds on previous material. You can browse it like a magazine or read it straight through. The chapters are organized by subject: sketches, history, people, dinosaurs, creatures, architecture, and vehicles, concluding with a look at the various professions that are looking for artists who have developed these skills.

The section on composition starting on page 155 is different from most other treatments of pictorial design, which tend to be based on abstract formulas of line, shape, or geometric proportions. My approach is centered more on tonal organization in the service

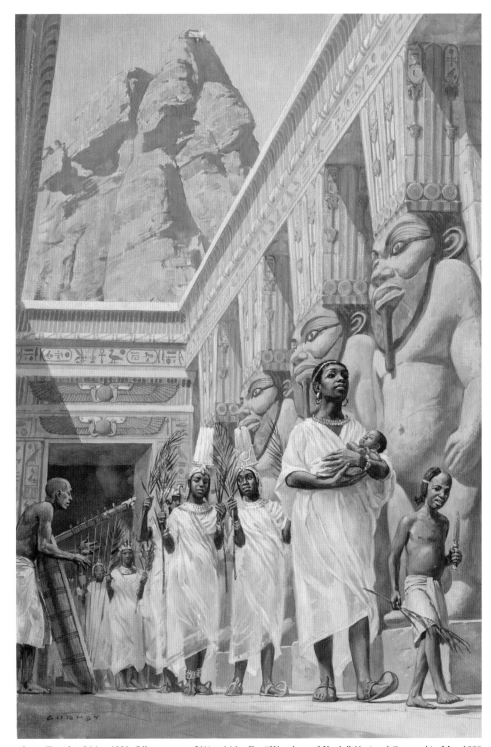

Above: *Temple of Mut*, 1990. Oil on canvas, 21½ × 14 in. For "Kingdom of Kush," *National Geographic*, May 1990.

Opposite Left: *Windham Farm*, 2006. Oil on canvas, 11 × 14 in.

Opposite: *Skull Study*, 1980. Oil on panel, 12 × 12½ in.

of a representational image. Because the art vocabulary in English lacks some words to describe key concepts, I have had to invent several terms such as *clustering* and *shapewelding* to describe compositional principles that artists often think about but lack the vocabulary to talk about. You'll find those terms defined in the glossary in the back of the book.

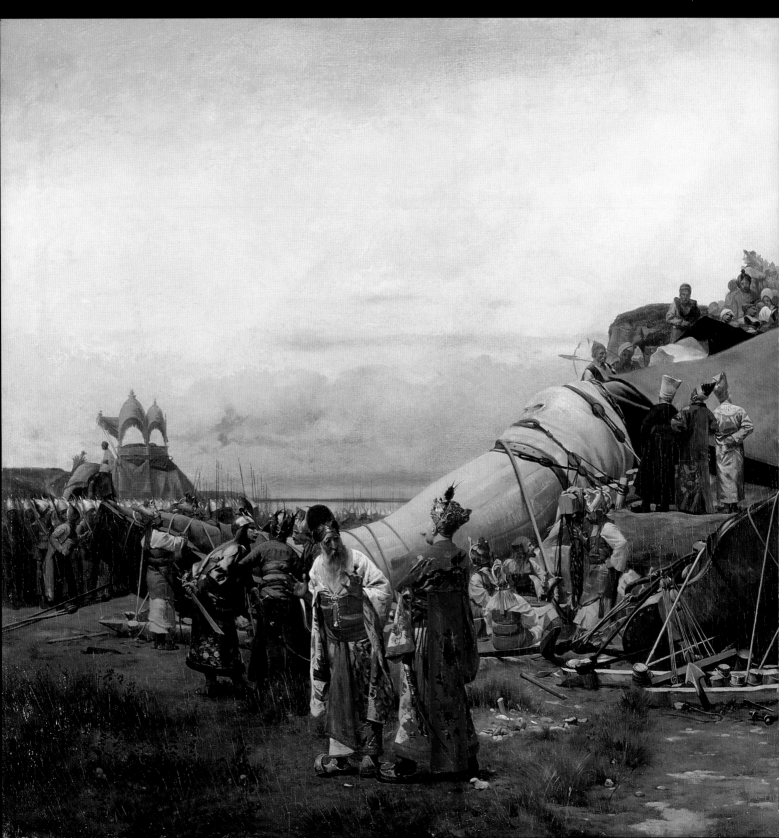

THE TRADITION OF IMAGINATIVE PAINTING

Artists have been ambassadors to the world of imagination for most of the history of Western art. Innovations in perspective and chiaroscuro starting in the Renaissance brought increasing levels of realism to these flights of fantasy.

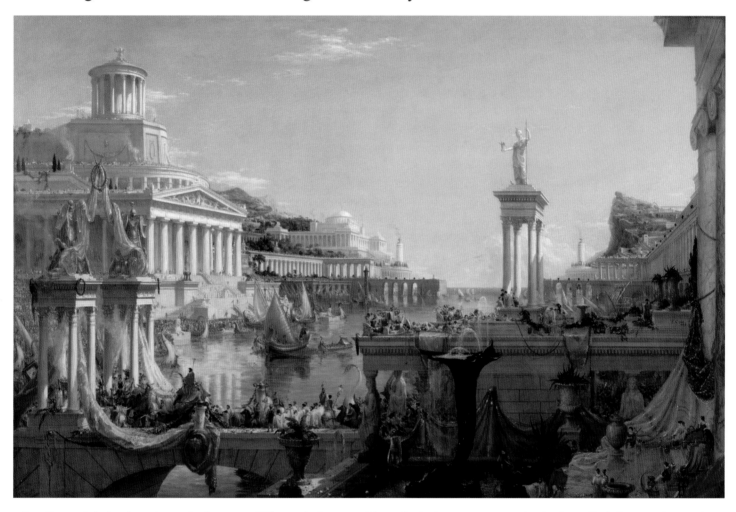

Above: Thomas Cole, American, 1801–1848. *The Course of Empire: The Consummation of Empire*, (3rd in series), 1835–36. Oil on canvas, 51¼ × 76 in. Collection of the New-York Historical Society.

Opposite: Edwin Austin Abbey, N.A., R.A. American, 1852–1911. *The Play Scene in Hamlet (Act III, Scene 2)*, 1897. Oil on canvas, 61¼ × 96½ in. The Edwin Austin Abbey Memorial Collection, Yale University Art Gallery, New Haven, Connecticut.

Preceding Pages: Jehan-Georges Vibert, French, 1840–1902. *Gulliver and the Lilliputians*, 1870. Oil on canvas, 22¼ × 43¼ in. Private collection. Photograph courtesy of Sotheby's, Inc. © 2008.

What paintings would you include on a checklist of enduring masterpieces? Perhaps you might name Botticelli's *Venus,* Michelangelo's Sistine ceiling, Leonardo da Vinci's *Last Supper,* Raphael's *School of Athens,* and Rembrandt's *Night Watch.* The subjects of these pictures did not come from the artists' direct experience. They were drawn from history, mythology, and the Christian tradition.

As early as the Renaissance, artists perfected a step-by-step process designed to transform an imaginative idea into a

convincingly realistic image. Sixteenth-century painter Federico Barocci (1528–1612) planned his paintings with a series of eight steps, according to his biographer, Bellori:

1. After deciding on his idea for a picture, Barocci made dozens of loose sketches to establish the gestures and arrangement of the figures.

2. He then made studies in charcoal or pastel from live models.

3. Next he sculpted miniature figurines in wax or clay, each draped in tiny

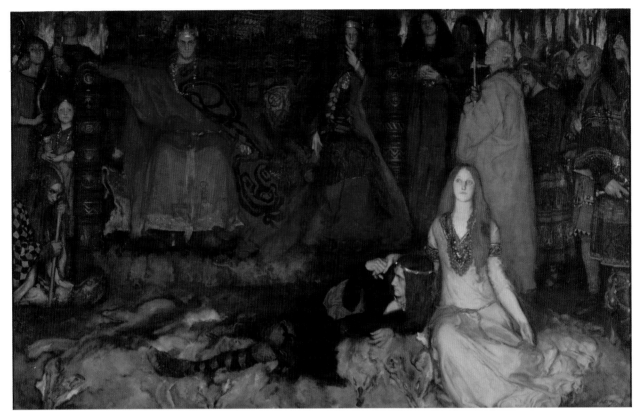

costumes to see how they would look under various lighting arrangements.

4. He proceeded with a compositional study in gouache or oil, considering the overall pattern of light and shade.

5. He then produced a full-size tonal study or "cartoon" in pastels or charcoal and powdered gesso.

6. He transferred this drawing to the canvas.

7. Before proceeding with the painting he made small oil studies to define the color relationships.

8. Finally he went ahead with the completed painting.

Barocci may have been more meticulous than some of his contemporaries, but his process was not unusual, and almost every imaginative artist since has followed at least some of these steps.

Baroque painters such as Tiepolo continued the tradition of fantastical paintings, producing grand ceilings festooned with angels. Romantic painters such as Turner and Géricault were moved by the spirit of the sublime to portray battles and shipwrecks known only to them from written accounts.

Throughout the nineteenth century, academic training refined the skills of drawing and painting from live models, painting outdoors, copying masterpieces, and generating compositional sketches. The primary goal of this art education was not to produce still lifes, portraits, or plein-air landscapes. It was to interpret the Bible and the classics. The apex of achievement in the École des Beaux-Arts was the Prix de Rome scholarship. To succeed in this contest a student had to produce a sketch on an assigned topic while sequestered in a closed booth with no references. The student then had to translate the essence of the sketch into a large painting made with the benefit of models, props, and maquettes. Academic instructors such as Jean-Léon Gérôme and William-Adolphe Bouguereau were masters of imaginative realism, the convincing portrayal of something that cannot be observed directly.

In America, imaginative painting was associated with grand landscapes. Thomas Cole produced a five-part series called the Course of Empire, which chronicled the growth and decay of a fantastical city. *The Course of Empire: Consummation of Empire,* opposite,

is in the tradition of the capriccio or architectural fantasy, with gleaming palaces surrounding a tranquil cove.

Subsequent American landscape painters such as Frederic Church and Albert Bierstadt painted epic scenes of the American wilderness. Their viewpoints were often imaginary; Bierstadt sometimes invented mountain peaks and named them after patrons. But the paintings seemed real because they were based on careful plein-air studies from nature.

The scene from Shakespeare's *Hamlet,* above, by American expatriate Edwin Austin Abbey won gold medals in three international exhibitions. Abbey visualized the story from the point of view of the actors of the play-within-a-play. Ophelia sits on the ground beside Hamlet, who steals a guarded look over his shoulder, hoping to "catch the conscience of the king." Abbey spared no effort or expense to make the painting believable, procuring "three wolfskins with the heads on—heads not to be stuffed," and had a costume made for the medieval Dane, using the finest black velveteen and purple satin.

ART IN THE TWENTIETH CENTURY

Imaginative art based on realism and storytelling did not disappear from the face of the earth with the onset of modernism. It flourished in the twentieth century, transformed and revitalized. The focus of the public's attention shifted from original paintings in public exhibitions to reproductions in books and magazines.

Above: Dean Cornwell, American, 1892–1960. *Queen of Riva*, from *Never the Twain Shall Meet*, by Peter B. Kyne, 1923. Oil on canvas, 36 × 30 in. Private collection.

Opposite: Howard Pyle, American, 1853–1911. *Extorting Tribute from the Citizens: The Sack of Carthagena*, 1905. Oil on canvas, 29½ × 19½ in. Delaware Art Museum, Museum Purchase, 1912.

Just as new recording technologies sparked the Jazz Age and rock 'n' roll, new modes of visual communication revolutionized systems of patronage and distribution, unleashing an avalanche of creativity. Instead of going to the Salon or the National Academy to feast their eyes, people were getting their art from books, magazines, and movie houses.

Howard Pyle's iconic images of pirate life (right) earned him the nickname "The Bloody Quaker." He was famous not merely as an artist but also as a writer and teacher. His students included N. C. Wyeth, Jessie Willcox Smith, and Harvey Dunn, who in turn taught Dean Cornwell (left). Pyle encouraged his students to paint from costumed models and to identify on an almost mystical level with the characters they portrayed. He believed that "pictures are creations of the imagination and not of technical facility, and that which art students most need is the cultivation of their imagination."

As the twentieth century progressed, artists in America and Europe perfected sequential forms such as comics and animation. Science fiction and fantasy films, computer-generated (CG) animation, and video games eventually replaced the classic illustrated novel as culturally dominant art forms. These collective enterprises have required the talents of many artists who can combine their daydreaming with sound fundamentals. Today, young artists with a combination of a strong imagination and accurate drawing skills have unlimited opportunities. There is no line between fine art and illustration; there is no high or low art; there is only art, and it comes in many forms.

COPIES FROM THE MASTERS

Art students in the nineteenth century spent a good deal of time making copies of the old masters. Some art schools are encouraging the practice again. It's a great idea because it makes you appreciate in a much deeper way what your heroes were actually doing.

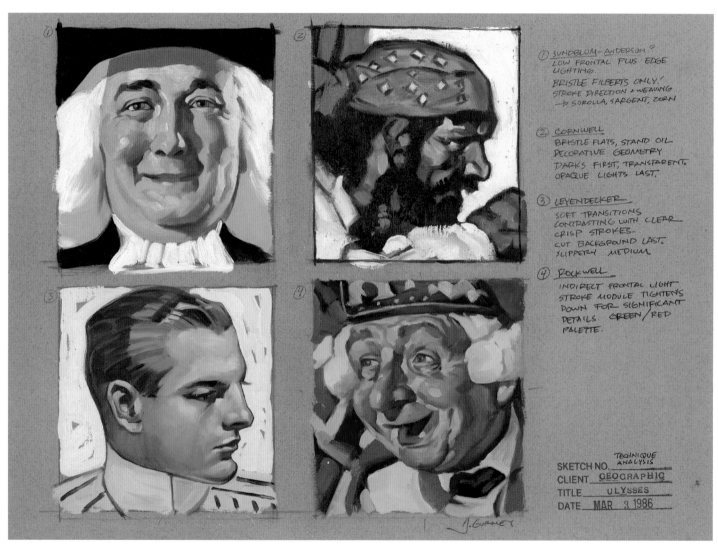

Heads by Illustrators, 1986. Oil on board, 12 × 16 in.

As an exercise before a day of composing, Chopin would spend an hour or two playing music from Bach's *Well-Tempered Clavier.* When he played Bach's music he felt he absorbed the master through the pores of his fingertips.

Why don't we artists do the same thing? Maybe it's because we're taught that it's bad to copy someone else's artwork. And we're justifiably concerned about becoming an imitator of another person's style.

But there's nothing at all wrong with copying as a way to practice and learn. It's the shortest path to understanding. The safeguard against becoming derivative is to copy several different artists side by side to see how many ways there are to solve a painting problem.

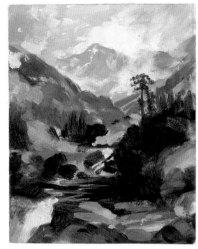

Copies of Thomas Moran, 2005. Oil, 6½ × 13½ in. overall.

The goal of the copies on the previous page was to compare how four classic illustrators painted a head. You may recognize, clockwise from the upper left, Haddon Sundblom, Dean Cornwell, Norman Rockwell, and J. C. Leyendecker. By trying to replicate a small section from each one, I could get a better feel for what kind of brushes and mediums they used and what sequence of steps they had to follow to get their results.

For example, Leyendecker must have spent time in the early stages laying down soft transitions within the form. Only at the end would he cut in the background with big, light strokes using a smooth, slippery medium.

Each of these great illustrators developed his own way of painting by absorbing earlier masters. There's a bit of Anders Zorn in Sundblom, Frank Brangwyn in Cornwell, Bouguereau in Leyendecker, and Rembrandt in Rockwell. We can build on the accomplishments of those who came before, and our generation has the unique advantage of having all of art history at our fingertips.

I made the copies above from reproductions of the paintings of Thomas Moran. They're all in oil, mostly about 4 or 5 inches across. Many museums will allow you to set up and do a copy, which is helpful if you want to do a larger or more comprehensive study.

Copying was an integral part of the academic training process. Students were expected to spend time in the museums doing small pencil or pen sketches called croquis to absorb the big structure of the paintings, and then they also spent time making painted copies. This was considered almost a mystical process of letting the earlier master's spirit into you.

Copy of Norman Rockwell's *The New Tavern Sign*. Oil on board, 6½ × 12 in.

15

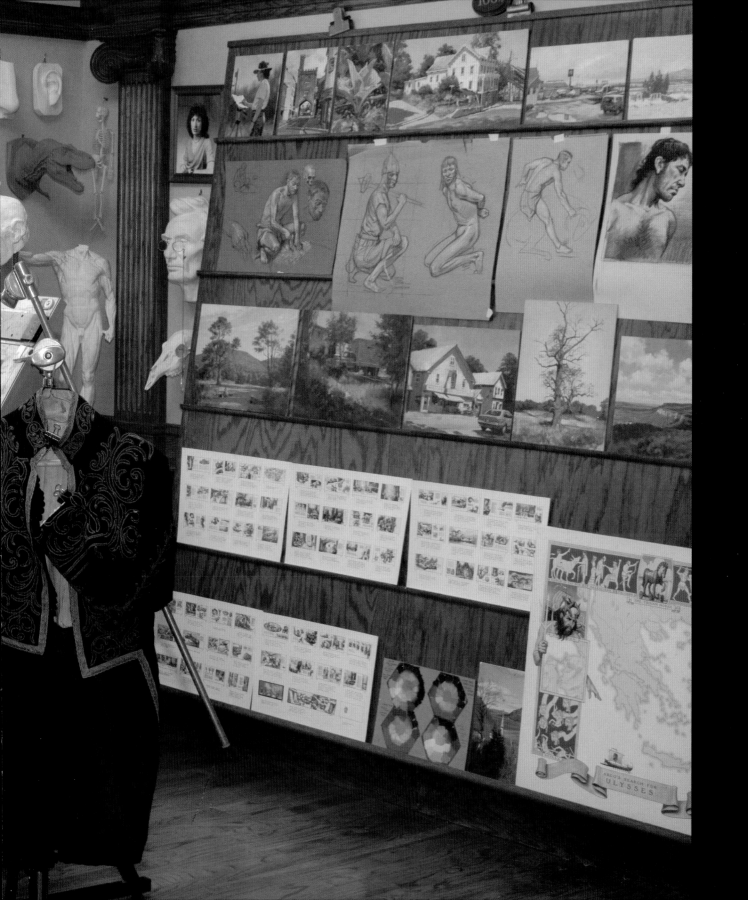

TABLES, EASELS, AND LIGHTS

If you're going to spend a lot of time drawing and painting, it's worth setting up a comfortable and efficient workspace, with good light, a way to hold your picture at a convenient angle, and the tools you use most often within easy reach.

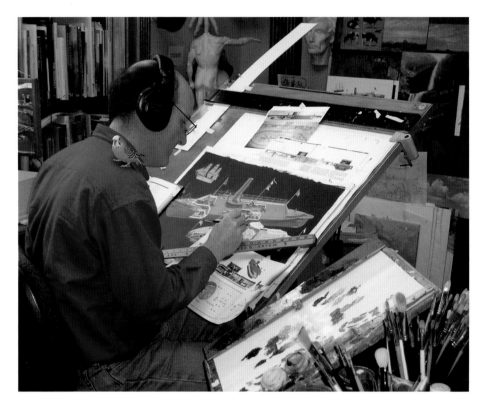

DRAFTING TABLE

Most of the time I use a slanting drawing table. The height and slant are fully adjustable. The angle adjustment ensures the optimal light on the surface while reducing the neck strain caused by leaning over a flat table. I cover the table with white paper to test out pencils, pens, and markers. Typically I have lots of sketches and photos taped around the outer margins of the table. I use a parallel rule for guiding horizontal lines. It is held at an even level by cables running along the side of the drafting table. With a triangle on the parallel rule, I can draw vertical or diagonal lines.

VERTICAL EASEL

For paintings larger than about 24 × 36 inches I like to use a vertical easel (right). The traditional vertical easel has a crank adjustment that lets you raise or lower the painting. Some artists prefer to use a vertical easel while standing up. One advantage of standing as you paint is that you can back up more conveniently to check your composition from farther away.

MAHL STICK

The standard mahl stick is a rod with a padded or cork tip held in the nonpainting hand. It helps to steady the brush hand and to keep it from touching the wet paint.

In the studio I use a 26-inch section of a wooden yardstick instead of a dowel. It is sanded and finished with tung oil. On the underside of the tip is a wooden spacer. This holds the stick at a constant height of about ¾ inch above the paint surface. The inside of the tip is hooked so that the mahl stick can hang vertically from the top of the drawing board when not in use.

The yardstick markings make it handy

for measuring and for ruling lines in the pencil stage. Wood-burned into the top surface is the classic maxim from Ovid, "ARS EST CELARE ARTEM" ("It is art to conceal art"); in other words, true art conceals the means by which it is achieved. You might find another maxim that suits you better.

From time to time I use an acrylic bridge. This also stands about ½ inch off the drawing surface and is especially good for inking with a dip pen or a technical pen.

LIGHTS

Whatever your studio situation, try to get plenty of color-balanced light. The simplest lighting arrangement is a lamp that combines fluorescent and incandescent light.

Incandescent light alone is composed mainly of yellow-orange wavelengths, and standard fluorescent light overemphasizes yellow-green. If you have only fluorescent light, try to select color-balanced light with as high a color rendering index as possible. The color rendering index is a measure of how true the colors look under the light, compared with the way they look in natural light. In my studio now, I have a large north light window to my left and a 4-foot-square skylight above with a white nylon diffuser that turns direct sunlight into diffuse scattered light. Flanking the skylight are fluorescent fixtures with twelve 4-foot color-corrected bulbs.

STORAGE DRAWERS

If you're getting a studio custom made, make sure you have lots of storage drawers. They're useful for paints, pencils, pens, triangles, tape, and all the other supplies you'll need at hand.

MUSIC

For me, music, radio, podcasts, and recorded books are constant companions during the long hours in the studio. Make sure your selections and controls are within easy reach from your drawing and painting area.

GETTING A FRESH EYE

As artists we literally get too close to our paintings, and we grow accustomed to their faults. There are at least seven ways to get a fresh eye on a work in progress.

- Turn it upside down and look at it (or work on it) inverted. I spend about one fourth of my time painting on an inverted picture, either to see it objectively or to get a better angle on the strokes and perspective lines.
- Step back from it, squinting and tilting your head or looking at it in dim light.
- Use a reducing glass, a double-concave lens that will make your full composition fit into the palm of your hand.
- Shoot a digital photo of your painting and look at it in the LCD monitor or process it in Photoshop to see how it looks in two values (see page 157).
- Set up an adjustable mirror on the wall behind and above your shoulder. Making the painting both smaller and reversed will help you spot problems right away.
- Ask a trusted friend, family member, or visitor to take a look at it. They don't have to be an art expert. What I want to know about someone's reaction is what strikes them first. It's not always what I was intending.
- If you can spare the time, turn the painting to the wall and leave it for a while. When you see it again, it will be like seeing it for the first time.

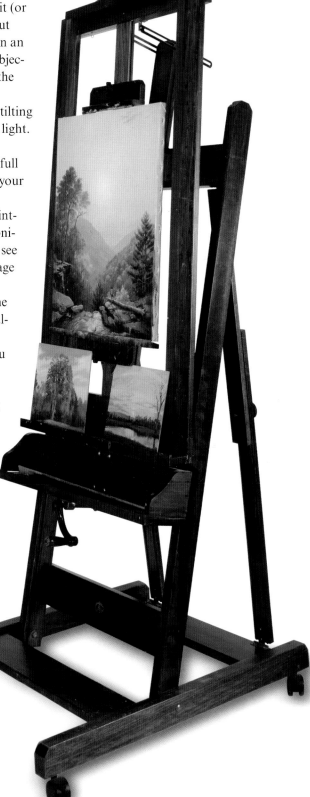

HELPFUL EQUIPMENT

In addition to the standard things you'd expect to find in an artist's studio, I recommend a few other pieces of studio equipment if you have the space for them and can afford them. You are more likely to find them in photo labs or movie studios, but they're just as useful for artists.

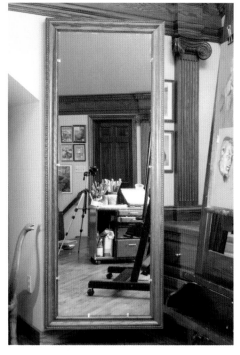

When you're setting up a model or a maquette to paint from life, it helps to use a strong light source, placed well away from the model. If the light is set too close, you get a variation in light intensity: a hotspot on the top half of the figure and weaker light on the feet. Painting is hard enough! We don't need obstacles like that.

The standard clamp-on reflector lights from the hardware store aren't adequate.

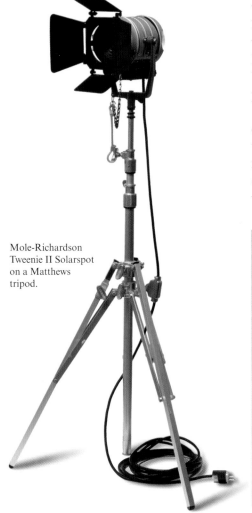

Mole-Richardson Tweenie II Solarspot on a Matthews tripod.

Their light is just too hard to control. But they're used all the time, even in art schools, which should know better.

It's well worth investing in a professional light designed for use on the stage or movie set. I use a small theater spotlight, which is a good solid workhorse for a small- to medium-size studio. It mounts on an adjustable tripod that lets you lift the light up to 14 feet in the air.

It will easily take a 650-watt bulb, which shines through a Fresnel lens. The lens has a knob that lets you choose a wide or narrow beam. If you want a lower intensity, you can use a smaller bulb or reduce the current with a properly rated rheostat.

The spotlight also has adjustable barn doors to control how much light spills to the sides and a detachable frame for inserting color effect filters in front of the light. The filters are made to withstand heat, but with a really hot

light, you might want to clip the gels to the barn doors, farther from the heat of the bulb.

In the photo below I'm putting a blue color correction filter in the frame. The light is shining on a plaster cast of Abe Lincoln and a plastic chrome hemisphere. The mirror ball is useful for recording the source and character of the various light influences in a given scene.

FULL-LENGTH MIRROR
This full-length mirror (above) is 6 feet tall and 24 inches wide, made from heavy

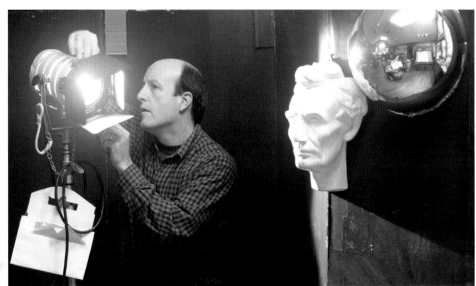

plate glass, attached to a plywood panel with a wood molding around it. The whole panel is firmly screwed to the wall studs with a very strong piano hinge along the entire left-hand edge. This allows the mirror to be swung out from the wall at any angle.

I use this mirror in two ways. First, because it is about 10 feet behind my drawing table, I can look back to see the design reversed. In this way I can quickly spot any flaws in the drawing, and I can see whether the tonal organization carries from a long distance.

I also use the mirror when I'm doing quick preliminary studies. Standing in front of the mirror, I take the pose, study the action, and draw the gesture on a piece of paper held on an adjustable easel (see pages 58 and 59).

C-Stand

You can hold up any model in the position you want on a Century stand, or C-stand (below), a standard piece of movie grip equipment. They'll hold anything at any angle: a dinosaur maquette, a light reflector, or a backdrop. For painting outdoors, they can hold a white umbrella for diffusing the direct sunlight.

C-stands can be found at specialty stores that carry lighting equipment for the film and theatrical industry.

Camera and Tripod

For photographing people, artwork, or maquettes, I recommend a digital single-lens reflex camera and a tripod. This way, you can photograph with a slow shutter speed and small aperture to get maximum depth of field.

Gallery Flambeau

In the back of every artist's closet is a stack of failed efforts, the paintings that just didn't succeed for one reason or another. I've got my share of clunkers. But an artist should not bequeath too many bad paintings to posterity.

To help delete unwanted paintings, my son and I invented the gallery flambeau. This solar-powered, environmentally friendly device uses a 4-foot-wide array of parabolically positioned mirrors to magnify the power of the sun more than three hundred times. Displayed under its unforgiving glare, a painting vaporizes into a cloud of smoke and a shower of ash. Each poor painting that you delete raises your artistic average a tiny notch.

Remember to protect your eyes from the intensely bright hotspot by always wearing sunglasses or welding goggles.

The Gallery Flambeau in action.

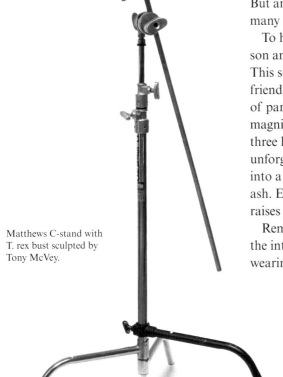

Matthews C-stand with T. rex bust sculpted by Tony McVey.

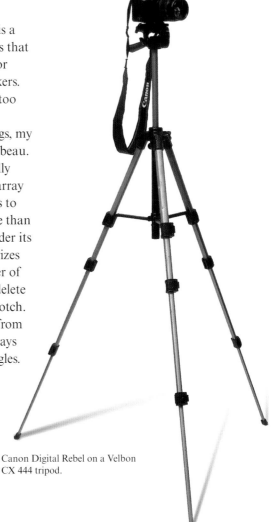

Canon Digital Rebel on a Velbon CX 444 tripod.

DRAWING MEDIA

You don't need to spend much money to get started with drawing materials. A soft pencil and bond paper is the foundation of all imaginative sketching, but there are some new materials such as water brushes and water-soluble pencils that are fun to experiment with.

GRAPHITE PENCILS

Graphite pencils are the traditional drawing tools of design development because they answer so readily to both line and tone and because they can be easily erased. It's worth paying a little more for art pencils, especially if you like softer leads. I use two hardnesses, HB (about the same as a #2 office pencil) and 4B (which delivers rich blacks).

CHARCOAL

Charcoal pencils come in various degrees of hardness, according to your preference. You can also use compressed charcoal in sticks or vine charcoal, which is soft, smudgy, and good for early stages of a drawing or for laying in a light overall tone. I use charcoal with accents of white chalk on tone paper when I want to make studies from the model (pages 60–61). Charcoal interacts well with architect's vellum for the comprehensive drawing (page 36).

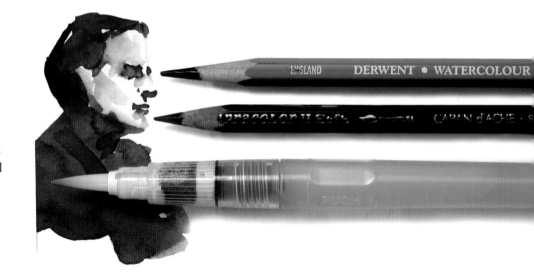

COLORED PENCILS

Colored pencils range from waxy to more like charcoal or Conté. Many designers like to start a sketch with a colored pencil and then add black lines later. Some colored pencils are formulated to be water soluble, so you can lay down a dry pencil stroke and later melt it with water.

SHARPENERS

In the studio I use an electric sharpener, but some artists prefer a hobby knife and sanding block for preparing special points.

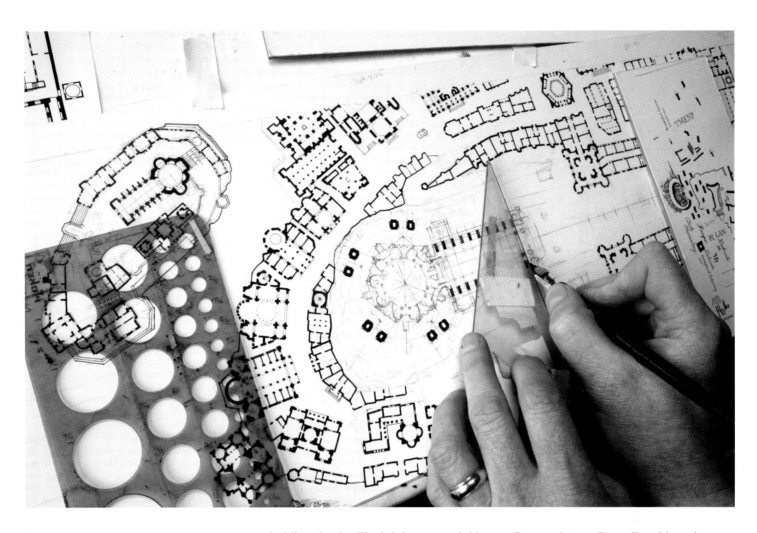

ERASERS

Kneaded erasers are versatile for both pencil and charcoal, and they don't leave crumbs. I use them frequently as part of the drawing process, restating a line over and over again until I'm happy with the design of a picture.

FIXATIVE

To keep pencil and charcoal from smudging, always use a fixative to seal and protect the surface. After you spray it on a drawing, you can't go back and change it. "Workable" fixative means it has a matte surface that lets you add some layers on top of it, whereas a gloss finish is shiny and not suited to additional working.

FOUNTAIN PENS

Fountain pens are versatile drawing tools, delivering a variety of line weights depending on the angle at which you're holding the tip. The ink is water soluble, so the line will dissolve if you use any water-based washes later. This can be desirable for creating a soft atmosphere of tone. I have both an expensive old pen and a cheap new one that flow equally smoothly. Try to get one with a pump-action ink filler, which allows you to use ink directly from a bottle of water-soluble ink.

TECHNICAL PENS

Technical pens deliver a constant line width and come in a variety of thicknesses. The traditional technical pens that you fill with ink have been largely replaced by disposable ceramic-tip pens with permanent ink.

DIP PENS

For old-fashioned lettering, there's no substitute for dip pens, which come in a variety of nibs. Old-fashioned Copperplate or Roundhand lettering styles are executed with flexible nibs and offset pen holders, which give a forward angle to the pen nib.

WATER BRUSHES

Several manufacturers make nylon filament brushes with hollow flexible plastic handles. You can fill them with pure water or with an ink or watercolor tone that you can apply over a line drawing. They combine effectively with water-soluble colored pencils.

MARKERS

Markers come in hundreds of colors, but for most sketching you need only a dozen or so. Their pigments are prone to fading, but they're a useful tool for quick indications of color in storyboards and concept sketches (pages 30–33).

PAINTING MEDIA

Whether you paint in oil, acrylic, gouache, or watercolor, many aspects of your painting setup will be the same. You need to have your brushes and paints close by and a mixing surface as near as possible to your painting area. Here's how I arrange things. Perhaps you can adapt some of these arrangements to your needs.

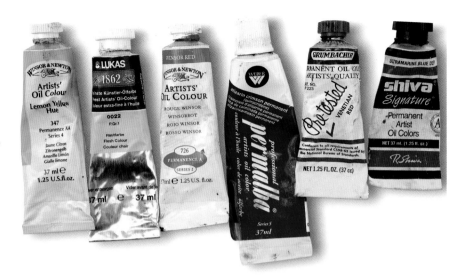

OIL PAINTS

I try all sorts of brands of oil paint, and I don't really have a favorite. In the studio, I use the larger 120-ml tubes of white and the earth colors.

My list of colors varies from project to project, but a typical layout might include viridian green, ultramarine blue, cobalt blue, cerulean blue, titanium white, lemon yellow hue, Winsor red, alizarin crimson (permanent), yellow ochre, raw sienna, burnt sienna, light red, and raw umber. I rarely use black, instead mixing a composite black with dark complementary colors such as viridian and alizarin crimson.

I have experimented with watercolor, acrylic, casein, alkyd, and other painting media. The sea monster painting on page 109 is made with a combination of gouache and acrylic. You have to try them all out to find the combination of drying time and opacity that you feel comfortable with. All the basic methods in this book apply equally to artists who use water-based media.

BRUSHES

I use three basic categories of brushes: bristles, synthetic flats, and sables. The bristle brushes are made from hog hair. These inexpensive brushes are stiffer than the others. They are useful for blocking in big areas and manipulating thicker paint.

Synthetic brushes are usually made from nylon. They are excellent for detailed painting of architecture and technology. They are available in widths as narrow as ⅛ inch, but I use the quarter-inch size the most. Synthetic brushes are also fairly inexpensive, but they don't last long.

For detailed passages, I use Kolinsky sable rounds, intended for watercolor but equally good for oil. These are the most expensive brushes, but they respond very sensitively to small touches.

MEDIUMS AND SOLVENTS

I use the alkyd-based medium Liquin, which is fully compatible with oils and dries quickly. It dries to a dull sheen that needs to be varnished later.

For a slower-drying and more traditional medium, I sometimes mix up equal parts of damar varnish, linseed oil, and turpentine. To cut down on the fumes, I use an odorless turpentine for thinning paint.

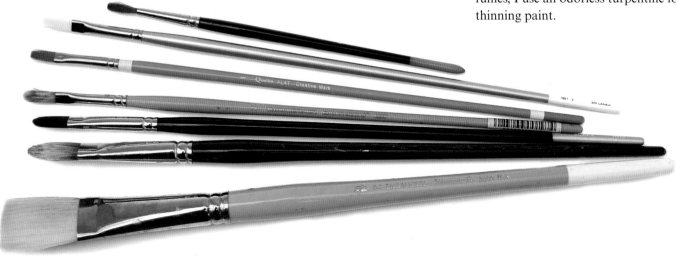

TABORET

The taboret is a little drawer unit that sits to the right of me when I'm painting in oil in the studio. It holds paints, brushes, pens, and pencils. The whole thing sits on wheels, allowing it to roll around to any position.

On the left half of the taboret is a white palette surface for mixing paints. The following notes are keyed to the numbers on the photo below.

1. The blobs of paint squeezed from the tube rest on a 3 × 18-inch paint shelf. This is a plywood surface that floats above the mixing surface.

2. I mix the paint with a palette knife on a roll of standard white plastic-coated freezer paper. The roll hangs on a wooden dowel below the left edge of the tip-up palette. Fresh paper unrolls with the plastic side up, constantly giving a new surface for mixing. The used paper tears off on the right of the palette. The tip-up palette rests on a hinged board, which can be set to any angle. It is held in position by a piece of cabinet hardware called a friction lid support.

3. Mixing cups for turpentine and medium are clipped onto an aluminum bar on the right side of the palette. Little wedges nearby hold the paper in tightly.

4. Peanut butter jar with kerosene for cleaning brushes. There's a screen halfway down inside the jar for the brush to scrub against. The sediment settles on the bottom.

5. Jars of solvents or mediums are normally stored in the taboret's drawers.

6. Plastic tub from a Chinese restaurant. The plastic lid has a rectangular hole cut into it. At the end of the day I scrape down the paints on the paint shelf using a palette knife, and the scrapings go in here. When it's full, I dispose of the whole tub when our recycling center has its toxic material day.

7. Paint rag with a wiggly wire next to it to hold the brush handles. This is where brushes rest while they're not in use.

8. Note the door hinges at the base of the mixing panel. This allows the whole panel to be raised up.

9. The brushes are kept in big jars or vases, divided according to the type of brush.

Following Pages: *Populonia Charcoal Comprehensive*, 1987. Charcoal on cotton vellum, 14 × 24 in.

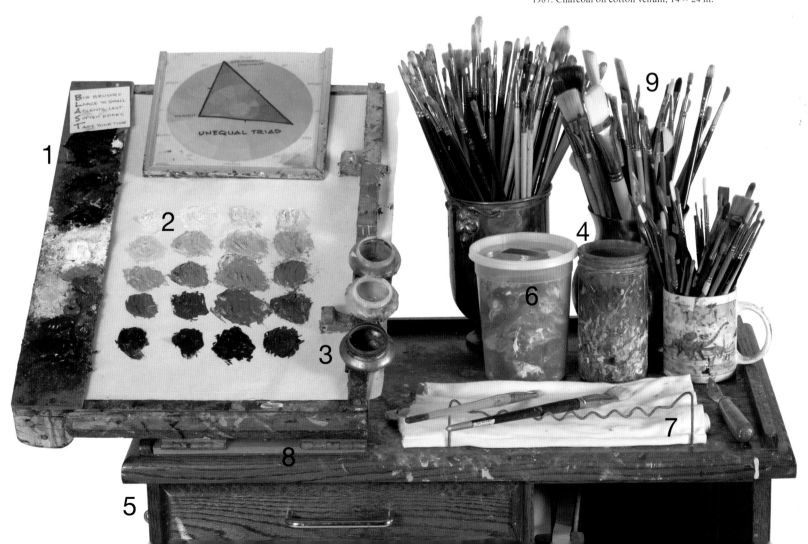

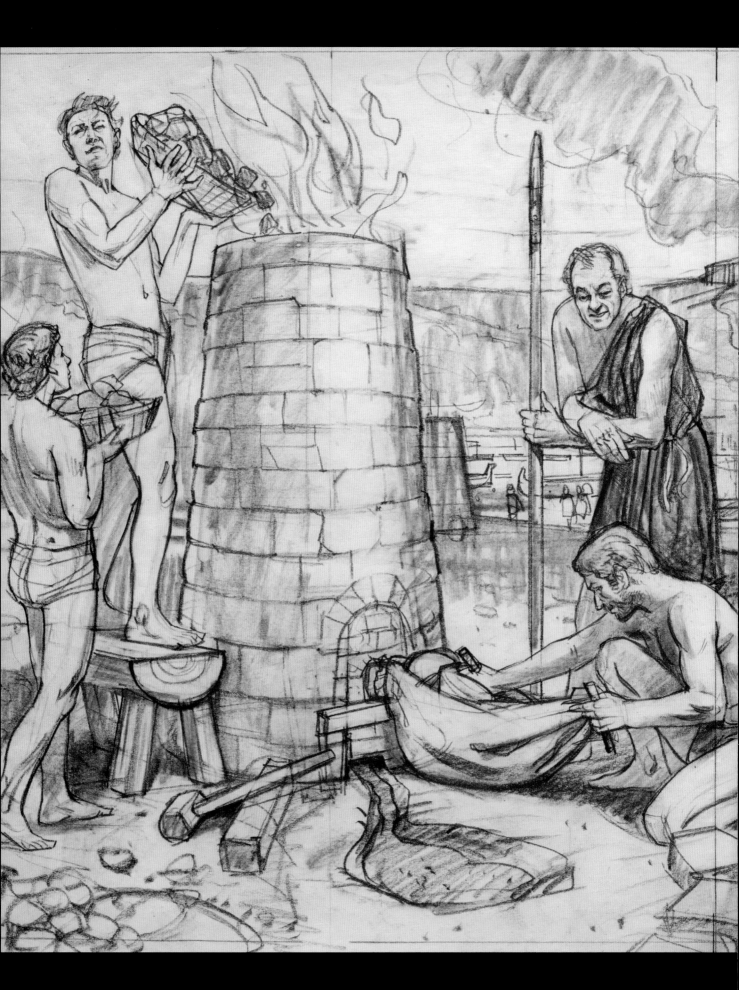

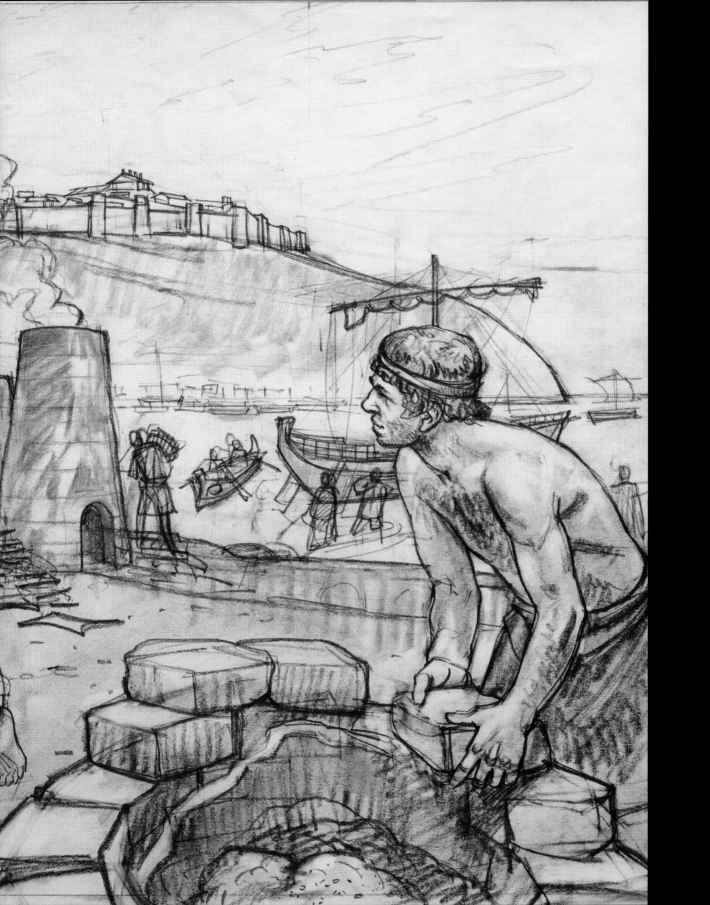

GAMES TO LOOSEN UP

Before you get involved with creating big, ambitious paintings, have a little fun sketching out of your imagination with no purpose other than to play. These doodles aren't preliminary to anything; they're just to help you loosen up and to make a space in your life for pure fantasy.

The drawing above was from a sketchbook that I brought to a college lecture. I was taking a class on psychology, and the professor was talking about the origins of aggression in human nature. Something about his gestures and facial expressions seemed to suggest a storybook creature, so I sketched him that way.

When I'm around other artists, we often pass drawings back and forth. I first did collaborative drawings with my grandmother, who would draw a random squiggle, hand me the paper, and let me finish the drawing. Kids under about eight years old lack the self-criticism that keeps the rest of us from taking chances and just drawing from imagination for the pure fun of it.

I have a large sketchbook called "Art by Committee" that I often bring to coffee shops when I hang out with other artists. The other artist might be my wife, or it might be a couple of notable comic artists, painters, or animators.

While waiting for the scrambled eggs, we take turns illustrating the scraps of stories. Some of these excerpts of novels are taken from the stacks of manuscript paper that I've gathered from years spent painting paperback covers. Sentences like this jump out at me: "Flames from the creature licked at his back. Something crackled around his head, and he realized his hair was on fire."

For someone who thinks visually, a line like that is hard to pass up. In the sketch below, the quote suggested a wordy, nerdy character sitting at the counter of a diner. I drew the guy from imagination, complete with bad teeth and hairy arms, and handed the book to my wife. She added the waitress.

You might want to glue Chinese cookie fortunes or business cards into a sketchbook and illustrate them. Or you might devote some pages to exaggerating or animating objects that you observe in the real world (see pages 124 and 125).

In my experience, most fantasy ideas come from combining two different things together that don't seem to go together. For example, Dinotopia's Waterfall City is a combination of Venice and Niagara Falls. Skybax riding is a combination of horseback riding and giant flying reptiles. If you put two dissimilar things together and shake them around, you'll come up with a million ideas.

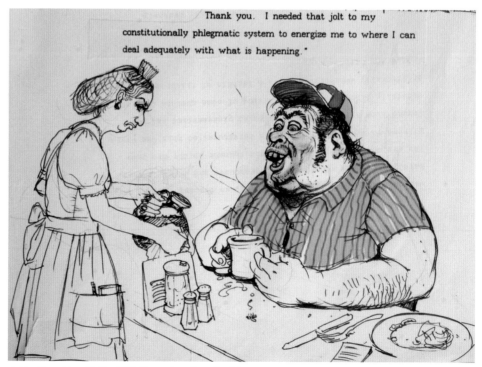

Art by Committee: Coffee, 1986. Pen and markers, 7 × 9 in.

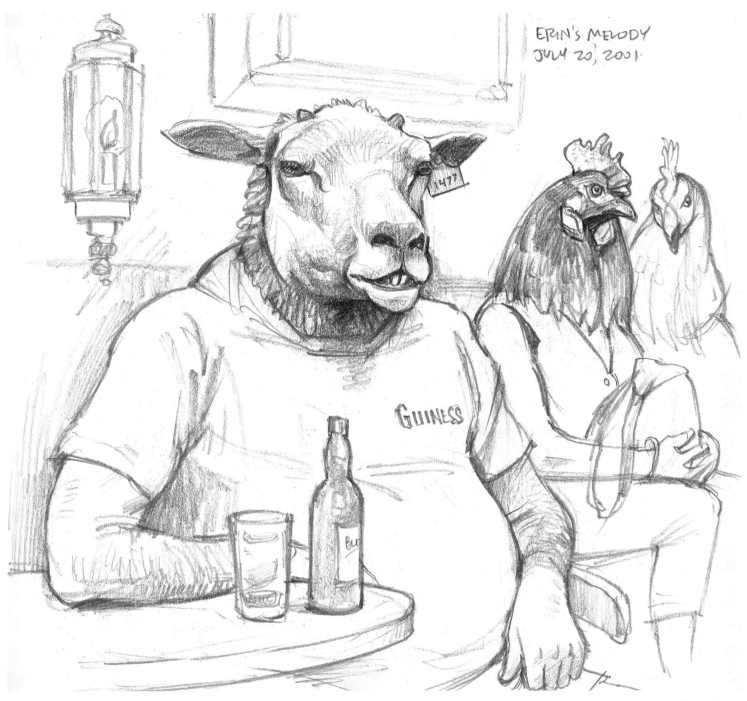

ERIN'S MELODY
JULY 20, 2001

Above: *Baa Man and His Chicks*, 2001. Pencil, 7 × 8 in.

For example, a while ago I went to a farm to get some practice sketching sheep and chickens. I was off to a good start with some head studies, but the animals got restless. They ran off before I could draw their bodies. All I had on the page were the heads of the sheep and poultry.

That evening I went to a pub to have a beer and listen to some Irish music. A couple sat down at a table in front of me, perfect targets for a candid sketch. My book popped open to the half-finished drawing. Amazingly, the animal heads lined up with the human bodies. So I just finished the drawing without giving it another thought.

About then, the woman spotted me. She turned to her husband and said, "Herb, that artist is drawing a picture of us. You should go take a look."

No, I gestured. Don't bother. But he staggered over anyway and stood beside me, staring at my picture, grunting and hiccuping.

I was sure that Herb would be furious. How could I possibly explain this insulting portrait?

But he didn't say a word. He toddled back and sank into his chair and took a long, searching look at his beer bottle. Then he pushed the bottle away and never took another sip that night.

THUMBNAIL SKETCHES

Thumbnail sketches are tiny, loose, scribbly sketches used to plan a composition. Keeping them small stops you from getting too caught up with detail at this first exploratory stage.

Howard Pyle used to say that he liked to do fifty thumbnail sketches for every illustration. Even if he felt confident of the first one, he had to do the other forty-nine anyway just to be sure.

No thumbnail sketch should take more than ten minutes. In a few hours of sketching, you should have plenty of variations on your idea, perhaps many of them ones that surprised you by bubbling up from your subconscious mind. These drawings are smaller than a business card. Eight or ten of them fit on a single sheet of paper.

I like to fill a few pages with doodles in a variety of media. Above right is one for a wraparound paperback cover (see pages 96–97). It is drawn first in pastel pencils and then charcoal on thin layout paper.

At right, center, is one made with a fountain pen and a dried-out gray marker to give a little tone. I intended this one for a two-page spread, but there was a problem: The dinosaur would be cut in half by the gutter of the book. So I left it and moved on. At this stage I'm not exactly sure what kind of dinosaurs those are. I don't know what time of day it is or what the color scheme should be. That will all come later.

At right is a drawing in pencil to organize the tones of a picture. Pencil is an ideal medium for tonal thumbnail sketches because you can get a full range of values very quickly.

- AT HOME - TONAL STUDY - OCT 15, 2006 James Gurney

It's important to plan out the tonal thumbnails first before exploring color because the tonal or value structure is the foundation of any picture.

At right are six tonal thumbnail sketches for *The Old Conductor* (page 191). All I really knew at this stage was that I wanted two figures in a room seated near a bright window. I was experimenting to see which figure should be silhouetted against the light and which should be edge-lit against the dark wall. I had no idea what the smaller details would be at this point.

If light and color are really important to the conception of the piece, you can do thumbnails in marker or watercolor. The four small sketches, right, were made with pen and marker. The light accents were added with white gouache. Adding light accents opaquely gives you more control over them.

The sketch below right was one of many I created to design a painting of fictional explorer Arthur Denison sitting in his study, surrounded by maps and artifacts (the finished painting appears on page 177). I was interested not only in the abstract statement of tone but in how that abstract design would tell the story of the explorer surrounded by his maps and mementos.

These sketches pile up like leaves in the autumn, and I rake them together and pick out one that might have a spark of life. This is the artistic equivalent of speed dating. You have to maintain a mental attitude of disinterest, detachment, and restlessness, always ready to try something else before getting married to one idea.

Top: Thumbnail set for *Old Conductor*, 2006. Pencil, 4 × 7 in. overall.

Center: Throne thumbnails, 2007. Marker and gouache, 4 × 6½ in. overall.

Right: *Arthur in His Study*, sketch, 2007. Marker and gouache, 1¾ × 4 in.

Opposite Top: *Glory Lane* thumbnail, 1986. Charcoal and pastel pencil, 3½ × 4½ in.

Opposite Center: Sauropod thumbnail, 2001. Fountain pen and marker, 1¾ × 3½ in.

Opposite Bottom: *At Home Study*, 2006. Pencil, 3½ × 7 in.

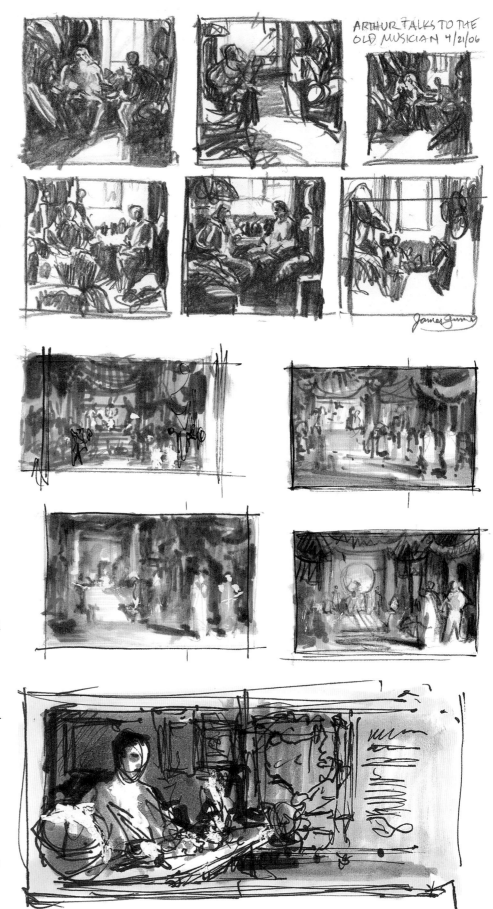

ARTHUR TALKS TO THE OLD MUSICIAN 4/21/06

STORYBOARDS

A storyboard is a special kind of thumbnail sketch where all the drawings work together to convey a narrative. Storyboards are usually displayed side by side on a wall or a bulletin board panel so that you can see at a glance what leads into and out of each panel.

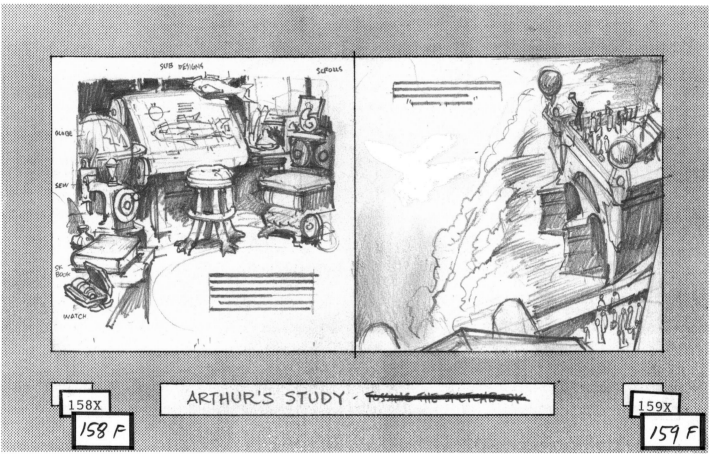

One wall of my studio has a 7-foot-tall sloping wooden panel with quarter-round dowels glued about every 16 inches. On this display panel I can safely rest any pictures in progress. But it also serves a vital function for displaying the storyboard.

The purpose of storyboards is to help plan a film, website, graphic novel, illustrated book, or other sequential artwork. In a long-form picture book

such as *Dinotopia,* the final illustrations not only have to stand on their own as separate paintings but also have to be part of an overarching story.

A lot of time goes into planning the plot, in the form of both a written outline and a storyboard sequence. Once I have a lot of picture ideas that are starting to click, I sketch each one onto a storyboard blank (above), which is printed on card stock at about one

quarter the size of the final book page. It takes about eighty of these cards to make up a single Dinotopia book of 160 pages. Keeping the storyboards on separate cards makes it easy to add or delete a page. I keep tinkering with the sequence throughout the production of the book. This whole procedure is similar to—and inspired by—the way animated films are planned.

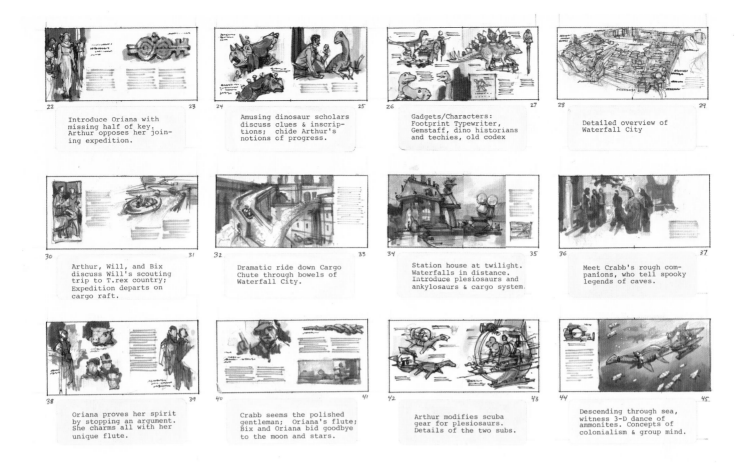

22 | 23 — Introduce Oriana with missing half of key. Arthur opposes her joining expedition.

24 | 25 — Amusing dinosaur scholars discuss clues & inscriptions; chide Arthur's notions of progress.

26 | 27 — Gadgets/Characters: Footprint Typewriter, Gemstaff, dino historians and techies, old codex

28 | 29 — Detailed overview of Waterfall City

30 | 31 — Arthur, Will, and Bix discuss Will's scouting trip to T.rex country; Expedition departs on cargo raft.

32 | 33 — Dramatic ride down Cargo Chute through bowels of Waterfall City.

34 | 35 — Station house at twilight. Waterfalls in distance. Introduce plesiosaurs and ankylosaurs & cargo system.

36 | 37 — Meet Crabb's rough companions, who tell spooky legends of caves.

38 | 39 — Oriana proves her spirit by stopping an argument. She charms all with her unique flute.

40 | 41 — Crabb seems the polished gentleman; Oriana's flute; Bix and Oriana bid goodbye to the moon and stars.

42 | 43 — Arthur modifies scuba gear for plesiosaurs. Details of the two subs.

44 | 45 — Descending through sea, witness 3-D dance of ammonites. Concepts of colonialism & group mind.

To give the full impression of each page, I indicate in light pencil lines where the text block will go on the page layouts. In comics, a storyboard might show the word bubbles.

It's important to keep the drawings loose. They don't have to be pretty or finished. If you get attached to a panel because it has a nice bit of drawing, you might overlook the fact that it really doesn't belong in the story. You have to be ruthless in cutting panels and changing the order of sequences. You're doing storyboards correctly when your stack of rejected panels is greater than the number that makes the final cut.

At the top of this page is part of the storyboard for *Dinotopia: The World Beneath*. For this book, I experimented with another way of doing storyboards. I drew each panel on paper in color, using markers and pens. Then I coated the backs of the pieces of paper with a thin layer of beeswax, using an old-fashioned paste-up tool called a waxer. In this way, I could reposition the panels or remove them easily, and then burnish them into

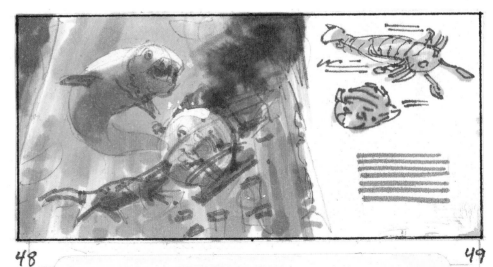

48 | 49

position when the project was over. Below each panel is a brief typewritten summary of the story point for a given page to help keep me on track for each painting and to guide the writing process later. In my case, the final written text is the very last part of the process.

Above is one of those color marker panels, reproduced at almost twice the actual size.

Opposite Top: Arranging storyboards on a display panel.

Opposite Bottom: Storyboard from *Dinotopia: A Land Apart from Time*, 1990. Pencil on printed card stock, 5½ × 8½ in. overall.

Top: Twelve panels from the storyboard of *Dinotopia: The World Beneath*, 1994. Marker, 10 × 16 in. overall.

Above, Storyboard panel: *Sub Attack*, 1994. Marker, 1½ × 3½ in. overall.

COLOR EXPERIMENTS

In addition to the color marker storyboard, you can make small color sketches in the same medium as the final painting. Color sketches can be a good testing ground for color combinations and abstract shapes.

Above: Abstract study, 1994. Oil on board, 4 × 9 in.

Below: Color script for *Dinotopia: The World Beneath*, 1994. Oil on board, 9½ × 6½ in. overall.

WATERFALL CITY — MORNING

BOTANICAL MUSEUM

THE SUBMARINE

LUMINOUS CAVERNS

DOORWAY TO "TREASURE ROOMS"

GIGANTIC GARDENS

TREASURE OF ATLANTIS

RUINS BENEATH THE SEA

Works of sequential art are made up of images grouped in storytelling units known as sequences. Each sequence tells a finite portion of the story and conveys a particular mood. To achieve that mood, the color designer chooses a family of colors, keeping in mind what comes before and after. The process of planning this color sequencing is called color scripting.

To the left is an exploratory color script for *Dinotopia: The World Beneath*. Each sketch is about the size of a business card, deliberately painted with an oversize brush, forgoing detail. The sequences are juxtaposed to make it possible to see how one color scheme will lead into the next. You can tape off multiple rectangles on an illustration board or a primed panel.

A color sketch doesn't have to be representational at all. Sometimes an abstract, painterly handling or even a collage of cut paper can best allow you to consider the emotional effect of the color combinations.

Small color sketches help you plan not only the overall sequence of color but also the concept for each individual painting. In academic training these sketches were called première pensées. The goal was originality, spontaneity, and sincerity. Diderot said that a color sketch should be "a work of fire and genius," and the finished picture should be the result of patient study, long toil, and consummate experience.

Before you start painting, spend some time mixing a family of colors with a palette knife. Lay the colors down

quickly, either with a bristle brush or with a painting knife. Try to paint without thinking too much. Have your favorite music playing, and let yourself be driven more by intuition than by rationalism.

The sketches at right were done in this way. I was imagining a nighttime gathering of humans and dinosaurs, with a grouping around firelight, perhaps for the blessing of a child; I wasn't really sure of the details. The second sketch was another variation on the idea of an evening ceremony taking place under the protective wings of a giant pterosaur. Both these sketches ended up on the cutting room floor. My conception evolved in another direction, and I cast them aside.

I developed the set of small compositions below when I began designing *Dinotopia: The World Beneath.* I knew that most of the pictures in the book would serve primarily as illustrations in the context of the story. But I wanted other paintings to be able to stand apart from the narrative. They had to be bigger paintings that made sense even to someone who was unfamiliar with the details of the story.

Color study: *Firelight*, 1994. Oil on board, 4 × 9 in.

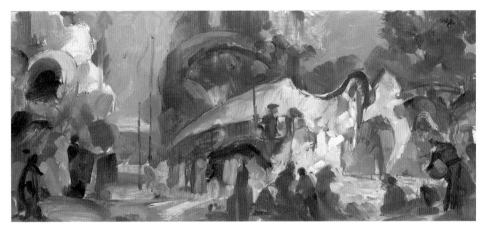

Color study: *Evening Ceremony*, 1994. Oil on board, 4 × 9 in.

Reawakening Pages 62 - 63 Rumble and Mist Pages 2-3 Steep Street Page 15

Station House, Midnight Pages 34-35 The Excursion Pages 70-71 Dangerous Alliance Pages 134-135

The Dividing Line Pages 58-59 Poseidos 1000 BC Gatefold 159-160

Small compositional studies for *Dinotopia: The World Beneath*, 1994. Oil on board, 8 × 15 in. overall.

CHARCOAL COMPREHENSIVE

A charcoal comprehensive is a drawing on semitransparent paper, usually the same size of the final painting, which establishes the placement and contours of all the principal components of the picture.

The full-size charcoal preliminary is sometimes called, confusingly, the cartoon. It was a common step in the process for academic painters such as Bouguereau and Vibert and also for many old masters. The academic masters typically emphasized only the outlines and scarcely hinted at the tone, which they developed in smaller oil studies.

Norman Rockwell took this step very seriously, rendering everything out in fully modeled tones. He said, "Too many novices, I believe, wait until they are on the canvas before trying to solve many of their problems. It is much better to wrestle with them ahead of time."

You can sketch the design loosely at first on inexpensive architect's sketch paper, sometimes called flimsy, which comes on a roll. By building up the drawing in separate flimsy layers, or in Photoshop, you can experiment with overlapping or flopping elements. You can use a soft vine charcoal first, and then switch to charcoal pencils, compressed charcoal, or graphite pencil to define the lines and tones more strongly. For the final drawing, a 100 percent cotton vellum provides a forgiving surface for relentless erasing and redrawing. This is the blueprint for the picture. Think of it as a chalkboard: Erase a line, move it a little, add and subtract elements until every part of the picture is in place to tell your story. If the piece is an illustration that must appear in the context of a designed page, be sure to take into account any titles, headlines, croppings, or gutters.

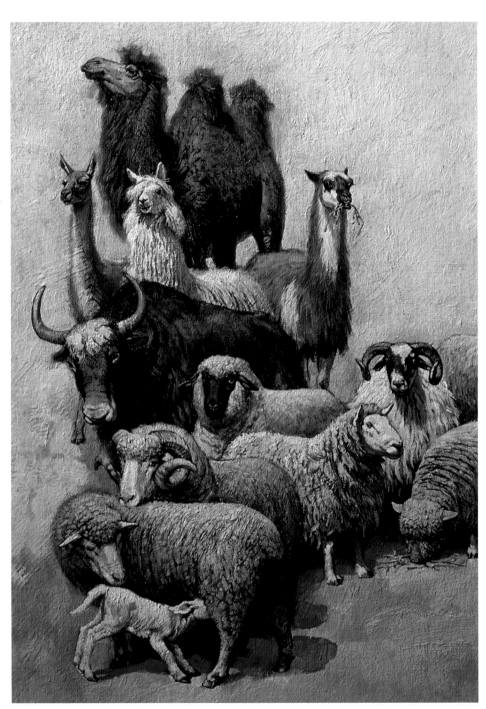

Above: *Wool-Bearing Animals* (Detail). Oil on canvas mounted to panel, 18 × 24 in. Published in *National Geographic*, May 1988.

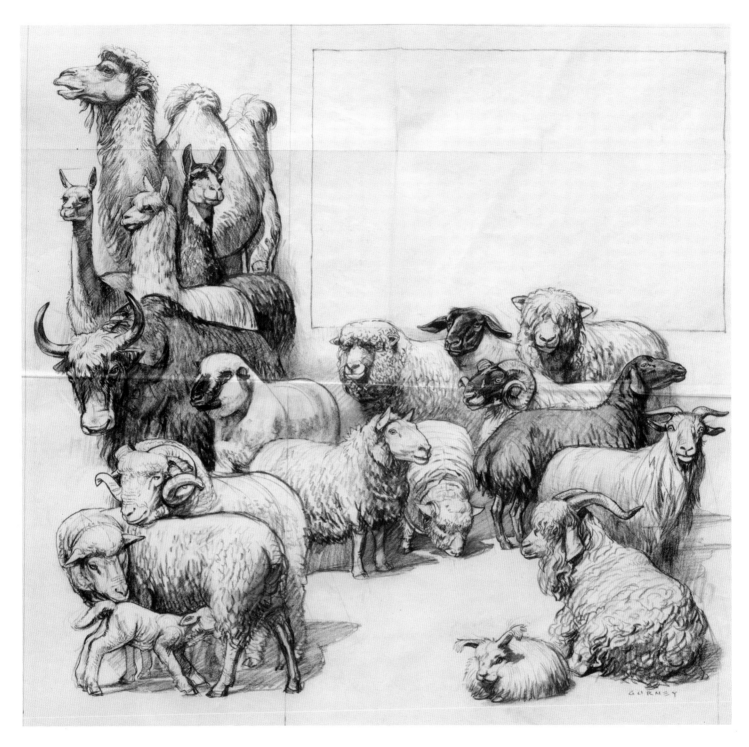

The charcoal comprehensive (above) shows a representative group of wool-bearing animals for a *National Geographic* article. The exact placement of the llamas changed a little as it went to the finished painting opposite.

When you have taken the drawing as far as you can, seal it with workable fixative, and then transfer it to the final illustration board or canvas. I use a piece of flimsy covered on the back with graphite or charcoal. When you draw over the key lines with a ballpoint pen, stylus, or hard pencil, the drawing will transfer. It should be sealed before painting (see page 192).

Above: Wool charcoal comprehensive, 1987. Charcoal on vellum, 20 × 21 in.

CORRECTIONS AND TRACINGS

Whether you're at the charcoal comprehensive stage or you've already started the final painting, you can keep experimenting with changes by putting them on separate layers.

The painting at right appeared in a 1985 *National Geographic* article describing explorer Tim Severin's voyage following the legendary route of Jason and the Argonauts in a reconstructed twenty-oar Homeric galley. I chose to depict the moment just before the Clashing Rocks began to close in on the *Argo*.

I started the painting without knowing where the sail should go. After painting in the rocky background, I made a paper cutout of the sail and held it over the painting until the position looked right. Then I traced around it in white colored pencil and painted in the sail.

The scene on the opposite page shows an Etruscan tomb in Tarquinia, Italy. The family is departing the tomb, accompanied by musicians and dancers. The pencil sketch at the lower left shows the figures as I first imagined them, still without reference to models.

For the charcoal comprehensive, opposite top, I drew each figure grouping on a separate layer of tracing paper. In this way I could experiment with overlapping without erasing or affecting the layers beneath. Of course, you could do all this in Photoshop, but drawing in pencil or charcoal is deliciously tactile and just as fast.

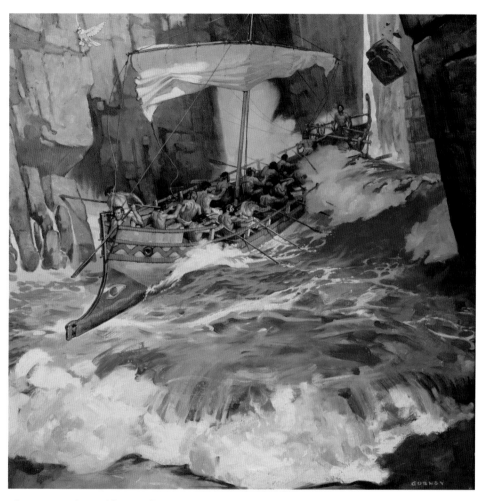

Above: *Voyage of Argo*. Oil on panel, 22½ × 22½ in. Published in *National Geographic*, September 1985.

Below: Maquette for Greek galley. Wood and cardboard, 19 in.

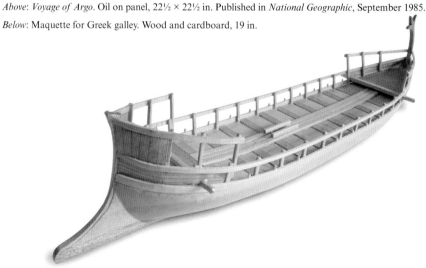

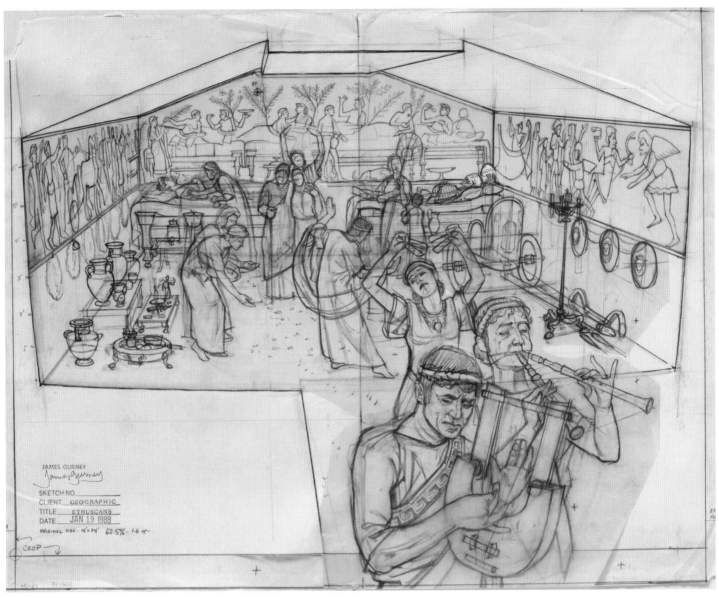

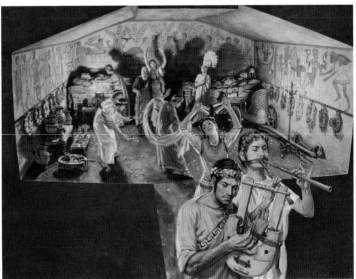

Above: Etruscan Tomb layout, 1988. Pencil, 10½ × 13½ in.

Top: Etruscan Tomb charcoal comprehensive, 1987. Charcoal on tracing paper, 18 × 24 in.

Above: Etruscan Tomb. Oil on panel, 18 × 24 in. Published in *National Geographic*, June 1988.

EYE LEVEL

The eye level is the height of the viewer's eye above the ground, usually represented by a horizontal line running across the picture, even if the horizon itself is not visible in the scene.

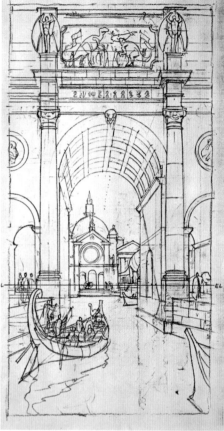

Eye level is basically synonymous with *horizon*. They're one and the same thing in the preliminary line drawing above, where the ocean is in view. But in most scenes, you don't have such a far vista. Either you're in a forest, or you're inside a room, or the view is hemmed in with buildings. But you still have to draw the imaginary line in the same place it would be if you could see all the way to infinity.

The eye level is the very first line you put into your drawing, even a figure drawing at a sketch group. I mark it with the letters *EL* to remind me what it is. If your scene is more of an upshot, the EL is toward the bottom of the scene. Everything that you draw above the line is something you're looking up at. In

a view that's more of a downshot, the EL is high in the composition because almost everything in the scene is below your level gaze.

If architecture appears in your scene, all the major vanishing points (VPs, of things such as eaves and sidewalks) are pegged on the EL line. Each VP should be marked with a little × surrounded by a circle.

In the line drawing of the archway, the VP is marked on the EL just beneath the circular window of the domed building. All the lines in the coffered ceiling of the inside of the arch and along the waterline inside the arch vanish to this point.

If you look again at the same scene, the arch is flanked by two circular columns. At the EL, the circular cross-

section of the columns is seen edge-on, so the bases of the columns don't appear as ellipses. But as you go up the columns, the ellipses become slightly fuller.

In a scene that takes place on flat ground, the EL usually intersects everything at about 5 feet above the ground. That's because 5 feet is the average height of the eyes of a standing person. Most photos are taken from that height as well. You can imply that the viewer is seated or that the viewer is a child by placing your eye level lower.

On flat ground, the EL line cuts through every figure at the same relative point. In the throne room scene on the opposite page, the EL is exactly at the height of the top of the dais, or platform. If you carry that line across

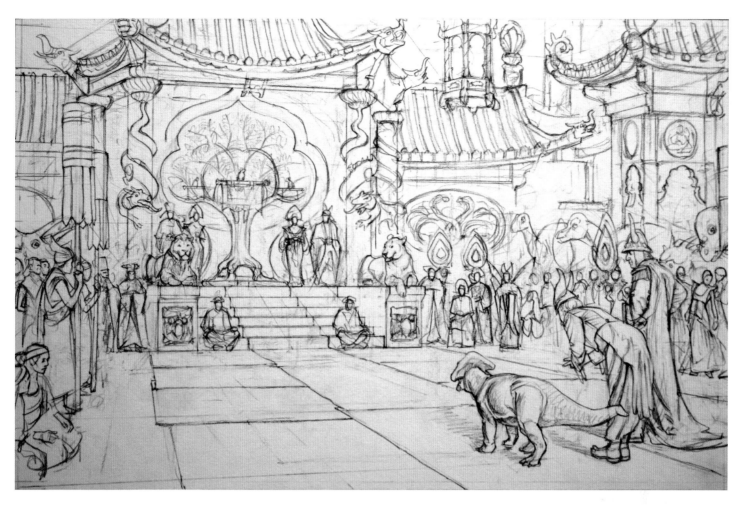

the scene, it will intersect every standing figure just below the shoulder.

On that drawing, the VP for the edges of all the carpets is just visible on the shoulder of the figure standing just to the left of the leftmost lion.

Incidentally, the drawing above was not drawn as a separate charcoal comprehensive. It is a pencil drawing made directly on the illustration board before painting. The same is true of the archway line drawing on the opposite page. That was drawn directly on the board, and I made a photocopy before beginning to paint.

The drawing to the far left is a schematic version of a charcoal comprehensive, though actually drawn in pencil. I drew grid lines on it so that it could be enlarged to the 24 × 30-inch final painting.

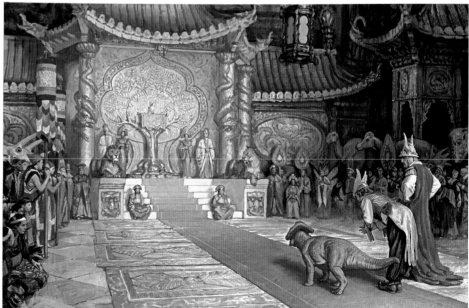

Above: Throne room, from *Dinotopia: Journey to Chandara*, 2007. Oil on panel, 12 × 18 in.

Opposite Far Left: Line drawing for *Chasing Shadows*, 2005. Pencil, 8 × 10 in.

Opposite Near Left: Study for *Sauropolis Entrance*, 2005. Photocopy of pencil on board, original 12 × 6 in.

Top: Preliminary drawing for throne room, 2007. Pencil, 12 × 18 in.

PERSPECTIVE GRID

A perspective grid is a set of reference marks or guidelines drawn lightly across a picture or in evenly spaced marks along the outside edge of the image.

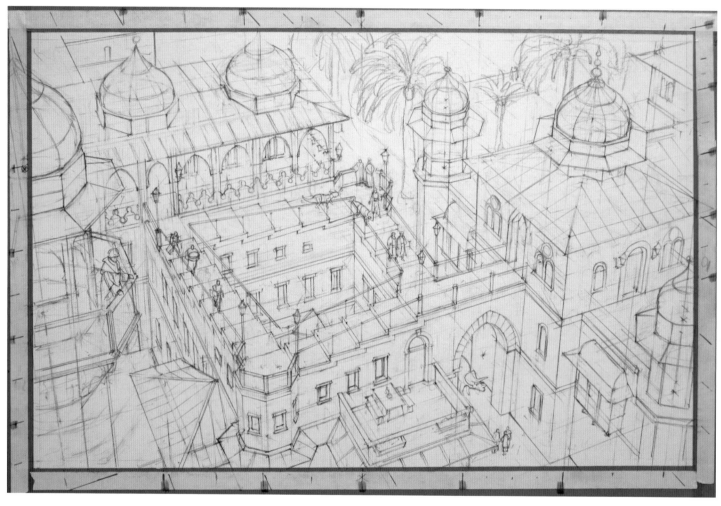

Perspective drawing for *Scholar's Stairway*, 2006. Pencil on board, 12 × 18 in.

This night scene of a stairway is a tribute to M. C. Escher's famous lithograph *Ascending and Descending* (1960), showing a stairway that appears to go forever up and down in each direction. Escher's illusion was based on an impossible figure designed by Lionel and Roger Penrose in 1959.

I've been fascinated by this illusion since I was a kid because there are no obvious clues that it's an impossible object. I started wondering whether such a stairway might exist in Dinotopia. How would it look in the early morning

lit by lamplight? Instead of being just an endless stairway going nowhere, what if it was used to connect two buildings? That way you could have two groups using the stairs, one group with low status—say, college freshmen—always forced to travel upstairs to and from class, while the upperclassmen could have the luxury of going downstairs to the same place.

This scene depended on a fairly complex three-point perspective. The eye level is not visible within the frame of the picture because it's entirely

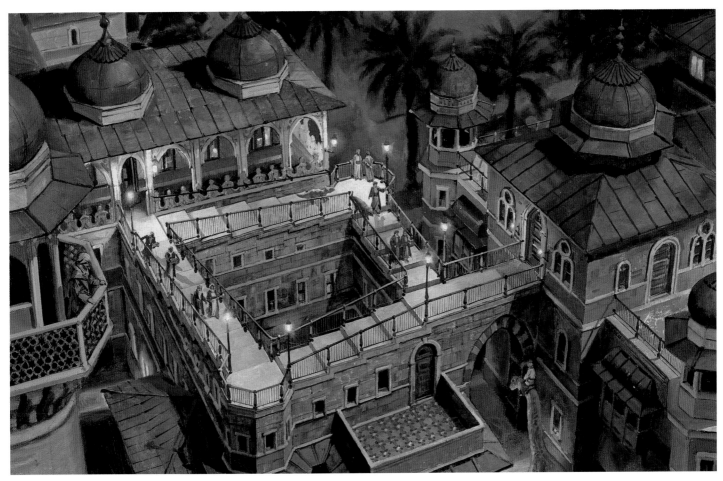

a downshot. As I began to apply opaque paint, I needed to find a way to accurately reference the slope of any line in the picture. None of the VPs were close enough to the painting to be reachable with my mahl stick. So instead of worrying about the VPs, I established a series of graduating slopes for each VP by means of a set of evenly spaced guide marks alongside the margins of the picture. They are marked off on a piece of white tape superimposed over the low-tack blue tape that defines the edges of the painting.

Any intermediate slope for any of the three VPs can easily be determined by lining up the mahl stick with the guide marks along the edge. Because the painting is not tied in space to the VPs, it can be moved around or turned upside down any time you want.

Having these guides was important in a painting such as this, where the line drawing itself (including the center lines for the domes) was eventually covered up by the opaque paint. When the painting was finished, I stripped off all the tape, leaving a clean white edge around the image.

Scholar's Stairway, 2006. Oil on board, 12 × 18 in. Published in *Dinotopia: Journey to Chandara*.

STICKING WITH IT

Picture ideas don't always come together right away. If there's something that just doesn't feel right about a composition, keep trying new ideas in the sketch stage until you're sure you like it.

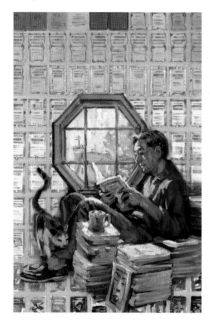

To honor its centennial in 1988, *National Geographic* asked me to paint a picture expressing the magazine's legacy of adventure and discovery. Instead of portraying some bold explorer, I thought it would be fun to show something more poignant and homespun: a man sitting in an attic looking back on his life and his world through the pages of old magazines.

In early concepts for the painting, the man sat all by himself. The first color sketch, above, shows the man against a background of magazine covers. I had hoped the octagonal window would convey the idea that he was sitting in an attic. But it was confusing. It wasn't clear where he was sitting.

So in the sketch at center I placed him in an attic and used the broom and dustpan to show that he was distracted in the process of cleaning up. But I wasn't happy with this idea either. It was depressing to think of the old man sitting up there all by himself.

To cure the loneliness problem, I drew the composition again in charcoal (above, right) and returned to the idea of a cat rubbing against his leg. But that still wasn't enough. I needed to show that he was passing his memories to someone, so I added a grandson. I had models pose and drew the charcoal comprehensive (right) at the size of the final painting.

The final painting shows the two figures surrounded by the mementos of the man's life: a military uniform, an old family photo, and a ship clock. When I started the project, I knew I would have to search out all those items from real attics in my hometown. In the finished painting I was interested in the cool light from the window and the warm illumination bouncing back from the attic space. I tried to capture the boy's faraway expression, as if the magazine and his grandfather's memories were taking him to another world.

Top Row: Assorted studies for *Attic Scene*, each 9 × 6 in.

Above: Charcoal comprehensive for *Attic Scene*. Charcoal on vellum, 36 × 24 in.

Opposite: *Attic Scene*. Oil on canvas, 36 × 24 in. Published in *National Geographic*, February 1989.

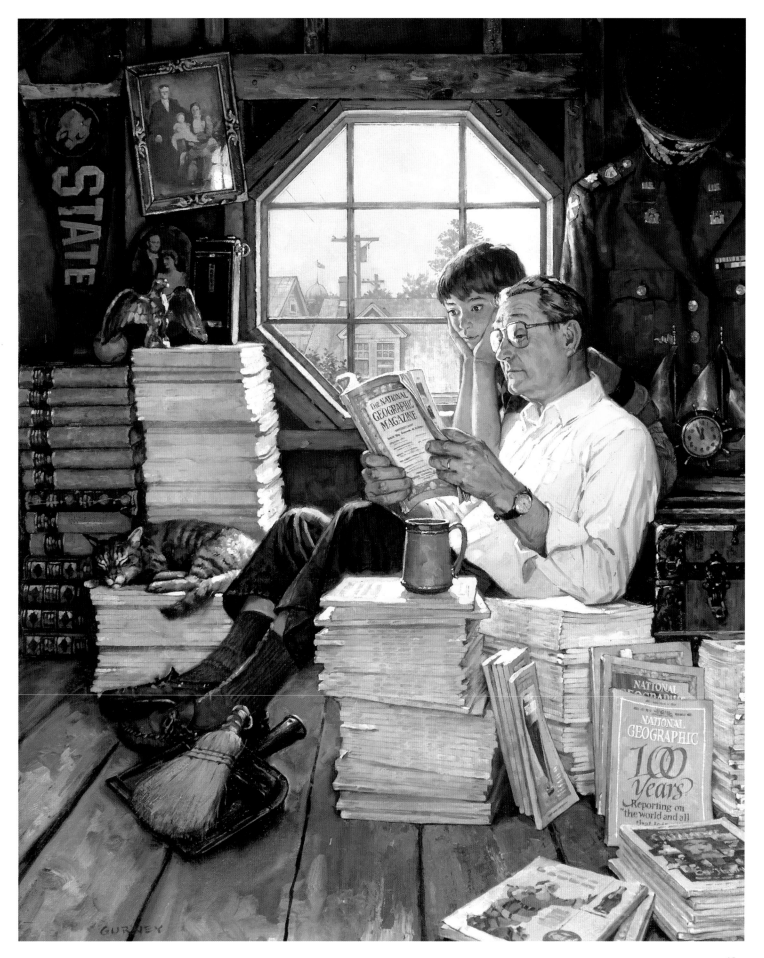

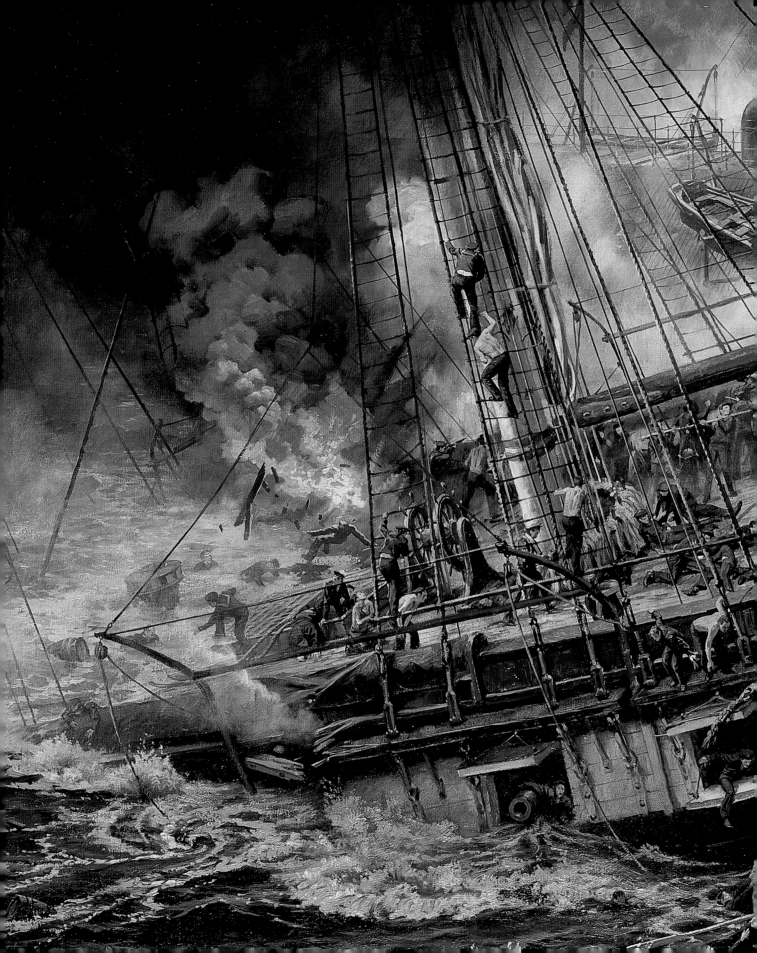

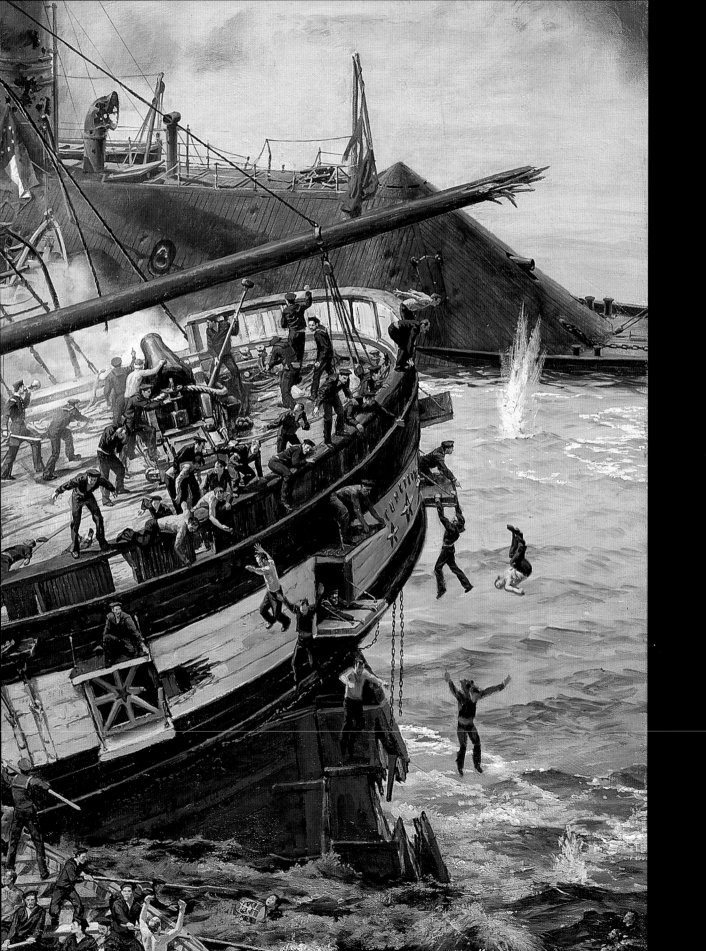

TELLING A STORY

History isn't a collection of facts. It's a collection of stories. A historical painting is first and foremost a storytelling picture with a set of characters at some moment of crisis or decision. Although you can show only a single snapshot of the events, your painting can suggest the full scope of the narrative. The challenge is choosing the moment and the angle that tells the tale in the most memorable and engaging way.

The painting that appears on the preceding pages was commissioned by the National Geographic Society to commemorate the series of naval battles that took place near Newport News, Virginia, in March 1862. The most famous of these battles involved the ironclads *Monitor* and *Merrimac* (known to the Confederates as the *Virginia*).

The day before its battle with the *Monitor, CSS Virginia* destroyed the *USS Cumberland.* The *Cumberland* went down at 3:37 P.M. on March 8, 1862, victim of the *Virginia*'s 1,500-pound iron ram and a relentless barrage that covered the deck with carnage. As his ship sank, Lieutenant George U. Morris gave the command for all hands to save themselves, but he remained on deck to encourage the decimated pivot gun crew, who kept firing even as the waves closed around them.

To Buchanan's demand for surrender, Morris defiantly replied, "Never! We will sink with our colors flying." The *Virginia* sustained only superficial damage as the *Cumberland*'s cannonballs bounced harmlessly off its 4-inch iron covering.

My first job was to read all the surviving firsthand accounts, not all of which agreed on the details. I then traveled to the location and met with historians, including John Quarstein, above, who pointed to the exact spot where the *Cumberland* finally settled. At naval history museums, I looked at the few remaining fragments of both ships, and I photographed scale models of the vessels.

With all this background information, I began visualizing the scene with some small color sketches of various possible viewpoints and compositions. The crucial moment, it seemed to me, was when both ships were firing on each other at close quarters, even as the *Cumberland* filled with water. Some of the men were trapped below decks. One man was seen trying to escape from a gunport and was swept back inside by the power of the water. Others scrambled into the rigging. Many jumped overboard and either were drowned or were rescued by the lifeboats.

Several accounts noted that the day was beautiful and clear, which presented a problem if I wanted to make the scene appear dramatic. One of the four sketches is painted in a limited color range, resembling the sepia photos of the time. Historians and reenactors told me that there would have been a tremendous amount of smoke and steam.

One detail that struck me was the account of a fat drummer boy who jumped overboard and used his drum as

1. *Virginia Trades Broadsides with a Sinking Cumberland*

2. *Deck View of Close Engagement in Antique Photo Style*

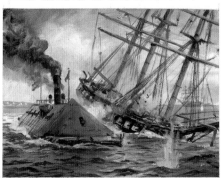

3. *"Give Them a Broadside, Boys, As She Goes!"*

4. *Front View of Action, Debris Flying, Congress in Distance*

Preceding Pages: *Sinking of the Cumberland*, 2005. Oil on canvas, 30 × 40 in. On loan to the Mariner's Museum, Newport News, Virginia.

Above: Four color studies for *Sinking of the Cumberland*, 2004. Oil on board, 11 × 14 in. overall.

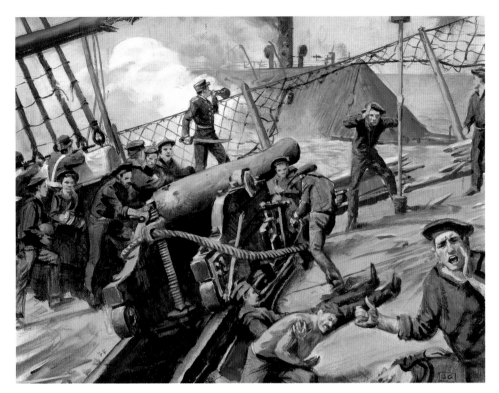

that I found in a surplus store, I jumped off a ladder and writhed around on the ground, trying to imagine what it would have been like for the various sailors who were coping with the tragedy. My wife took snapshots with a digital camera. One of the photos has a motion blur effect that I used in the final painting.

While all this was going on, I was making a detailed line drawing of the *Cumberland,* based on photos, drawings, and models, as well as photos I took of its sister ship *Constellation* in the Baltimore harbor.

A detail of that comprehensive line drawing can be seen below with notes from naval historian Colan Ratliff correcting some of my errors. I had shown the old-fashioned deadeyes instead of rigging screws and had drawn the wrong kind of gooseneck attaching the boom to the mast.

With all the references and corrections in place, and after nearly a year of research and roughs, I finally was ready to start the 30 × 40-inch oil painting, which took a couple of months. Most of the time was devoted to painting the various figures.

Another artist with different sensibilities might have chosen to tell the story in a different way, focusing on a different moment in the narrative or a different angle on the action.

a float. You can see him on page 47 just to the right of the lifeboat.

All along, my instinct had been to view the scene from enough distance to see the lifeboat and the waterline of the *Cumberland*. But before I went into full production on the painting, the art director suggested that I produce one more sketch, above, showing a much closer view of the action. We see the pivot gun crew suffering great losses and yet bravely fighting on, with Morris calling out through his speaking trumpet.

Like all compositional decisions, this one would have been a tradeoff. Getting this close to the action brings the viewer closer to experiencing the psychology and the horror of battle. But if this scene was all that the viewer saw, it wouldn't be clear that the action is set on the deck of a sinking ship. We agreed to pull back the viewpoint to its original position.

I then had to act out the parts of all the sailors in various conditions of leaping, swimming, nursing injuries, or manning oars. Wearing a navy uniform

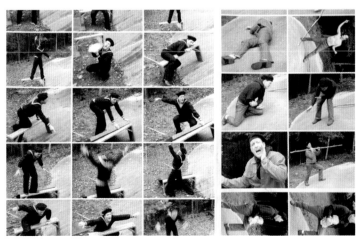

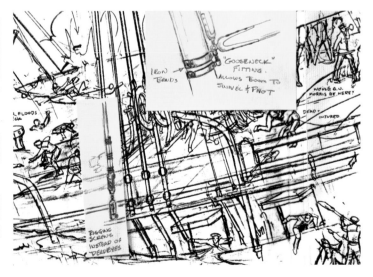

Top: *Pivot Gun Crew Sketch*, 2004. Oil on board, 10 × 12 in.

Above: *Cumberland* poses, 2004. Ink jet printout of digital photos, 10 × 14 in.

Right: *Cumberland* line drawing (detail), 2004. Photocopy with notes, 5 × 8 in.

EARLY HUMANS

When paleoanthropologists discover a skull or a skeleton of a human ancestor, they study the bones and teeth very carefully and use advanced dating techniques to determine the age of the fossil. Artists and sculptors work closely with the scientists to restore the living appearance of the original early human.

Creating a life restoration of an early human or hominin takes a disciplined approach that combines careful observation of the known facts with reasonable speculation based on living analogues.

The painting at right was commissioned by *National Geographic* in 2004 as a cover proposal for a feature on *Homo floresiensis,* nicknamed the Hobbit.

Several fossil skeletons were discovered starting in 2003 on the island of Flores in Indonesia. The skeletons were diminutive in stature, with skulls that had a small braincase and a low forehead. Yet they were associated with fairly advanced tools in deposits dating to as late as eighteen thousand years ago, leading some scientists to speculate that they were living remnants of an isolated population of primitive hominins like *Homo erectus,* possibly coexisting with modern humans. Other scientists believe that the fossils represent a group of diseased individuals with abnormally small skulls.

Top Right: Homo floresiensis. Oil on board, 10½ × 8 in.

Far Right: Hominin maquette, plaster cast of clay original. Head is 6 × 4 in.

Right: Homo floresiensis skull.

To paint a life portrait, I started with a variety of images of the skull: photos, drawings, and computer models.

I then made pencil sketches and a small maquette. I experimented with a variety of angles and lightings. These choices are essentially artistic ones, the same choices that a portrait painter uses to convey an interpretation of the sitter's character. Using the same maquette as a starting point, two different artists could make a given hominin look brutish, intelligent, aggressive, or timid. I chose a slight upshot with warm frontal lighting. The eyes are turned upward to suggest its small stature and to express curiosity. The setting is a forest interior, painted out of focus to convey a sense of photorealism.

The images on this page are from a visual development project for a film called *The Missing Link,* released in 1988. The producers were planning a live action docudrama to help visualize the two-million-year-old *Australopithecus*.

I gathered images of all known fossils of this group of hominins and went to the Smithsonian National Museum of Natural History to study the casts of the fossils and to meet with scientists. In the sketch to the right, I drew the *Australopithecus* skull in a three-quarter view alongside nonhuman primates and comparative human skulls. I also studied films and photographs of humans and apes with various facial expressions, including the open-mouthed stare, a threat gesture in primates. The sketches analyze which muscles come into play in creating that expression.

One of the challenges of restoring early humans is the soft morphology: skin, muscle, hair, cartilage, and other perishable tissues that don't fossilize as readily as bones and teeth. These play an important role in the overall impression of the life restoration.

Experts often disagree on soft morphology. How much of the body should be covered by hair? Should the hair be curly or straight, brown, red, or black? The forms of the ears, nose, and lips have very little to do with the shapes of the bones underneath, so it's reasonable to come up with different proposals. In the sketches to the right, I offered a range of choices for the nose and lips based on an assortment of modern human and nonhuman faces.

The job of the artist doesn't end with drawings of structure and anatomy. The sketch at the bottom is one of many that I did to imagine plausible behaviors. The creature is shown at a kill site of a young giraffe at Amboseli, Kenya, squatting and using the mandible as a hand tool.

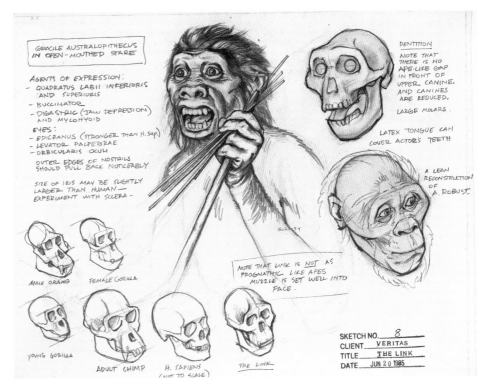

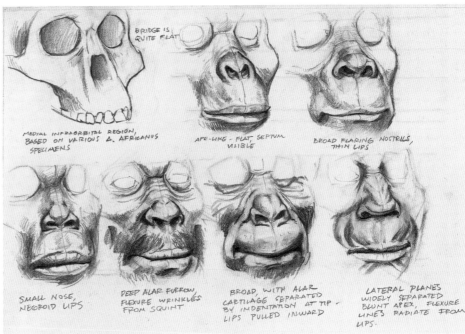

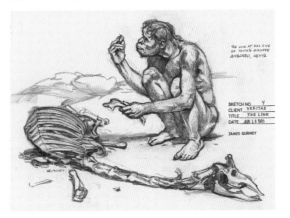

This Page: Visual development sketches for *The Missing Link*, released 1988. Pastel and pencil, each drawing 11 × 14 in.

CLOSE OR FAR VIEW

From a high perspective, a crowded festival looks like an anthill, bustling with activity. From this distance it's hard to tell emotional, human stories, but you can give a sense of scale that no other view can provide.

The scene opposite shows an Etruscan necropolis, or city of the dead, with funeral rites under way to mark the passing of a prominent citizen of the now-ruined city of Norchia in north-central Italy. On the bluff, a horse race has begun, with a chariot race about to start. Nearby is a fight between a man and a dog, and below the false fronts of the funerary monuments is a family carrying the deceased patriarch.

This painting, which was reproduced as a two-page spread in *National Geographic,* brings to life an archaeological site that now slumbers under vines and overgrown vegetation. When I visited the location with an archaeologist, I took photos and measurements and then made maquettes of the whole scene, trying various angles and viewpoints to determine which view conveyed the most information. One thumbnail sketch (above) shows a closeup of a chariot race, which was dramatic but not as informative.

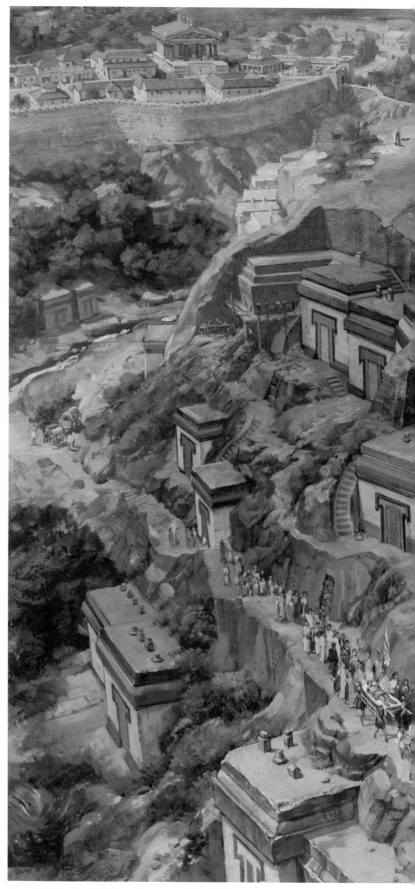

Above Left: *Chariot*, 1987. Pencil on paper, 4¾ × 6½ in.

Above: *Norchia*. Oil on canvas mounted to panel, 18 × 24 in. Published in *National Geographic*, June 1988.

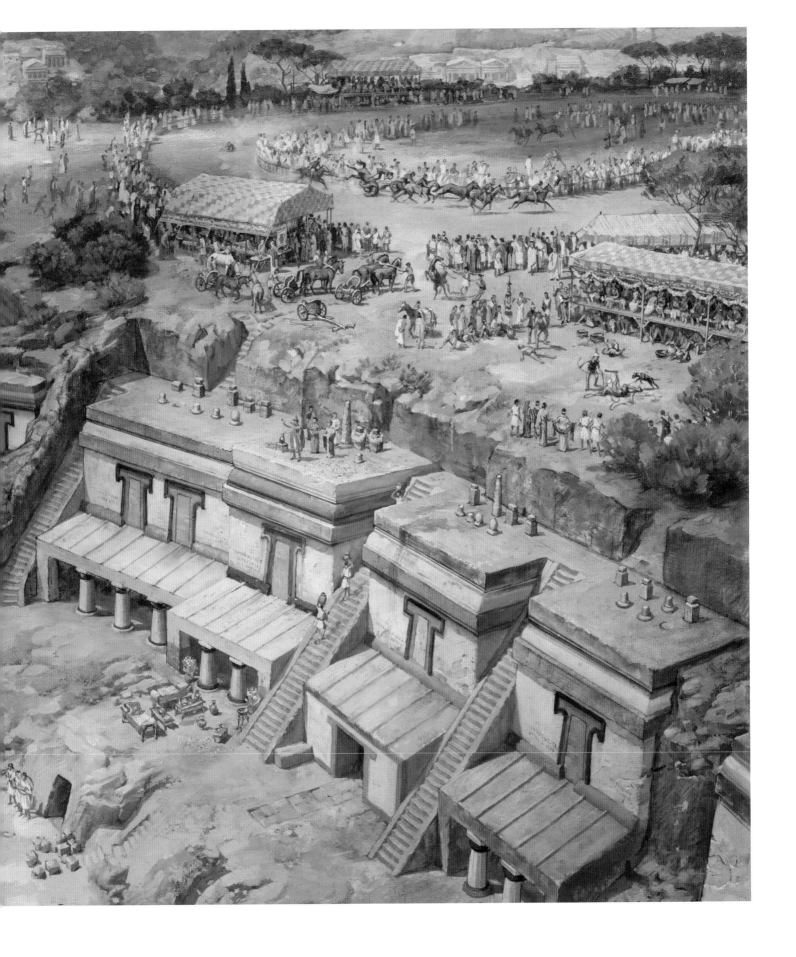

INFORMATION AND ATMOSPHERE

Suppose you want to portray a group of ancient hunters who have just killed a mammoth, a family of pioneers building a log cabin, or a gathering of ancient Maya playing a Mesoamerican ballgame. Sometimes you want a single picture to convey a lot of didactic information, but it still needs to convey the right mood and atmosphere.

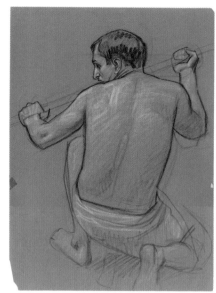

In this scene from 700 B.C. near the Etruscan city of Populonia, my goal was to show some of the key action poses from various stages of iron smelting. I started by traveling to the archaeological site, now a popular tourist beach, to figure out what the view of the old walled city would look like. By setting the scene in sunset light, I could show the various actions illuminated by the glow of the smelters, while the radiant city in the distance gave a focal point for the whole scene.

The archaeological consultant provided me with written descriptions of the iron smelting process used by the Etruscans. The steps involved loading the chimneys with ore and charcoal, pumping air into the base of the chimneys with animal hide bellows (lower left), and recovering the chunks of slag from the disassembled chimney using a long pole. It always struck me that paintings of work scenes show everyone looking too earnest and industrious. In real life, some of the laborers must have been standing around doing nothing. So I made sure to have one figure leaning on his staff and supervising.

I tried out each of these actions myself and then brought in models to pose for charcoal studies in various stages of the action.

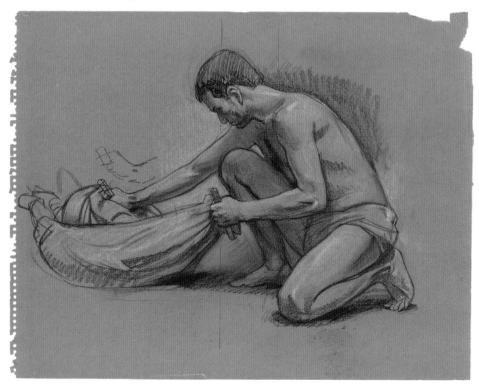

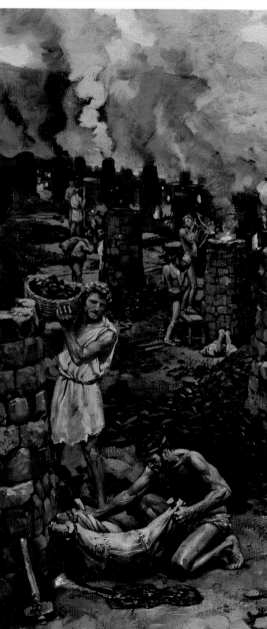

My first charcoal comprehensive layout (see spread on pages 26–27, "Preliminary Sketches") was a false start. It doesn't show the removal of the iron ingot, a crucial part of the process. Also, because it takes a view so close to the figures, it becomes more of a genre painting exploring incidental details of character and psychology rather than a more epic overview that places the figures on a wider stage.

Whatever actions you are called on to visualize, keep in mind what the Golden Age illustrators taught: Capture the epic, not the incident.

Opposite: *Populonia Study*, back view, 1987. Charcoal and white chalk, 18 × 12 in.

Opposite Bottom: *Populonia Study*, bellows, 1987. Charcoal and white chalk, 12 × 18 in.

Below: *Populonia*. Oil on canvas mounted to panel, 14 × 24 in. Published in *National Geographic*, June 1988.

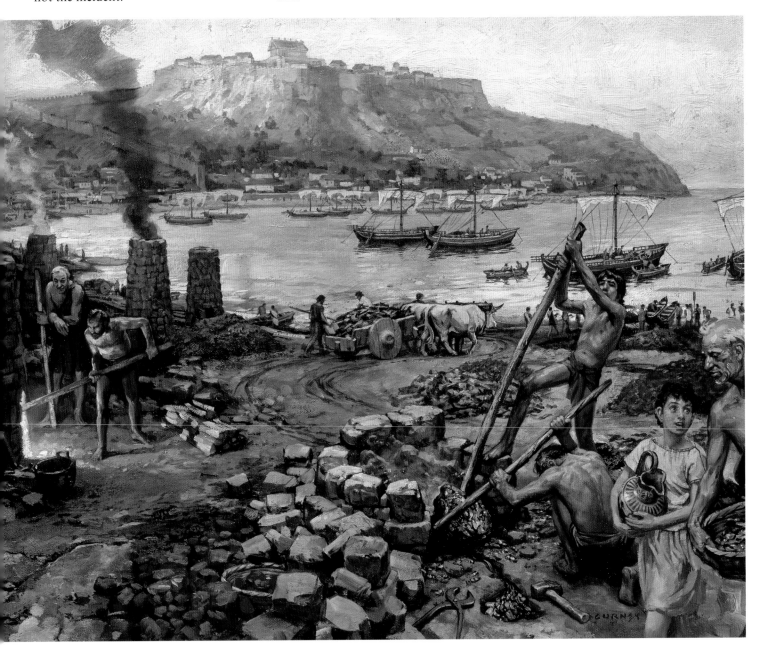

MIRROR STUDIES

A great way to get reference for painting a character is to pose yourself in front of a mirror and make a charcoal study on tone paper.

For this *National Geographic* illustration showing a Kushite king in Egypt, I set up the drawing paper on an easel and acted out the pose, sketching a little at a time. It's okay if you're not exactly the right type for the character you're portraying. What you're looking for is the basic action of the pose, something to begin with. With a mirror study, you can make minute adjustments in the hands, feet, or drapery as you go along, so as to get the most expressive features of the pose. The result is that you will have more confidence in the drawing and more willingness to subtly exaggerate and caricature.

Artists have used mirror studies for centuries, and it's still a viable method as long as it's possible to hold the pose for a while. It's just about as fast as shooting photo references. I like the way drawn studies give me only the information I need and no more. The limitation of mirror studies is that you're locked into a standard eye level, and it takes two mirrors to do side and back views.

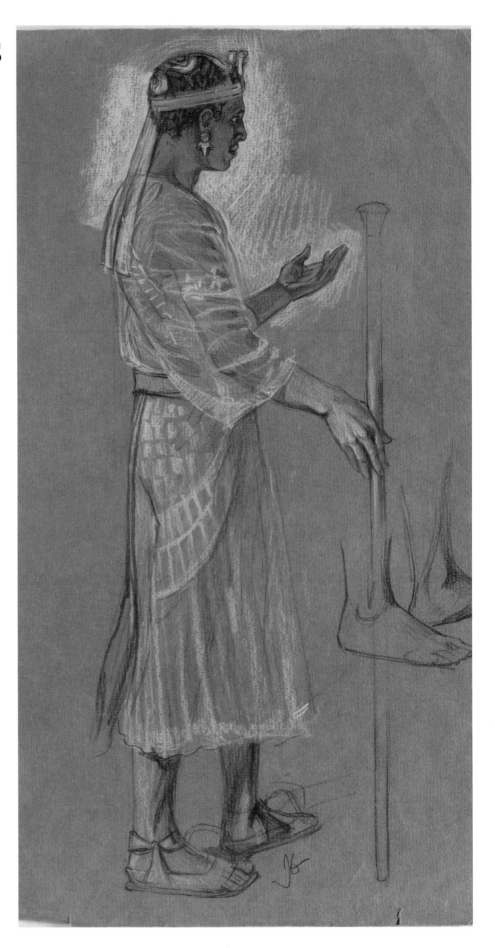

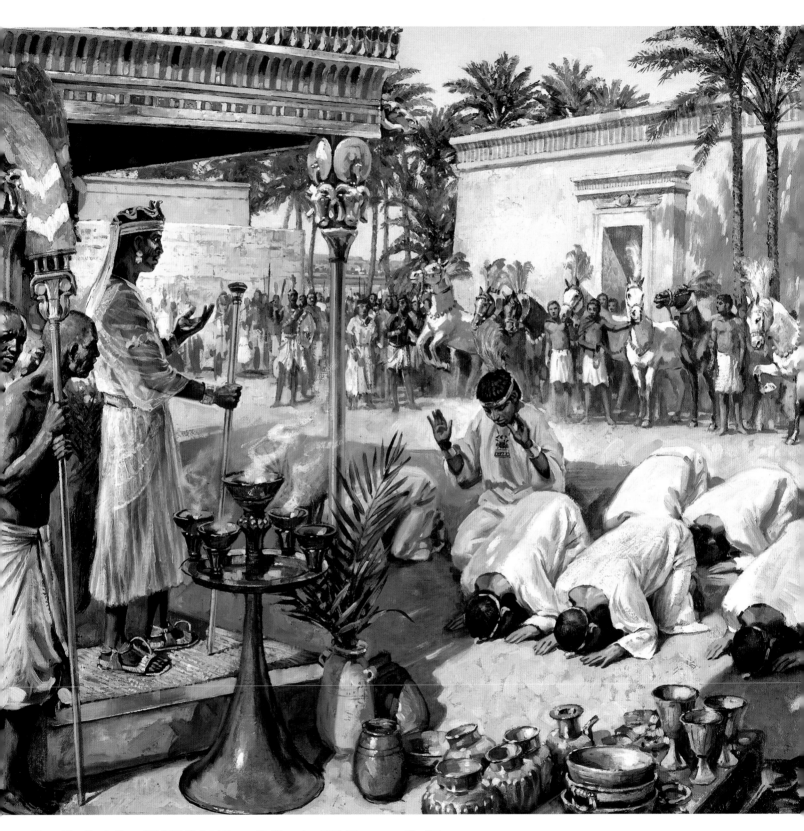

Above: *King Piye in Egypt, 724 BCE, National Geographic,* November, 1990. Oil on canvas, 20 x 22 in.

Opposite: *Kushite King Study,* 1990. Charcoal on tone paper, 13 x 20 in.

Opposite, Far Left: *Posing for Kush Study,* 1990.

TONE PAPER STUDIES

This scene shows captured prisoners from the Moche culture of ancient Peru. It was developed entirely from studies from the model, not from photography. If you're doing a reference study of yourself or a model taking the pose, you can capture all the reference information you'll need by drawing on tone paper.

Above: *Study for Peruvian Prisoner*, 1988. Charcoal and white chalk on tone paper, 19 × 25 in.

In most art schools, the tradition of drawing posed figures on tone paper tends to be regarded as an end in itself, or else purely as a timed practice exercise for training the eye and hand for observational drawing. But for most of the last five centuries, tone paper drawings were merely a means to an end, and the drawings themselves were not highly valued.

A light gray or tan paper works well for figure studies. The tone of the paper should be approximately equal to the darker halftone—the point where the form turns away from the light just before it enters the shadow.

You can begin either with vine charcoal or with a soft charcoal pencil and draw the pose lightly in line, noting the dividing line between the light and the shadow. Once you've got the pose where you want it, reserve the blackest charcoal for the shadows and accents.

The light side of the form can be defined with just a few careful touches of white chalk or white charcoal pencil. Where the form turns more to the light in the brightly illuminated areas, you can scumble a light tone overall, saving your strongest touches of pure white for the highlights and accents.

As you make your studies from life, don't just draw what you see. As Howard Pyle said, "Don't copy the model, but make a picture." Accentuate the muscles and tendons that are important in telling the story. Describe to your model the character you want him or her to act out. Better yet, act out the part yourself, and ham it up a little. Your model will feel less inhibited if you make a fool of yourself.

Let your imagination guide your eye. This mindset leads to better drawings than ones where you are just copying what you see. The drawings you produce as preparatory studies will have more urgency and confidence than the standard twenty-minute figure drawings that are done without feeling or imagination.

Above: Moche Prisoners. Oil on panel, 18 × 24 in. Published in *National Geographic*, October 1988.

ACTING IN CHARACTER

The more you project yourself into the character you're portraying, the more convincing your painting will be. You'll know which muscles are tensed and which leg is bearing the weight. All this transmits to your final result. As Harvey Dunn said, "We can't stand outside of a man and paint him well. We've got to *be* that man."

Below Left: *Pirate Study*, 1996. Charcoal on newsprint, 18 × 12 in.

Below Right: Detail from *Dinotopia Lost* cover, 1996. Oil on board, 17½ × 26 in.

Opposite Top: *Timestone Pirates Study*, 2002. Charcoal and white chalk on brown paper, 14 × 11 in.

Opposite Right: *Timestone Pirates*, 2002. Oil on board, 23 × 11 in. Poster for *Nintendo Power* magazine.

Opposite Bottom: *Eskimo Disaster*. Oil on panel, 10 × 6 in. Published in *National Geographic*, June 1987.

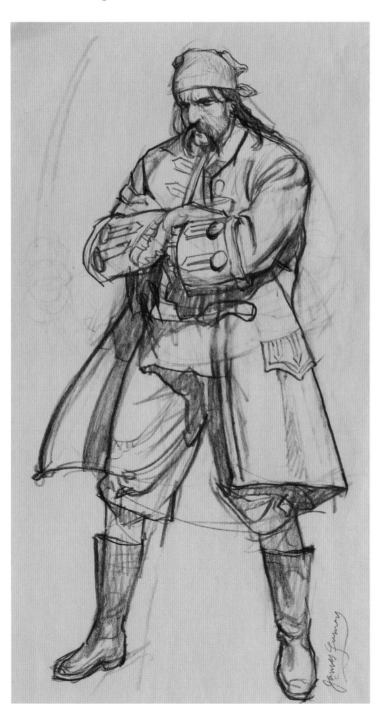

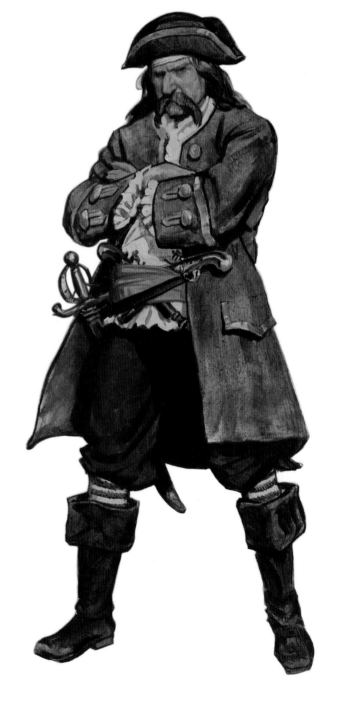

A few years ago, I needed to create the character of a warrior riding an armored dinosaur. I took the pose myself, wearing a wig and scowling in front of the mirror.

Another time I had to do a painting showing an Eskimo woman from five hundred years ago who was found by archaeologists in a death pose that showed she was protecting herself from a falling roof beam in her summer igloo. When I was interviewing the archaeologist in his office, we tried to imagine the scene, but we had to act it out. The archaeologist reached for a couple of cardboard mailing tubes, and I volunteered to lie on the floor, reaching up to fend off the falling tubes.

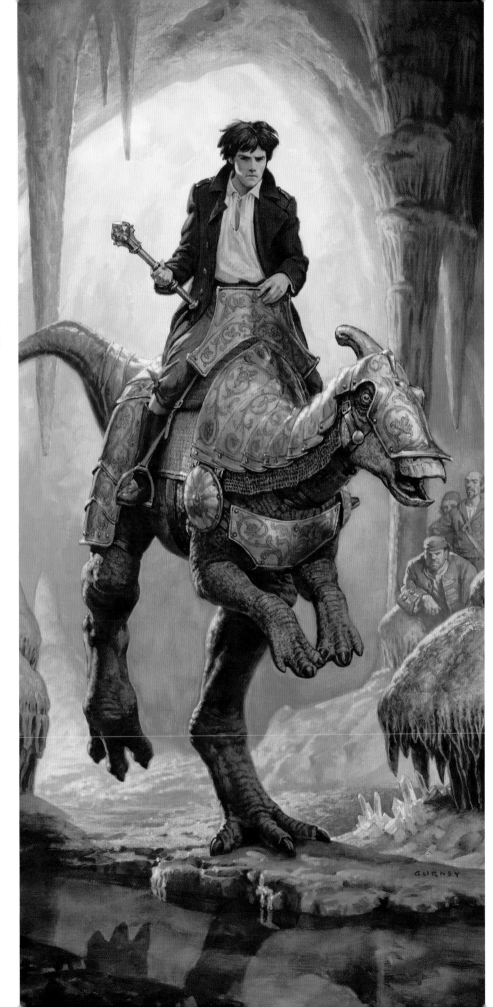

PHOTOGRAPHING MODELS

For a long time I held out against using photos for reference, preferring to look at charcoal studies made directly from live models. The reason I finally started using photos was to capture kids and animals, who can't usually hold a pose for very long.

Photos are a big help, but you can't take them too literally. In the painting below, for example, I wanted to paint a picture of a man scrubbing the teeth of a *Baryonyx*. But all I had available for a model was myself. So I grabbed some baggy pants and a long jacket and stood in the driveway with a push broom.

On its own, the photo is fairly unpromising. The shadows are too black. The legs appear too short. The coat hangs straight down in wrinkles that don't describe any action. The pose needed a better sense of gesture and a clearer silhouette. But the photo provided a lot of little details for cast shadows and costume details, such as the hat made from spiraling pieces of cloth.

Every photo is just a starting place, and the fun begins when you depart from the facts that the camera records.

For some action poses the still or video camera can play a vital role, freezing the action so that you can study the dynamics. You'll notice nuances of light, texture, and movement that might escape someone who has to rely solely on the imagination or observation.

For example, one *Dinotopia* painting required that I imagine a kid playing tug-of-war with a dinosaur. I recruited my cousins at a family reunion and had them act out the game. I even got up on the bucket myself to try it out, but the kids beat me every time.

Photographing the actual game gave me a reality check for the poses I had imagined. The sketches I had done out of my head just weren't convincing, but I didn't know why.

Children can't hold an action pose like this long enough for a careful charcoal study. It wouldn't have helped much for me to try to pose the action in the mirror.

The disadvantage of using photos is that we're easily lured into copying their random details. We tend to forget what we had in mind at the beginning of the picturemaking process. Characters based on photos of friends or neighbors sometimes have a mundane snapshot quality rather than an otherworldly storybook feeling. The girl in the painting opposite runs into this problem. There's also the danger of copying the colors—and the black shadows—literally from the photos.

The word *photodependent* describes a painting with an unwanted photographic look. There are a few safeguards against becoming photodependent.

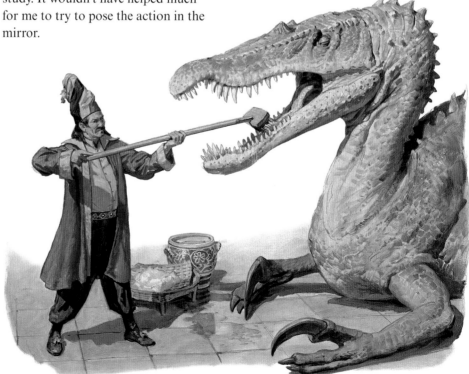

- Take your initial thumbnail sketches as far as you can before taking photos.

- Use the photos only for the comprehensive stage, and put them away for the final painting.

- Print your photos in black and white to avoid being influenced by the color.

- Take lots of photos, and use more than one model or more than one costume.

Opposite Far Left: James Gurney posing for *Clean Teeth*, 2006.

Opposite Left: *Clean Teeth*, 2006. Oil on board, 10 × 12 in.

Top: *Tuggle*, 2005. Oil on board, 7 × 13 in.

Above: Posing for *Tuggle*, 2005.

PROFESSIONAL MODELS

You can find all kinds of professional models through a modeling agency. If you need someone of a certain age, race, or type that you can't find in your neighborhood, an agency is the best resource. Large agencies will also provide lights and even professional photographers to assist you, but you can usually bring your own equipment if you prefer.

Over the years the U.S. Postal Service has released stamps designed to help raise awareness about health issues. When the Stamp Committee decided on a stamp recognizing sickle cell disease and asked me to design it, I was honored to take on the challenge.

I knew it would not be easy to visualize an incurable hereditary blood disease in a way that would be inviting and interesting. The image that comes readily to mind when people think of sickle cell disease is a microscope slide showing the elongated red blood cells alongside normal round cells.

The credit for the design solution belongs to veteran art director Howard Paine, who suggested portraying the scene in universal human terms. Because the disease or the trait is passed down from parent to child, he proposed showing a parent's love for her baby. Why not show a mother and a child interacting with love and affection? The message then becomes a positive one, reminding at-risk parents to test early to find out whether they carry the gene.

I sketched up several different design ideas in color. The most successful version shows the mother holding up her

year-old child in profile and giving him a kiss. The committee approved the design (sans microscope slide) and gave me the go-ahead.

Normally I use friends and neighbors as models, but I didn't know anyone who had the right look for a young African American woman or a baby of the right age. Through a modeling agency, I located excellent models for both characters. Unfortunately, they were no relation to each other and had never met.

That meant the modeling session might be risky, because babies of that age often are afraid to be held by strangers. And

Opposite: Color comps for *Sickle Cell Awareness*, 2003.

Above: Photo of models. Digital photo, 2003.

in this case, the woman posing as the mother was a young dancer who didn't yet have children of her own. If the baby started crying, the session would be a disaster. To be safe, I scheduled the modeling sessions back to back.

The "mother" posed first, holding a stuffed bear as a stand-in for the baby. Then I photographed the baby being held by a favorite aunt. Finally, we put the baby in the model's arms. After a moment of wide-eyed consternation, the baby broke into a smile, and the two got along wonderfully.

The resulting photos provided a basis for the final oil painting. I had to change the little girl into a boy, and I changed the pose so that the mother was leaning back more. I also softened the light source to remove the harsh shadows.

Even a photo reference shot from professional models should be regarded as just a starting point, and you should feel free to change anything to make the final result express your initial vision for the pose.

Above: *Sickle Cell Awareness* © 2004 United States Postal Service. All rights reserved. Used with permission. Issued September 2004. Original art in oil on bristol board, 6 × 4 in.

HEAD MAQUETTES

If you are developing a sequential work, such as a graphic novel, illustrated book, or animated film, you'll need to portray the main characters again and again. Regardless of whether your character is a naturalistic portrayal or an extreme caricature, you can be better assured of consistency if you make a maquette first.

Below: Head maquettes. Polymer clay and plaster, each head 3½ in. tall.

Right: Arthur Denison, 1991. Pencil, 6 × 4 in.

Far Right: Digital photos of Arthur Denison maquette.

Traditional animators and illustrators use maquettes to stay "on model" with a character, even in unusual angles or light situations.

I made this bust of explorer Arthur Denison from *Dinotopia* (below, far left) because I couldn't find a real person with exactly the features that I had established in the preliminary drawing that I did from my imagination (opposite page). The maquette is 4½ inches tall and is made from polymer clay or compound, marketed with trade names such as Sculpey and Fimo. The material can be shaped like clay and then baked hard in the oven. To economize with the polymer clay, and to make the maquette stronger, you can use a crumpled ball of aluminum foil formed over a loop of armature wire that can anchor the head to the wood base and take up some of the volume of the head. You need the polymer clay to be only a half inch thick.

Instead of mounting the maquette firmly to a wood base, another option is to embed flexible brass tubing (available at a hardware store) inside the maquette. This tubing can be set on a dowel and then angled to any position.

If you want to use your maquette for observational study, especially for studying effects of colored light, it's best to leave it white because color effects are

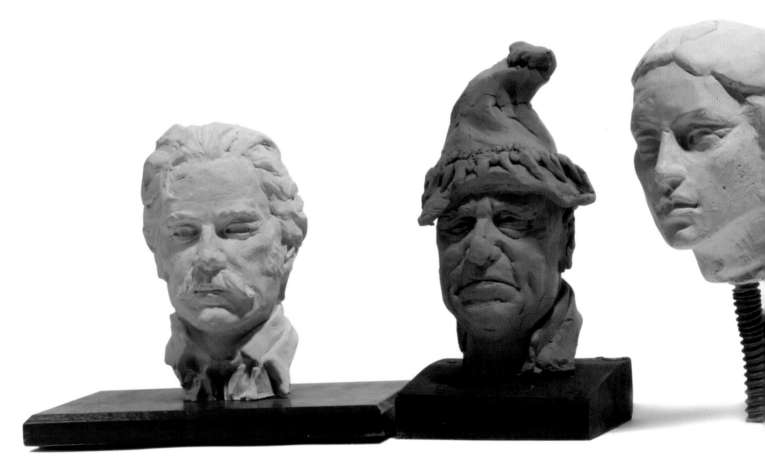

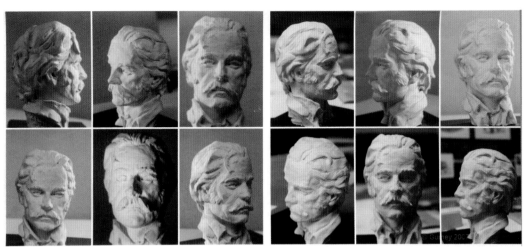

much easier to see on a white surface. If you intend to photograph it, it's better to paint it with a flat gray primer. Some people prefer to paint a head maquette in naturalistic colors.

You can experiment with hundreds of different combinations of poses and light situations from a single maquette.

If your character dramatically changes expressions, it helps to sculpt those expressions as separate maquettes.

You can also accessorize the maquette with a hat or turban. Small hats, wigs, or glasses can be found at doll supply stores.

I have also sculpted a rogue's gallery

of other stock characters: a rugged action hero, a simplified "plane head," a horse, and a woman (below). The plane head is based on anatomy teacher George Bridgman's analysis of form, and it helps me to see the head's basic construction without getting distracted by the features.

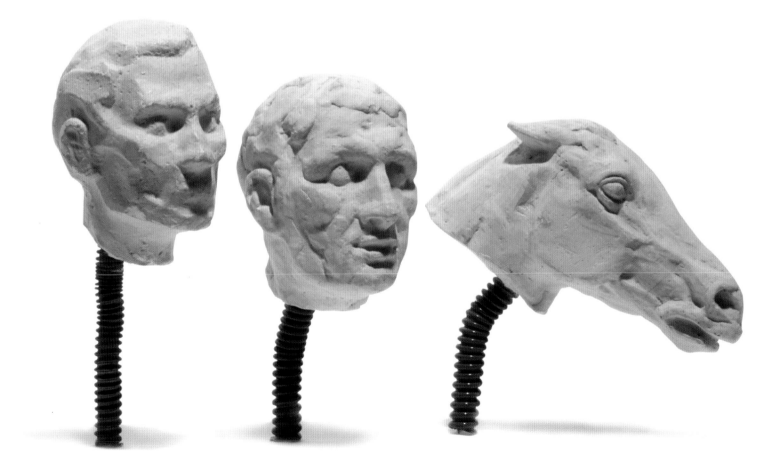

COSTUMES

Good costumes can be expensive to buy or rent. And they can be difficult to make. But having a real costume makes a huge difference in your finished pictures. You can tell right away if an artist just dreamed up a costume or went to the trouble to get a real one. So what do you do? Here are some tips to save you money, time, and trouble.

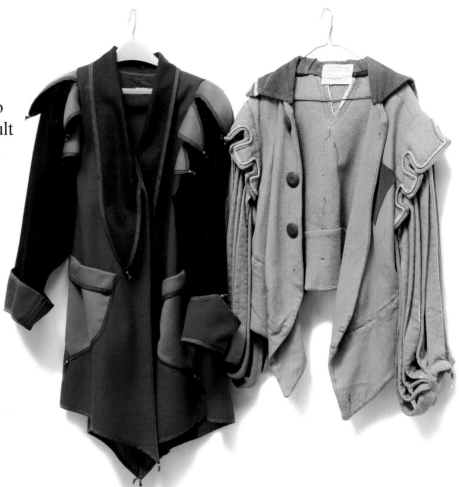

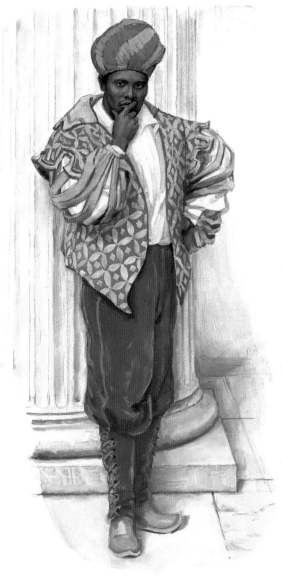

- You can find costumes in thrift stores or junk shops. Almost every yard sale has a Halloween or Carnevale costume or an unusual hat that you may want to use later.

- Most smaller communities have local theater companies with costume collections, and they are sometimes willing to lend their costumes to illustrators.

- Renaissance festivals have costume vendors with an assortment of hats, cloaks, corsets, gowns, breeches, and doublets. The blue and red jacket above is from a Renaissance fair.

- You can find a lot of helpful pictures in costume history books at the library. Remember that there are two kinds of sources. The best are primary source images, which include photos of actual costumes and portraits made from observation during the period in question. The second kind are illustrations made by artists reconstructing the costumes from a later time period. Use both, but check the second against the first.

- Living history museums or war reenactments often include people in authentic historical costumes. They may be willing to pose for illustration reference, but be sure to get their written permission first.

- Big cities such as New York, London, and Los Angeles have rental agencies serving theatrical or movie productions. Sometimes they will sell off their older, worn-out costumes. That's where the doublet with the slashed sleeves, above, came from. It was the basis for the figure to the left.

- Large museums, such as the Metropolitan Museum of Art in New York and the Victoria and Albert in London, have costume collections that can usually be sketched or photographed.

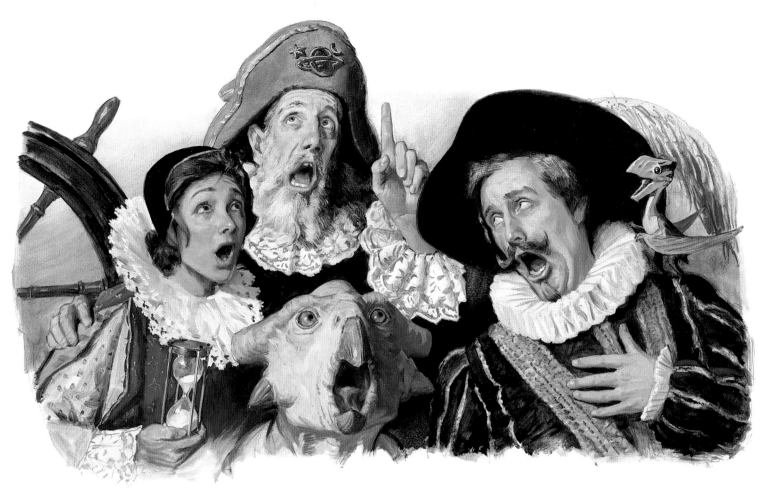

- If you can't find the right costume, at least get fabric remnants. Scraps of leather, satin, brocade, or velvet can provide you with helpful information. In the makeshift costume at left, I used a piece of flexible packing foam to simulate a millstone ruff.

- For simple togas and capes, you can drape and pin fabric samples over an artist's manikin.

- Don't be shy to ask for help. If you know someone who is clever with a sewing machine, they might be able to help you.

- Once you get your model (or yourself) in costume, you can take reference photos in a variety of poses. If it's an easy pose to hold, you can paint or draw directly from the model (right).

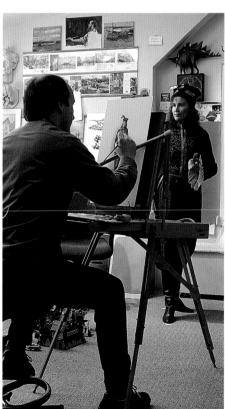

Top: *Chorus*, 2005. Oil on board, 8 × 14 in.

Above: James Gurney posing for *Chorus*. Digital photo.

Right: Painting *Oriana*, 1993. Digital photo.

Opposite Bottom: *Sauropolis Guide*, 2005. Oil on board, 13 × 6 in.

CHARACTERS IN SETTINGS

Think of a few of your friends: What do their garages look like? Some garages are as neat as a pin; others are a mess, full of jars of used motor oil and bent nails that they can't bring themselves to throw away. Some are full of sports memorabilia; others are packed with motorcycle parts. The setting defines the person. In the same way, the environment into which you place your imaginary character should be unique and defining.

Above: *Pumpkin Man*, 2000. Oil on board, 17 × 13½ in.

Top: *Pumpkin Head* maquette, 2000. Air-dry craft foam, 7½ in. tall.

A pumpkin man dressed in an antique Dutch costume rises up out of a Hudson Valley pumpkin patch in late October. The cornfields are dark and dry behind him. The leaves of the pumpkin vines have lost their greenish color. Little gourd people peek out curiously from the edge of the field. A swirl of starry mist spirals around the character, lifting a dry leaf with it, while a modern boy looks on in wonder.

Simple as it is, the background is vital to the story that I was trying to tell with the picture. I needed to show the time of day, the time of year, and at least a hint of place. I wasn't sure what pumpkin leaves actually look like, so I went to a pumpkin patch with my camera and sketchbook, documenting the actual setting.

Think like a novelist when you paint a person into a scene. What do you want to reveal about your character? Is he or she at home, at work, or in an unfamiliar place? What props should be included in the picture? Can some of them be placed in the foreground or partially cropped off the edge? These are questions to consider during the thumbnail stage. Later, you can go on a treasure hunt to find whatever elements you need.

In the little village where I live in upstate New York, the tradition of Santa Claus is alive and well. If you stop in at the local hardware store in December, you'll find an electric train layout winding its way through a group of motorized elves near the snow shovel display. Beyond that is a raised platform where Harry, a retired police officer, sits near a teenager in a green suit holding a digital camera.

Harry *is* Santa Claus. He has no need for a polyester beard or a pillow over his stomach. People call him Santa even when he's not in the suit. He already knows the kids' names and what they want and whether they've been good.

Harry agreed to pose. He came in costume to my studio for a photo session. But I needed to place him in a setting. At first I had planned to show him on the rooftop, and I tried some sketches with him at the North Pole.

But I settled on a scene in front of a decorated hearth. I went around town on a scouting expedition with my camera. I found a brick hearth at the old inn in town. The mantle clock came from an antique store. The tree and the Steiff train came from the house of a friend who collects antique Christmas decorations. Another friend had the hearth rug and the white dog.

Once I had established the lighting on the pose, I kept the same lighting on the props, bringing a portable light with me on the remote photo shoots. I also brought a ruler to photograph beside each of the props so that later I could composite them together in an accurate scale. Back in the studio, I juggled all these elements in different combinations in revised thumbnail sketches.

Above: *Santa Claus*, 1993. Oil on linen, 35 × 24 in.

MANAGING DETAIL

Some pictures are more complex than others. In 1986, *National Geographic* asked me to paint a single picture that shows all the uses of soybeans. The art director and I came up with the idea of a tableau in front of a general store where all the products feature soybean ingredients. I thought of the famous April Fool's *Post* covers painted by Norman Rockwell, which have hundreds of hidden details.

Below Left: *Soybean* concept sketch, 1986. Pencil, 9 × 9 in.

Below Center: Megan, 1986. Charcoal, 7 × 6 in.

Below Right: Gary, 1986. Photograph.

Of course, comparisons to Norman Rockwell are inevitable with a subject like this. His images come to mind whenever you paint all-American characters in profile in a narrative setting. I love Rockwell's paintings, but I wanted to make a picture that was authentic and not derivative, so I closed all my books on him while I was involved with this piece and tried to find my answers in real life.

The first step was to visualize as much as I could from my imagination. In the pencil sketch above, I explored the idea of a handyman who is overloaded with home improvement materials from the hardware store. Because the character is a nice guy, he wants to stop and buy a muffin from the girl out front. Her brother is under the table reading the old copies of *National Geographic*, ogling the topless natives. (We could justify this gag because for a period of time the magazine used a soybean additive in their inks.)

More than sixty products that use soybean ingredients appear in the store window and on the sidewalk. Most of the items were processed food and animal chow, but the researchers at *National Geographic* discovered that there are also soy ingredients in some pesticides, cosmetics, and gas additives. Even the alkyd paint medium I used had some soy in it, according to the Winsor & Newton company. We had to write to all the companies for permission to show their products. And I had to actually buy all the products from our local stores and set them up in the studio to make sure the comparative sizes were correct.

This painting was the only time in my career that I have traced over a projected photo. I did it for the product label designs, not the figures. I didn't see how I could improve on the labels by redrawing them all over again.

The neon sign had to be invented because marketing people for Falstaff Brewing Company told us they didn't

have a window neon sign at the time. I had to design a hypothetical one, based on studies of other related signs (opposite, below).

The figures were based both on charcoal sketches from life (center, above) and photos (above). The character of the shopkeeper was modeled by a handsome young man in his late twenties (above). I asked him whether he would mind if I changed him into a portly and balding shopkeeper some twenty years older. He was very understanding about the way I aged him in the final painting. Today, more than twenty years after the painting was published, his wife jokes that he's starting to look more and more like the painting.

Coordinating all these details involved making lists and organizing references into folders. I also did a full charcoal comprehensive (not shown). The whole project took about three months from start to finish.

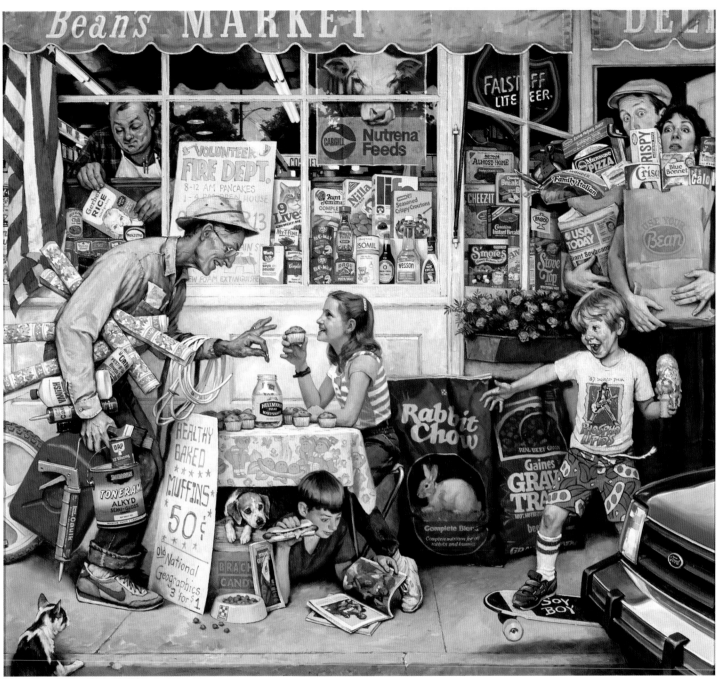

Above: *Uses of Soybeans*, 1986. Oil on canvas, 24½ × 27 in.

Left: Falstaff, 1986. Pencil on tracing paper, 5 × 4 in.

Far Left: Pabst, 1986. Pencil, 10 × 8½ in.

Following Pages: *T. rex Drinking*, 1986. Oil on board, 14 × 30 in. First published in *Discover Magazine*. Winner of the gold medal for editorial illustration in *Spectrum 10*.

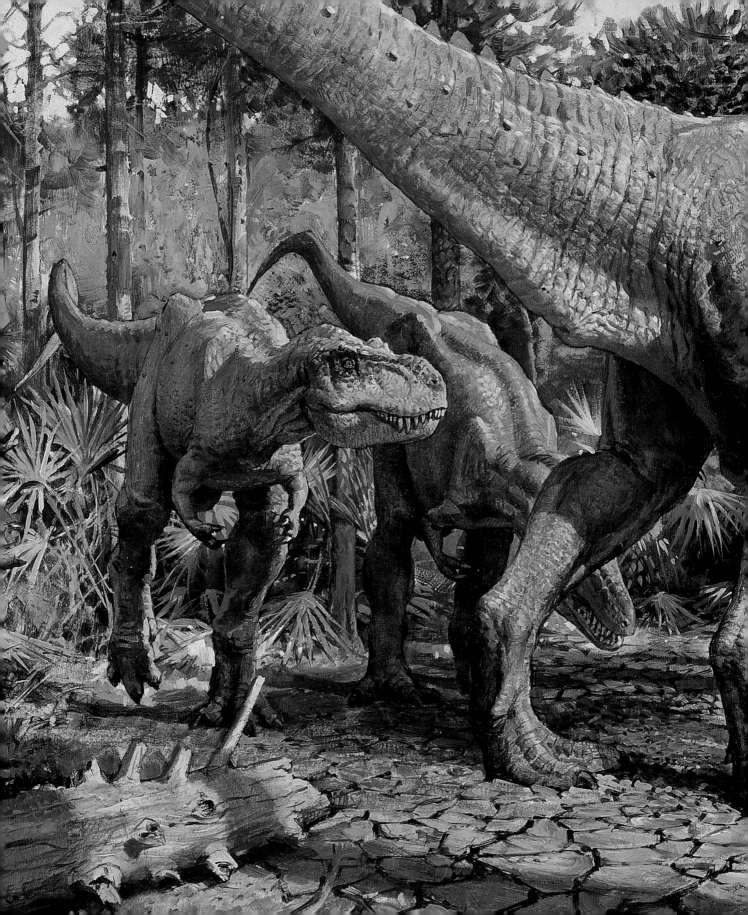

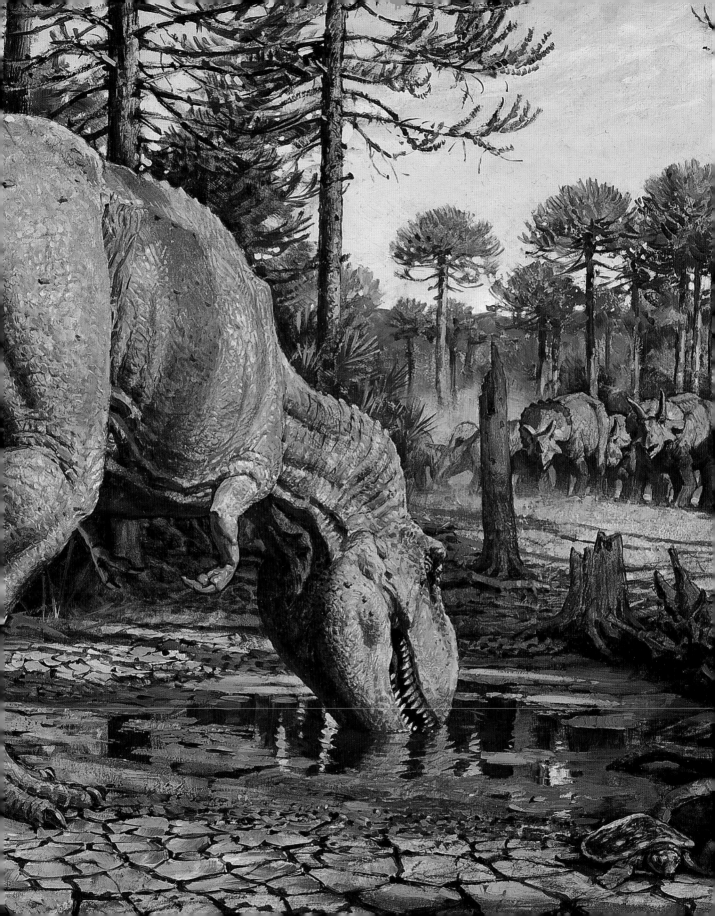

DIGGING DINOSAURS

Artists are the eyes of paleontology. Our illustrations give visual form to the theories that scientists have developed about dinosaurs and other extinct creatures. Paleoart helps shape the way the public imagines dinosaurs.

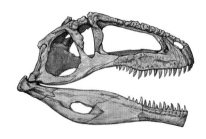

Above: *Giganotosaurus Versus T. rex*, 1997. Oil on board, 23 × 9 in.

Below: *Argentinian Dinosaurs*, 1997. Oil on board, 12 × 24 in.

Opposite: *Giganotosaurus*, 1997. Oil, 21 × 14½ in.

In 1993 paleontologists in Patagonia discovered fossil remains of a new type of giant meat-eating dinosaur. A few months later I met with Dr. Rodolfo Coria, the Argentinian paleontologist who named the dinosaur *Giganotosaurus*. This creature made a stir among scientists and the general public because it was said to be larger than *T. rex*.

Dr. Coria assisted me in making one of the first reconstructions of *Giganotosaurus* for *Dinotopia: The World Beneath*. Soon afterward, *National Geographic* asked me to do a few illustrations for a science article on Argentinian dinosaurs. One painting (right) shows the skull of *Giganotosaurus* compared with "Sue," the famous giant *T. rex*.

The painting opposite shows *Giganotosaurus* running at a thundering pace. To accentuate the motion, I used a shallow depth of field, blurring the distant trees, and kicked up a splash and a dust cloud from the feet.

I did this painting more than ten years ago. Since then, biophysicists have convincingly argued that giant dinosaurs such as *T. rex* and *Giganotosaurus* probably didn't have the leg muscles to be able to run at high speeds. So if I were to do this painting again, I'd show him at a fast walk. A walking dinosaur may not be quite as impressive as a running dinosaur, but he needs only to walk faster than his prey to be successful.

Paleontologists are nearly always willing to share their expertise with artists. They are usually glad to answer any questions and let you sketch from actual fossils. You can call the natural history museum in your area or the local university's paleontology or geology department for contacts.

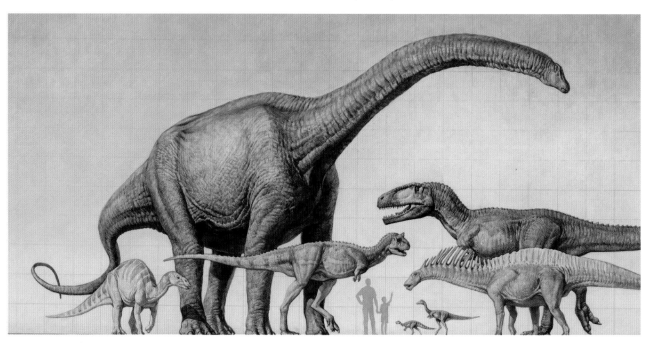

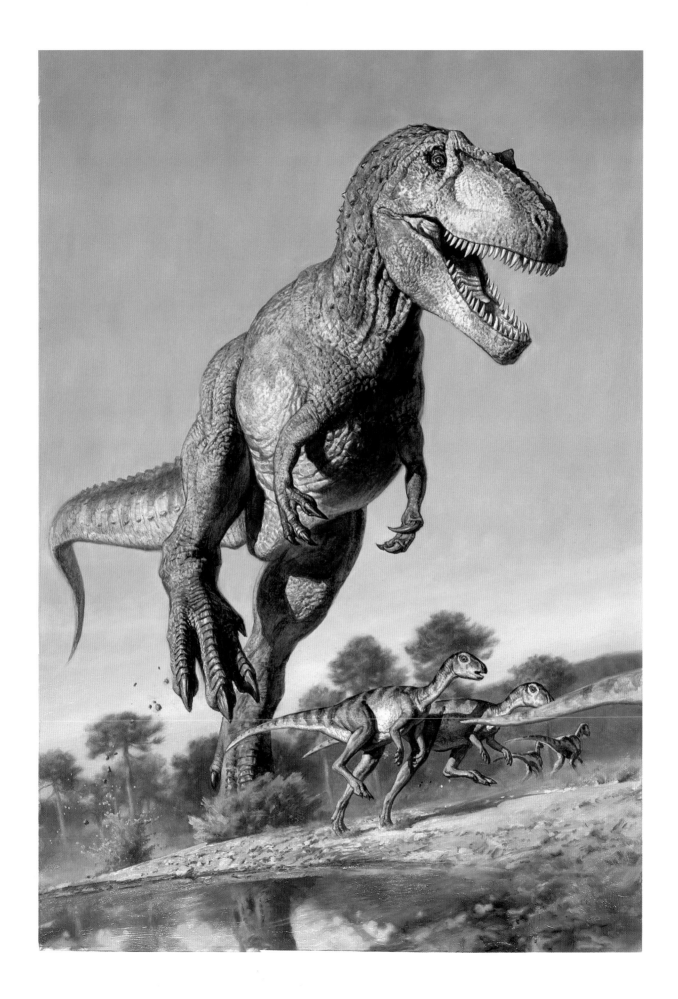

DINOSAURS IN THEIR ENVIRONMENT

Designing *The World of Dinosaurs* commemorative issue for
the U.S. Postal Service was an unusual compositional challenge
because the stamps had to be appealing as individual stamps,
but they also had to fit into larger panoramas.

The U.S. Postal Service has a rule: A person must be dead for at least ten years before he or she can appear on a stamp. Dinosaurs have been dead for 65 million years, so they definitely qualify.

Over the years, dinosaurs have cropped up on stamps from many other countries. But surprisingly, the United States has issued dinosaur subjects only twice before in its 150-year history of producing postage stamps.

So I was excited when I got a call from the art director inviting me to prepare some design ideas for a new release. They started by suggesting the idea of including four dinosaur stamps as part of a larger scene with illustrated margins around the stamps themselves. The committee's original proposal was to bring together dinosaurs from all over the world into the same scene, but we eventually realized that it would be more effective to show dinosaurs that actually lived together in North America.

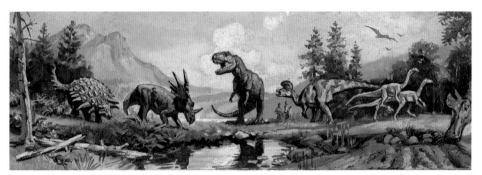

Above: Dinosaur Stamp Sketch, 1996. First concept sketch.

Top: Dinosaurs: Masters of the Mesozoic, 1996. Revised concept sketch.

I quickly sketched up a design showing four dinosaurs from the late Cretaceous period, including the head of *T. rex* and the bodies of three others (left). The committee loved the sketch. They immediately wanted to increase the number of stamps to ten. I proposed the idea of dividing the presentation into two different scenes separated by 75 million years, one in the Jurassic and the other in the Cretaceous. This way we could feature representative species of the best known types of dinosaurs.

The Postal Service offered to supply me with all the research material I needed. They appointed Jack Horner as the official consultant. Horner is the famous paleontologist who discovered Egg Mountain in Montana. I was

delighted because I had collaborated with Jack before and had traveled with him to his museum and fossil sites. To gather even more expert input, I asked permission to contact several other scientists directly to help not only with the dinosaurs but also with the plants, insects, birds, mammals, and amphibians that appear in the margins of the scene. Our ground rule was that every plant or animal in each scene had to come from the same geological formation so that we could be reasonably sure that they would have coexisted in the same environment.

I wanted each panorama to portray a rich and diverse ecosystem and to tell a variety of stories, not only predators looking for a meal but also babies hatching from eggs and mammals hiding

THE WORLD OF DINOSAURS

A scene in Colorado, 150 million years ago

in trees. To show a fossil in the making, I placed the skull of a *Chasmosaurus* in the mud at the edge of the pond (above, next to the wading bird).

For the dinosaurs, I studied fossils in museums and set up a variety of maquettes. For the plants, I traveled to Florida and to the Brooklyn Botanical Gardens, where living analogues exist. I snipped branches from ginkgo trees in my hometown, brought them home, and painted them into the scene just as they appeared. I discovered later that the leaves really had a multilobed shape in the Jurassic, so I had to go back and repaint each leaf.

When it came to painting the ferns, I found out that cut ferns wither within minutes. So I set up a sketching easel in the woods behind my house. It's probably the first time that artwork for a postage stamp was painted outdoors. At one point a mosquito landed in the wet paint and got stuck. I thought of leaving him there for a little touch of naturalism, but mosquitoes as we know them didn't exist in the Mesozoic, so I had to scrape him off.

The stamps were issued on May 1, 1997 in Grand Junction, Colorado, just a few miles from where many of the original dinosaurs were found.

Top: *The World of Dinosaurs*, issued May 1, 1997. Oil on bristol board, 17 × 22 in. © 1996 United States Postal Service. All rights reserved. Used with permission.

Left: *Daspletosaurus Face*. Oil on bristol, 5 × 3 in.

Above: Painting the stamps. New York, 1996. Photo by Jeanette Gurney.

UNUSUAL BEHAVIORS

Artists often portray *T. rex* and *Allosaurus* as ruthless and invincible predators, usually in the process of attacking or devouring another dinosaur. When biologists study the analogous behavior of modern carnivores, they find a variety of other interesting behaviors, which are worth considering when you're planning a dinosaur picture.

Above: Gurney and Norell, 2007. Photo by Jeanette Gurney.

Left: *Allosaurus Itch*, 1997. Pencil and oil wash on bristol board, 5 × 10 in.

Below: *Camptosaurus Portrait*, 1997. Pencil and oil wash on bristol board, 3½ × 5½ in.

Instead of painting running, snarling meat-eaters, why not show a dinosaur drinking water, scratching an itch, bathing, sleeping, or courting a mate? If a dinosaur has feathers, there's a whole repertoire of preening behaviors that you can infer from birds.

Animals often strike surprising poses when they're resting. There's a tendency for us to paint dinosaurs earnestly running from one place to another or rearing up in human-like poses. But recent thinking suggests that both meat-eaters and plant-eaters spent most of their lives in more head-down, tail-up postures unless they were alarmed. Modern day plant-eaters spend the majority of their waking hours grazing vegetation, which takes an enormous amount of time.

Dinosaurs, especially carnivores, are nearly always depicted with their mouths open, but how often do you see contemporary animals or birds with their mouths agape? Unless they're in the act of biting or vocalizing, most creatures keep their mouths closed. On most predatory dinosaurs, the closed mouth has a distinctive overbite, and most articulated skeletons are found that way, too.

It helps to visualize a pose as a part of a continuous motion. Looking at still wildlife photos helps to a degree,

but there's no substitute for studying a slow-motion action sequence on a DVD or the Internet. Nature documentaries are a treasure trove. They will give you fresh ideas for things such as nesting, parenting, flocking, flying, and attack and kill sequences.

The painting that opens this chapter on pages 76–77 shows a different facet of *T. rex* behavior, where an adult is drinking water from a receding water hole in the Hell Creek Formation in what is now Montana. Tyrannosaurs didn't have lips, so it's a bit of a mystery

how they could hold water in their mouths and swallow it down.

My consultant for the *T. rex* painting was Jack Horner of the Museum of the Rockies in Bozeman, Montana (below right). Horner proposed the provocative idea that the *T. rex* may have been a scavenger as well as, or instead of, an active predator. At his suggestion, I gave the creature a reddish face, similar to the faces of vultures and many other scavengers.

Horner was one of the first to find direct evidence that some dinosaurs actively looked after their young. Other paleontologists, including Dr. Mark Norell (opposite), have found two-legged meat-eating dinosaurs called oviraptors who died and were preserved in the very act of sitting on their nests, which leaves no doubt about their birdlike nest behavior.

The painting at right shows an adult *Allosaurus* offering a scrap of meat to its young in the nest. The adult has a tiger-like coloration pattern, with black and orange stripes, and the nestlings have a light downy coat of feathers, based on life studies of robin hatchlings from a backyard nest (below). The young might have had downy feathers to keep them warm while they were small, but once they grew bigger they might have lost their feathers altogether.

Above Right: Allosaurus and Young. First published in *Discover* magazine, June 2003.

Below: Baby Robins, 2007. Pencil, 2 × 3½ in.

Below Right: James Gurney and Jack Horner, 1992. Photo by Tobey Sanford.

BABY
ROBINS

2 DAYS
OLD

3 IN THE
NEST-
EYES ARE
VISIBLE
THROUGH
SKIN-

7/26/07

MULTIPLE MAQUETTES

To make a painting of a dinosaur look three-dimensional, it helps to look at sculpted maquettes. By setting up a variety of models under the same light source, you can pick and choose details and effects that you want to include in your final painting.

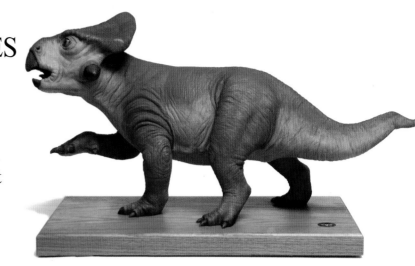

The cheap hard plastic models that you can get in museum stores aren't bad, but if you can afford to pay a bit more, get some larger ones from the top sculptors. You can also find scale model skulls or skeletons that are really helpful in visualizing the anatomy.

If you're going to feature a dinosaur as a main character in a sequential art piece, you can sculpt your own hero maquettes. A hero maquette is one that you use a lot, which is made with more detail and with some elements that can be changed for later illustrations. For *Dinotopia: The World Beneath,* I made a Bix (right) from polymer clay and painted it with acrylics. The head is a separate piece and attaches with a swivel

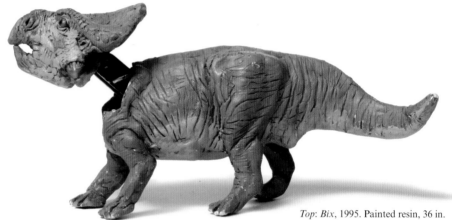

Top: *Bix*, 1995. Painted resin, 36 in. Sculpted by Jim Henson's Creature Shop.

Above: *Bix* model, 1993. Polymer clay, 7 in.

Below: *Will and Bix*, 1993. Oil on board, 9 × 16 in.

Opposite: *Chasing Shadows*, 2005. Oil on canvas, 24 × 30 in.

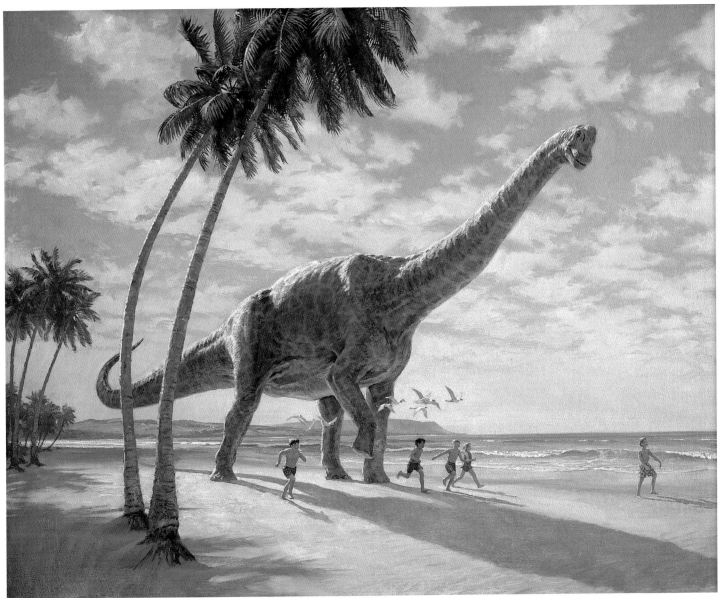

joint, which I pirated from a jeweler's third hand device. The head can be set to any angle. I used this small maquette for the painting of Will and Bix (left).

The larger maquette was sculpted by Jim Henson's Creature Shop. It's about 36 inches long (about half the size of a real *Protoceratops*) and cast in resin from an original in oil-based clay.

The painting above, called *Chasing Shadows,* shows a *Brachiosaurus* walking on a beach. He is lit from behind by a late morning sun, and the light is bouncing up from the warm sand onto his belly. The challenge with this lighting was to find out exactly where the light turned to shadow on that particular form.

The photo at right shows the painting in progress. Surrounding the painting are digital photos of a variety of dinosaur sculptures.

It's a good idea to refer to a lot of different maquettes so you're not basing the painting on just one. Each model has unique little revelations about form and texture. It also helps to paint the models a flat, neutral gray tone so that they photograph well. If the texture is too shiny, a dulling spray varnish can give it a more matte surface. If your scene is set outdoors in sunlight, it helps to shoot the models outdoors in the same conditions. Be sure to use a ground color that resembles the color of the ground in your scene because the reflected light will have a strong influence in the shadows.

Depending on your preference, you can print out the photos or view them on a monitor, but it helps to compare several at one time.

SETTING UP A TABLEAU

A tableau is an artful arrangement of three-dimensional objects on a stage-like surface. If all your maquettes are in scale with each other, you can experiment with the arrangement and lighting until you get exactly what you want. This method gets you beyond thinking only in two-dimensional terms.

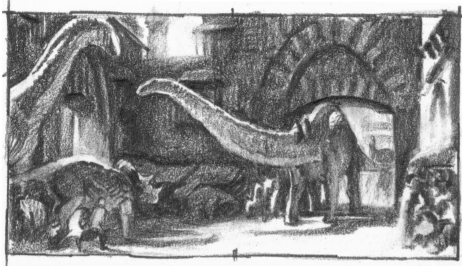

MARKET SQUARE - TONAL STUDY - MAY 9, 2006 ©James Gurney

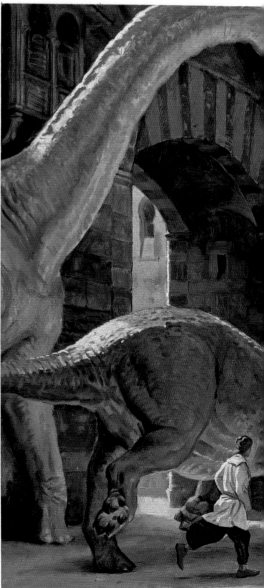

This Dinotopian market scene shows a large sauropod passing through an arch into an Orientalist market. I planned it using a scale tableau.

To begin with, I constructed a maquette of an arch to the same $1/72$ scale as a set of tiny dinosaur maquettes. By moving these dinosaurs around, I could more easily imagine where they were going and how one might overlap another.

The arch is made out of foam core board and mat board hot glued together, with domes made of Styrofoam balls.

I coated the structure with gesso and modeling paste and painted it in acrylic. The wall on the left is made from toy wooden blocks, which cast a shadow on the left of the scene.

I set up the tableau outdoors on a plywood base. It was possible to rotate the whole arrangement until the sun was shining into the scene at an interesting angle. What chiefly interested me was how the forms were affected by the reflected light bouncing up from the warm, sandy surface in the foreground.

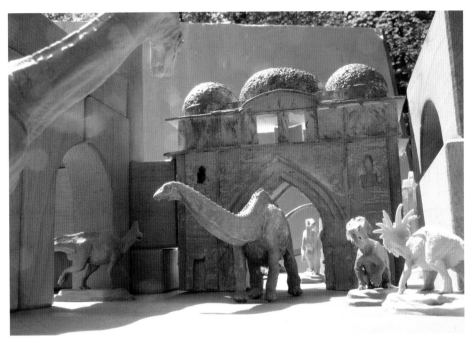

Left: *Market Square* model, 2006. Mixed media.

Opposite: Triceratops skull. Plastic model, skull 3 in.

Opposite Left: *Market Square* sketch. Pencil, 3 × 6 in.

Below: *Market Square*, 2006. Oil on board, 14 × 28 in.

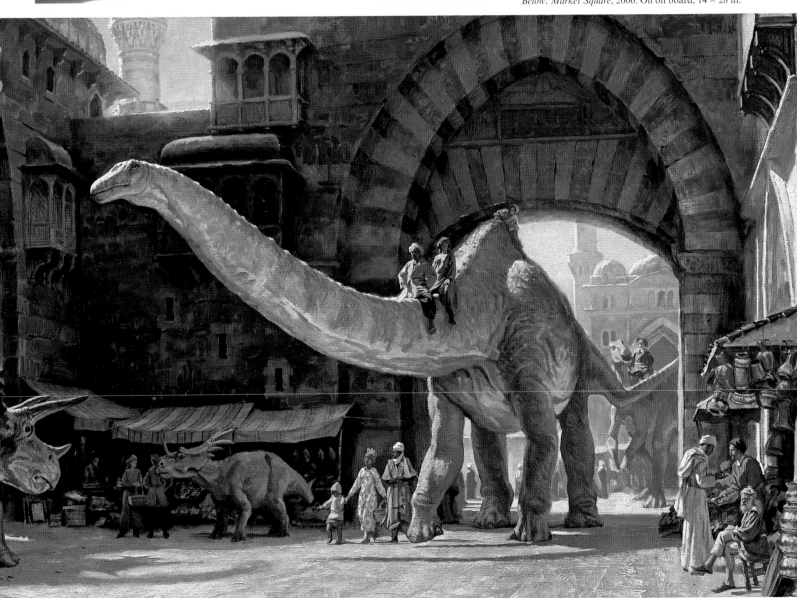

HOMEMADE MINIATURES

If you're designing an imaginary world, it is well worth the time to sculpt a few of your own maquettes. These are the elements that, in our hurry to get to the final painting, we often pass up, but the viewer will recognize right away that you took the time.

Below: Busts of ancient animals. Polymer clay, $2/3$ actual size.

I made the maquettes above as reference tools for individual projects, but they have come in handy afterward in ways that I didn't expect.

The shallow-relief keystone on the left represents a *Triceratops* head in a decorative setting. The maquette is sculpted out of polymer clay and mounted on a plywood base. I painted it in metallic brassy spray paint and then gave it a bronze-like patina with green acrylic. The keystone sculpture has repaid itself many times as a decorative element in the Dinotopia universe.

If your world is based on dragons, you might come up with a dragon-headed ship's prow. If it's an insect-based world, you might want to sculpt capitals and finials based on beetles and butterflies.

I made the *Triceratops* head from polymer clay over a wood and wire armature and painted it in acrylic. I've used it so much that the lower jaw fell off and got lost, and the horns have been repaired two or three times.

The maquette on the right represents the extinct mammal-like reptile *Estemmenosuchus*. One of the paintings based on this maquette appears on page 102 of this book. The pinkish orange color is the natural color of the Super Sculpey brand polymer clay. The eyes are the cheap plastic eyes sold at craft stores for stuffed animals. I was careful not to turn up the heat too high when curing the maquette for fear the eyes would melt.

By making just a detached head, I could hold him in my hand at any angle when I was drawing him. I also embedded a loop of wire at the top so that I could hang him on the wall like a trophy.

The painting below shows the ring riding event of the Dinosaur Olympics in *Dinotopia*. Each pair of bold teenage riders climbs atop a *Deinocheirus,* a large theropod known only from its arms. Each team represents a different quadrant of the island. Their goal is to steer beneath a banner of the correct color and capture as many of the rings as possible.

This basic concept sounded fine in theory, but when it came to drawing it up in thumbnail form, I couldn't be sure how to stage all the elements. What should be in the foreground? How would the banners look in the sunshine? Where would the cast shadows appear on a sunny day? I went through several pencil thumbnail sketches but never felt sure of what I was doing until I built a maquette of the *Deinocheirus* and a three-dimensional sketch of the audience pagodas, made from wire, dowel rods, and tissue paper. I discarded the paper pagodas after the photo shoot, but by then they had served their purpose.

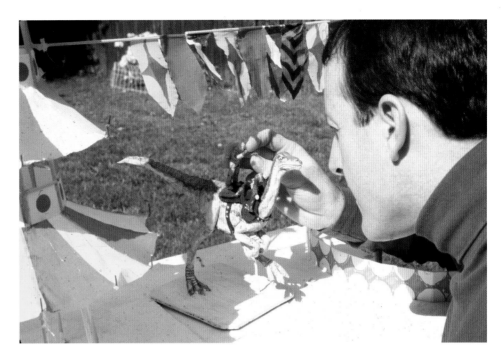

Above: *Ring Riders* maquette. Polymer clay, dowels, and tissue paper.

Below: *Ring Riders*, 1990. Oil on canvas, 30 × 40. Published in *Dinotopia: A Land Apart from Time*.

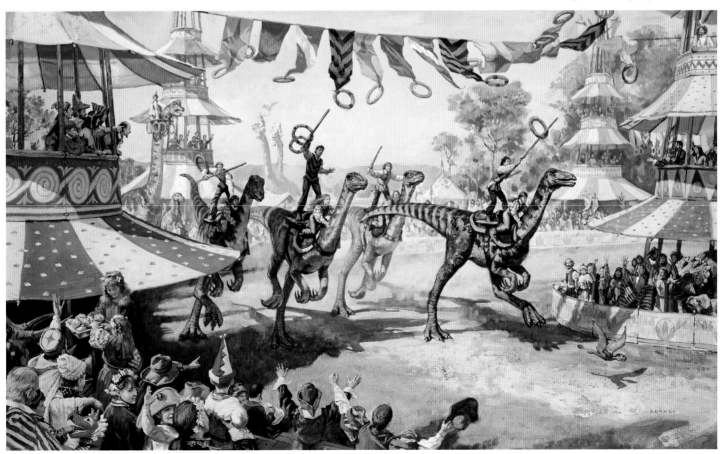

WINGS AND CAPES

Polymer clay is fine for flesh and bone, but how do you build a maquette that includes a thin, membranous material, like the wing of a dragon or the robe of an angel? The trick is to use paper, plastic wrap, thin cloth, or even stockings.

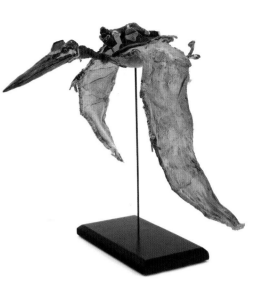

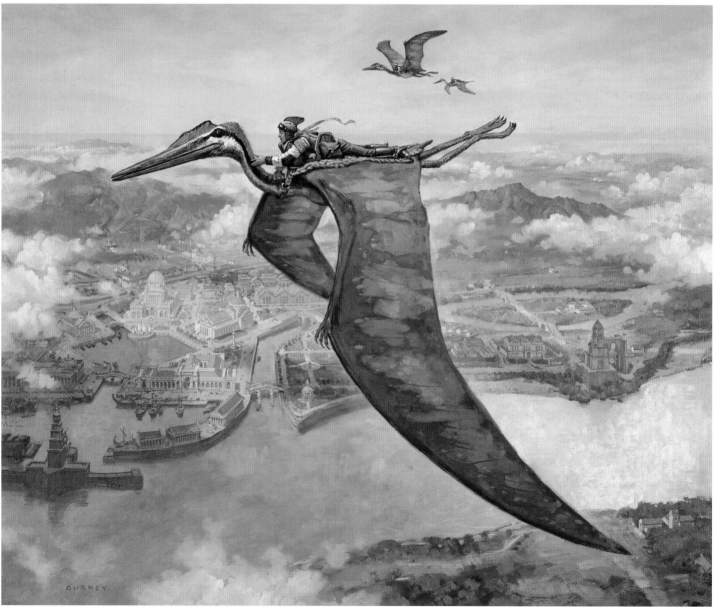

Top: *Skybax* maquette, 1991. Mixed materials, 22 in. wingspan.

Above: *Skybax Rider*, 1991. Oil on canvas, 25 × 29 in.

This painting, called *Skybax Rider,* (opposite) depicts a giant pterosaur known as a *Quetzalcoatlus* flying over a city in Dinotopia. Like bats, pterosaurs had a thin layer of skin stretched over their arm and finger bones.

Because the skybax was to be an important character in the Dinotopia stories, I needed to build a posable hero maquette. The maquette at right is made from wood and polymer clay, and the neck is flexible armature wire covered with painted foam. The figure is made from modeling compound on a saddle of thin leather.

For the wings, I used wire and toothpicks for the bones and thin floral wire zigzagging across the wing and running along the trailing edge to give it support. I tried a lot of things for the wing membrane and finally ended up using a pair of my wife's old stockings stretched over the wing bones. With a thin coat of liquid latex, the stocking had more opacity, but it still was flexible enough to pose in almost any position.

That's fine for a pterosaur, a bat, or a dragon's wing. How do you get reference for a cape flapping in the wind? That was my problem when I needed to paint a man riding way up high on a *Brachiosaurus.* I made a little manikin out of chunks of wood and wire and set it on a brachiosaur head and neck model that I sculpted out of polymer clay.

The cape was made from a small piece of red fabric that was soaked in acrylic matte medium. I arranged it the way I wanted it and let it dry. Matte medium is like plastic. When it dries, it holds all the folds just the way you arranged them. For the photo it's held up by little wires underneath.

For very tiny maquettes, you can also simulate drapery with cellophane draped over a form and spray-painted. Cellophane scales down proportionally better than fabric does.

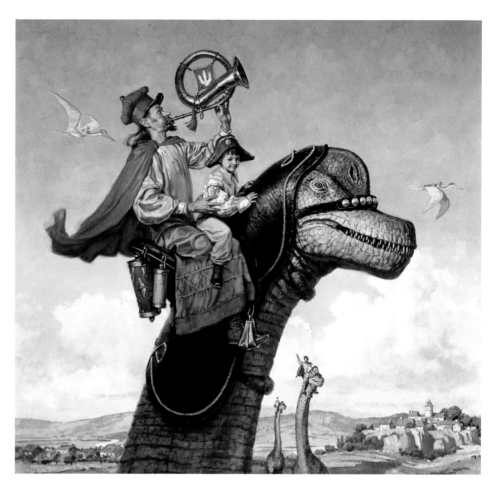

Above: *Up High*, 1992. Oil on canvas, 27 × 27 in.

Left: Brachiosaur maquette with rider, 1992. Mixed materials, 9 in.

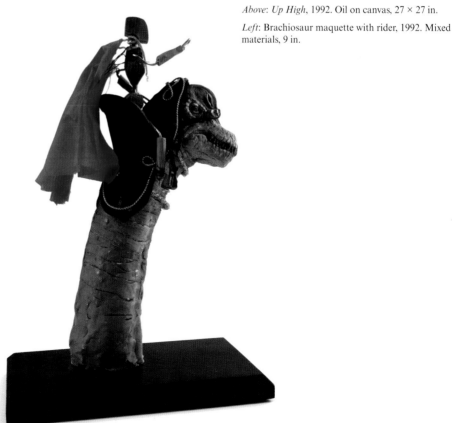

2D TO 3D MAQUETTE

A quick method for making a sculpture of something that is basically flat to start out with is called a 2D-to-3D maquette. This method is ideal for insects, birds, and fish.

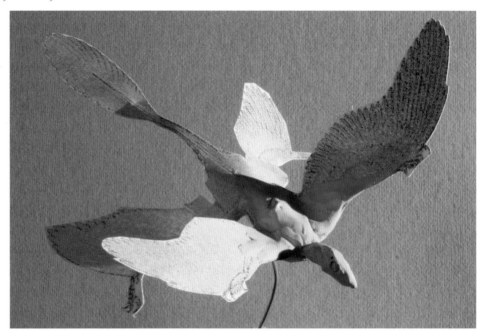

I used a 2D-to-3D maquette to reconstruct the *Microraptor gui,* which was discovered recently in Liaoning, China. In the painting opposite, the *Microraptor* can be seen flying over the rooftops in Dinotopia, with its front wings up and its back "wings" or legs down. Whether this creature was capable of flapping and how it held its arms and legs in flight are the subjects of lively debate among both scientists and artists.

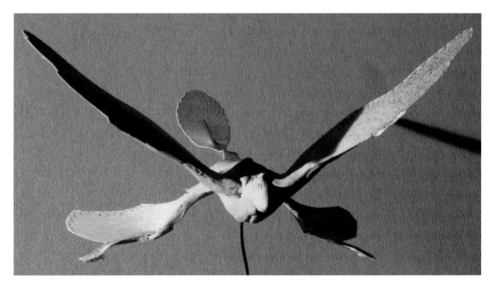

I began with a photocopy of the scientist's drawing on card stock. Then I glued armature wire where the wing bones would be and beefed up the head and chest with modeling clay.

It was now possible to experiment with different wing positions and lighting arrangements. The little maquette, which only took a half hour to make, gave me crucial information about the foreshortening of the wing shapes, the cast shadow on his left wing, and the appearance of the tail.

Left Above: Microraptor drawing by Mr. Li Rongshan.

Left: The maquette under construction, 2006. Paper, clay, and wire, 5 in. wingspan.

Above and Top: *Microraptor* 2D to 3D, 2006. Paper, clay, and wire, 5 in. wingspan.

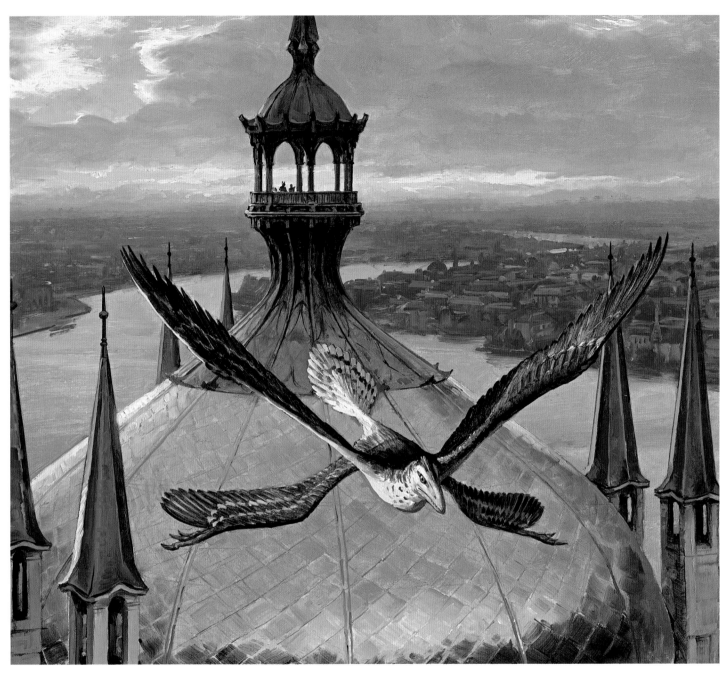

Above: *Gold Dome*, 2006. Oil on panel, 13 × 14 in.

COLORATION

Fossils tell us a lot about dinosaur bones, skin impressions, and even feather shapes, but so far there isn't much hard evidence on color. That leaves room for some educated guesses, and you can look to nature for ideas.

Once in a while a design feature shows up in animals that are not closely related. A good example is the eyestripe coloration pattern, which appears in sparrows, antelopes, and chipmunks.

In all these creatures, a dark facial stripe runs from the snout to the eye. Directly above the eyestripe is a bright white line called a supercilium, and above that is another dark line called a lateral crown stripe. Presumably eyestripes serve as protective coloration in all these prey animals, disguising their eyes from predators.

Whenever such features exist in animals as diverse as birds, ungulates, and rodents, it's reasonable to speculate that they may have appeared in dinosaurs as well. This was my rationale for showing eyestripes on the *Beipiaosaurus,* above left.

I used the same idea when I painted a dark patch on the flank of a *Camptosaurus,* above middle. This flank patch also appears in the springbok. The *Camptosaurus* was a tasty morsel for ceratosaurs and allosaurs in the Jurassic, just as the springbok is the Chicken McNugget of the Kalahari.

The boldly colored *Giganotosaurus,* above, was based on the bright color scheme of certain large birds such as cassowaries. Many birds use bright colors to attract mates or to intimidate rivals, and some dinosaurs probably did too. But many other large animals—rhinos, elephants, and hippos, for example—are grayish in color.

Some mammals, such as zebras and tigers, use camouflage to remain hidden from their predators or prey. Camouflage is a form of protective coloration in which surface patterns or colors help an animal blend in with its surroundings, concealing it from view. The juvenile *Allosaurus* at right would spend most of his time in a forest habitat, so I colored his sides and tail with light and dark stripes to help him blend in.

Most creatures are lighter on the belly than on the back. This form of camouflage, called countershading, disguises prey animals by offsetting the effects of shadowing on the bottom surfaces.

WHITE-THROATED SPARROW

DORMOUSE

THOMSON'S GAZELLE

TEGU LIZARD

PORKFISH (GRUNT)

Above: *Allosaurus and Crocodile*, 2003. Oil on board, first published in *Discover* magazine, June 2003.

Opposite Top: *Giganotosaurus*, 1994. Oil on board.

Opposite Bottom: *Eyestripes*, 2009. Colored pencil.

Following Pages: *Glory Lane*, 1986. Oil on board. Wraparound paperback cover for novel by Alan Dean Foster.

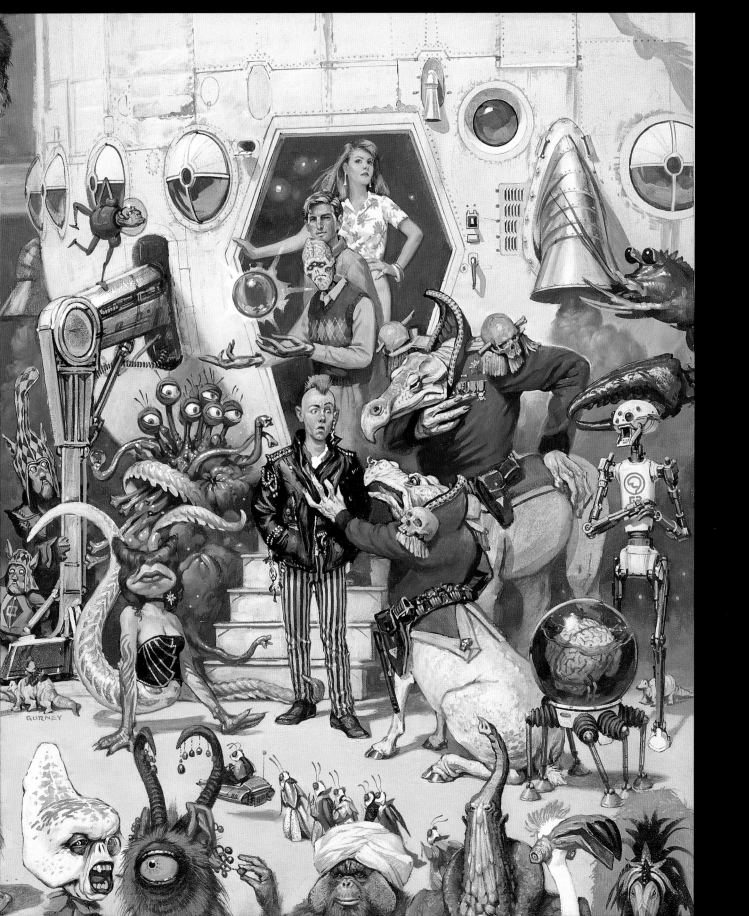

CREATURE MAQUETTES

We've seen how maquettes can help you visualize realistic human or dinosaur characters. But they're equally valuable for completely imaginary characters, such as aliens, elves, trolls, and monsters.

Here are some steps in the design of an elf-like alien. He began life on a science fiction paperback cover. I sketched a variety of versions of the character in marker, and the art director selected this one by putting a red dot on it.

Then I sculpted a maquette in plasticine, an oil-based clay. I drew this study on tone paper with charcoal and white chalk. This study from the maquette gave me valuable information about form and lighting. You can see how it helped with the cast shadow on his left ear and the reflected light under his left eyelid and cheekbone. From this reference, I drew the small charcoal layout above to establish the size and placement of the head. The original paperback cover had a row of warriors in front of the tightly cropped elf portrait. When I got the painting back, I painted out the figures, extended the wood panel, and changed the elf into an artist.

That required making two new maquettes. One was the elf hand (on page 1 of this book). The wide fingertips and webbed skin were based on scrap photos of frogs.

The other maquette of the elf, below, is made from polymer clay and painted in acrylic. This is a very quick sketch, but it gave me crucial information about the pose.

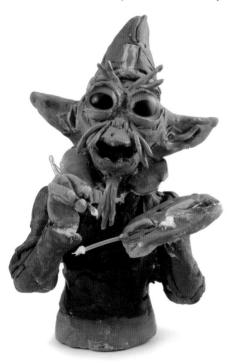

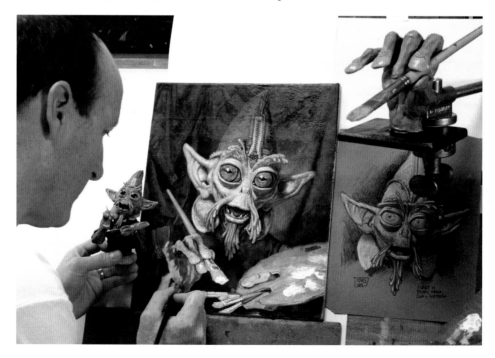

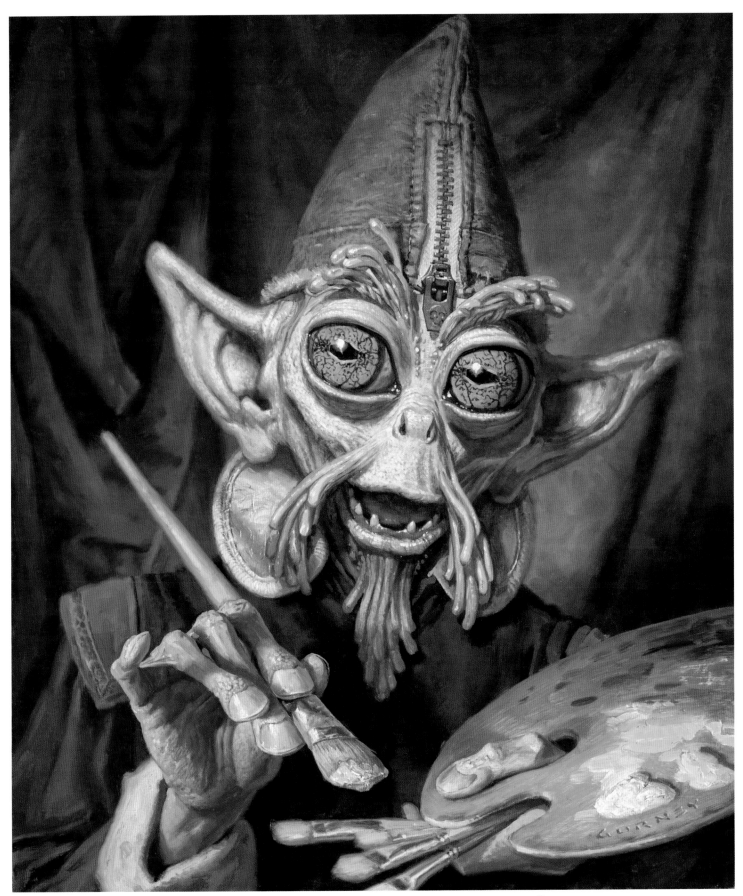

Above: Outsider Artist, 2008. Oil on canvas mounted to panel, 14½ × 12 in. Earlier version published as cover for *Fleet: Sworn Allies*.

SKELETON MODEL

A scale model of a human skeleton is a useful reference tool, whatever kind of imaginative art you do.

There are several sizes and kinds to choose from, ranging from the 15-inch-high plastic model at right to full-size plastic reproductions that cost thousands of dollars.

I originally bought this skeleton model as a general studio reference tool to put in the same pose as any figure I was developing for a scene, just to be able to check what a person's bones would look like from a particular angle. When I received a paperback cover assignment for a story that actually featured skeleton pirates, I knew I could offer a starring role to my little actor.

The sketch on pages 188–189 shows how I set up the skeleton, along with an actual human skull, next to my drawing table. I tried various color sketches (below) until I arrived at just the right muted color scheme. Then I found some photos of sailing ships, treasure chests, and cannons to toss around on the deck. A cannonball has broken through the railing at right. His right leg is held

together with a strip of cloth, and his missing left leg is replaced with the end of an oar, whittled into a simple hinge for his knee. He is a skeleton that refuses to die.

Opposite: *Shiver Me Timbers*, 1987. Oil on board, 17 × 11 in. Cover for *On Stranger Tides* by Tim Powers.

Left: Skeleton sketches. Oil on board, each 4¼ × 2½ in.

Above: Skeleton model. Plastic model, 15 in. tall.

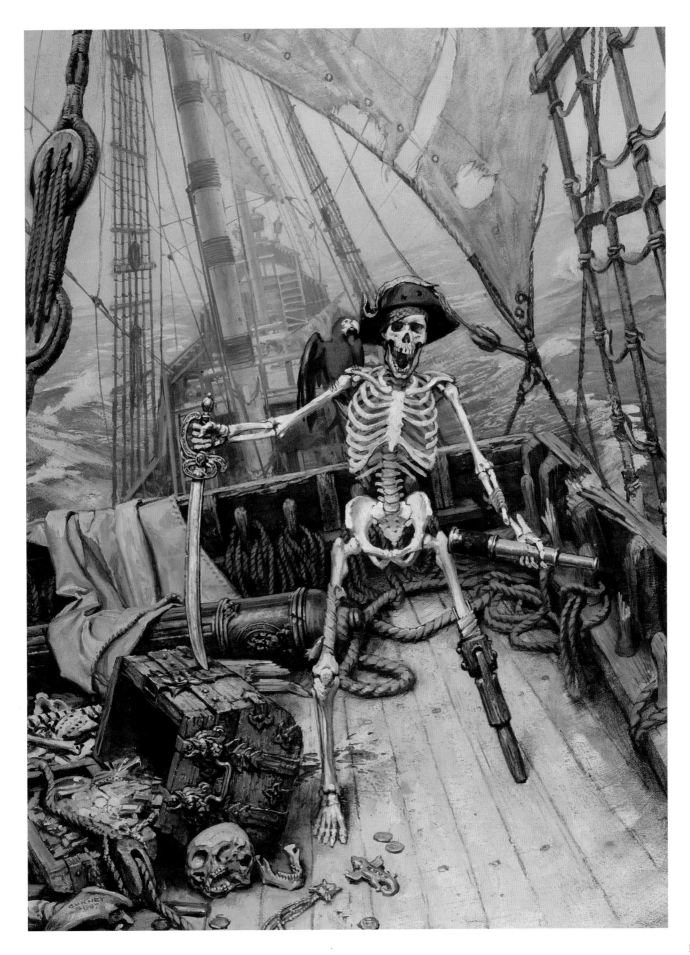

ANIMAL CHARACTERS

If you want to design animal characters, you have to figure out ways to infuse them with personalities. Those personalities can be established in human terms, but the greatest challenge is to design them so that they communicate emotion without losing too much of their animal nature.

Some animals have body types that make us think of them in anthropomorphic or humanized terms. Monkeys, mice, bears, kangaroos, and the extinct raccoon-like *Plesictis,* above, all seem to have hands. They appear to be comfortable walking on two legs. It's no wonder these kinds of animals have been so popular as characters. In the satirical paperback cover painting opposite, aliens that look like a cross between primates and rabbits have just arrived on Earth and are trying to make sense of the life forms that inhabit this planet.

Prey animals tend to have their eyes on the sides of their heads. This presents a problem for a character whose eyes both need to be visible from a lot of angles. One of the first jobs of the designer is to bring the eyes forward. It also helps to show some whites around the pupils so you can see where they're looking.

Quadrupeds such as horses and donkeys are harder to humanize. Some have expressive faces, but their mouths are far from their eyes. They don't have hands, and they don't often walk on their back legs. The same is true of the extinct mammal-like reptile *Estemmenosuchus,* above, which didn't seem likely to rear up on its hind legs.

I did the sketch below while listening to my son and his friends play traditional music on the fiddle, accordion, and tambourine. As they played, a dog and cat circulated around the room, and a squirrel was visible outside the window. Instead of drawing the musicians the way they appeared, I tried to imagine the animals as if they were scaled up and holding the instruments.

You have to think much harder if you want to develop animal characters that are not just human surrogates but instead retain as much essential animal character as possible. Instead of anthropomorphism, you might call this "animalmorphism." This is easier to accomplish if they aren't required to talk. Any dog or bird owner knows exactly what their pet is thinking, just by their eyes and body posture. A dog will let you know he feels angry or apologetic or playful, using a different repertoire of expressions than we humans use. Animalmorphic characters don't have to be realistic in a photographic sense, but they have to be believable.

Above: *Quozl*. Oil on canvas, 18 × 24 in. Paperback cover for the novel by Alan Dean Foster, 1989. The Frank Collection.

Opposite Top: *Bandy and Budge*, 1998. Oil on board, 6 × 6 and 8 × 7 in. Published in *Dinotopia: First Flight*.

Opposite Bottom: *Fiddler Dog*, 2001. Pencil sketch, 5 × 4 in.

HALF-HUMAN

It's one thing to give some personality to an animal character, but it's another to create a whole new being that is halfway between a human and something else. Mythology is full of composite creatures such as centaurs and minotaurs that combine parts of humans and animals. You can also infuse trees, vegetables, or manufactured objects with human traits.

Above: *Raccoon Man*, 1985. Pencil, 6 × 10 in.

Below: *House Face*, 2008. Colored pencil, 4 × 4 in.

Opposite Top: *Garden Goblins*, 2000. Pencil, 8½ × 11 in.

Opposite Bottom: *Old Stone Man*, 2000. Pencil, 6 × 4 in.

The pencil sketches above were the first steps in developing a design for a creature that is halfway between a human and a raccoon. I surrounded myself with photos of both and borrowed a nose from one and an ear from another. Each sketch is a little different, and it takes a few dozen until one emerges as the winner.

On the page opposite are designs for garden goblins, which appeared in the background of the pumpkin man painting on page 72. These started with a grocery bag full of sweet corn and ornamental gourds from a farm market. The corn husks seemed like a logical material for their homemade costumes. I wanted them to look impish, so I looked at photos of chimpanzees.

Try developing these ideas on location. If you take a sketchbook to a place with old gnarled trees, you can push the forms

JUNE 19, 2008 JG

Garden Goblins

SPROUT FROM ORNAMENTAL GOURDS —
LIVE IN CORN STALKS — CAN BE A MENACE.

you see just enough to suggest faces, hands, and feet.

You can also develop characters from stones, cars, household objects, or buildings. Whenever you see a face in a cloud or the man in the moon you're experiencing a phenomenon called pareidoliac apophenia. In east Asian folklore, they don't see a man; they see a rabbit.

The term *apophenia* was coined by Klaus Conrad in 1958. It refers to our tendency to find meaningful patterns or to draw connections in random sets of data.

Pareidolia is a specific kind of apophenia in which faces or other patterns emerge from random shapes. The Rorschach test is a classic example. It also explains the remarkable discovery in 1978 of the face of Jesus in the burn marks of a tortilla and the appearance of the Virgin Mary in a grilled cheese sandwich.

As artists, we can have some fun with this phenomenon. Whenever I sense a face emerging from the randomness of the world, I like to sketch it, accentuating the pareidolia just slightly. In the sketch at left I emphasized the eyes that seemed to emerge from the dormer windows of a building.

Another time on a hike I stopped in my tracks when I saw a face in the rocky cliff. I did this sketch to accentuate the forms just enough to make it apparent but without making it too obvious, I hoped. British illustrator Arthur Rackham filled many of his illustrations with half-disguised faces of this kind.

The Old Stone Man watches the pedal boats on Lake Mohonk

FROM MODEL TO MERMAID

How do you get a mermaid to pose? Like unicorns and dragons, they are fantastical creatures not entirely of this world. I wanted my mermaid painting to look real but not in a literal or material sense.

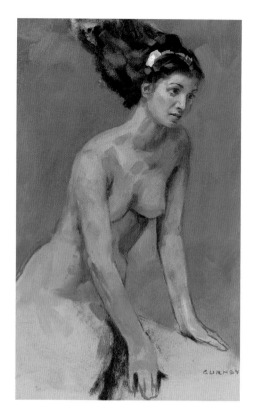

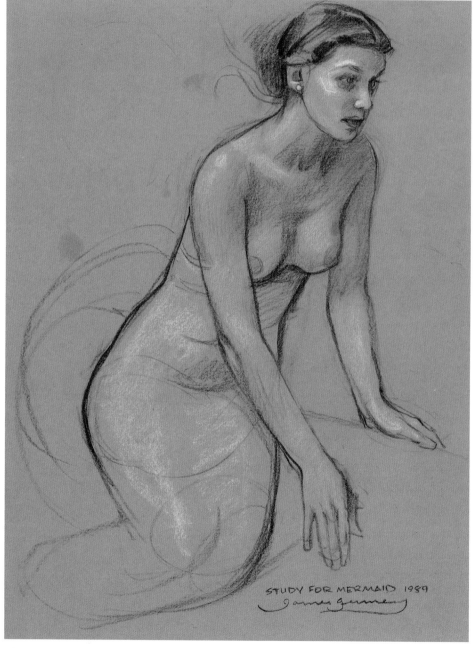

For mythological or storybook beings I prefer to use life studies rather than photos for reference because I feel freer to be guided by my imagination. I did two studies, one in charcoal and one in paint, directly from the model. In the charcoal study I concentrated on the basic linear gestures and on the soft lighting of the form. I also started thinking how to join the human form with a fishlike tail and how to bend the tail so that she could ride sidesaddle on a tamed sea creature.

I recalled from my experience snorkeling that skin tones appear cooler in water than they do in the air, and the side planes of the figure fall away to a bluish hue, lit from all directions by scattered light in the water. The color study above, made with the model in front of a blue cloth, allowed me to start exploring this unusual and magical color quality.

In both studies, I took the first step toward my mental image, making changes in what I was seeing and not copying the model literally.

Above: *Study for Mermaid*, 1989. Charcoal and white chalk on gray paper, 12 × 9 in.

Above Right: *Mermaid Oil Study*, 1989. Oil on panel, 12 × 8 in.

Opposite: *A Ride to Atlantis*, 1989. Oil on canvas mounted to panel, 24 × 20 in.

CYBORGS

A cyborg is a cybernetic organism that blends natural and artificial systems. Cyborgs are usually based on humans, but they can also be designed on a variety of nonhuman forms; the first actual cyborg was a white lab rat in the 1950s with an artificial hormone pump.

Left: Sea monster heads, 1981. Pen and marker, 7 × 12 in.

Below: *Sea Monster* sketch, 1981. Pencil and pen, 11½ × 8½ in.

Bottom: *Sea Monster* color sketch, 1981. Gouache, 11 × 8 in.

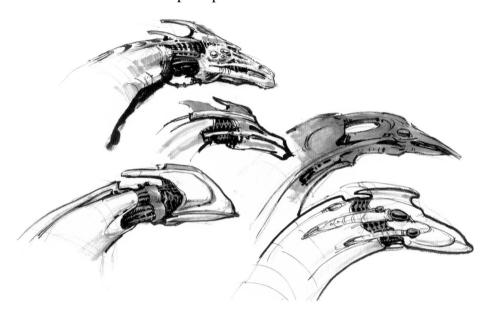

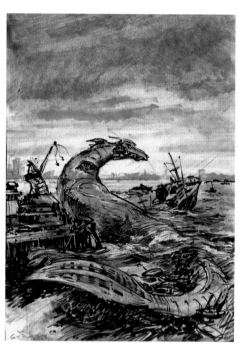

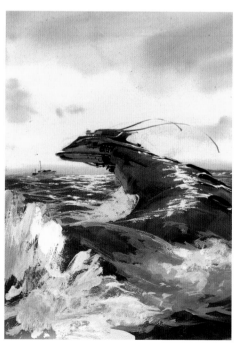

Cyborgs have played an important role in science fiction, often serving as a measure of our discomfort with the increased mechanization and depersonalization of life.

I began with the ancient idea of the leviathan or sea serpent. Perhaps the legend grew from the reports of sailors who had seen the backs of whales rising above the surface of the water and imagined the rest of the body as a huge snake.

I then explored the idea of the sea monster as part animal and part machine, a kind of mechanical juggernaut invading the human world to take vengeance on us. I tried a lot of design ideas, some sleek and streamlined, others more baroque and organic. I loved the idea that the creature had a smooth outer skin protecting its more delicate inner structure and that it was injured somehow, making it act recklessly and unpredictably.

In the sketch above right, made with graphite, markers, and ink, I tried staging the scene in a harbor, with smashed piers and sinking ships. I established the basic idea for the *S*-shaped gesture, but I realized that seeing the full body including the tail was too obvious and undramatic. So I brought the action across the foreground, disorienting the viewer and making it hard to tell how big the monster really is.

One more color sketch in gouache explored the afternoon light shimmering off the water. Photo scrap of submarines and whales helped me imagine how the bright highlight might run along the back.

The last piece of the puzzle was to photograph a plastic tugboat model half-sunk in a swimming pool. This helped me figure out how it would look at the strange angle. I was finally ready to embark on the final painting in gouache and acrylic.

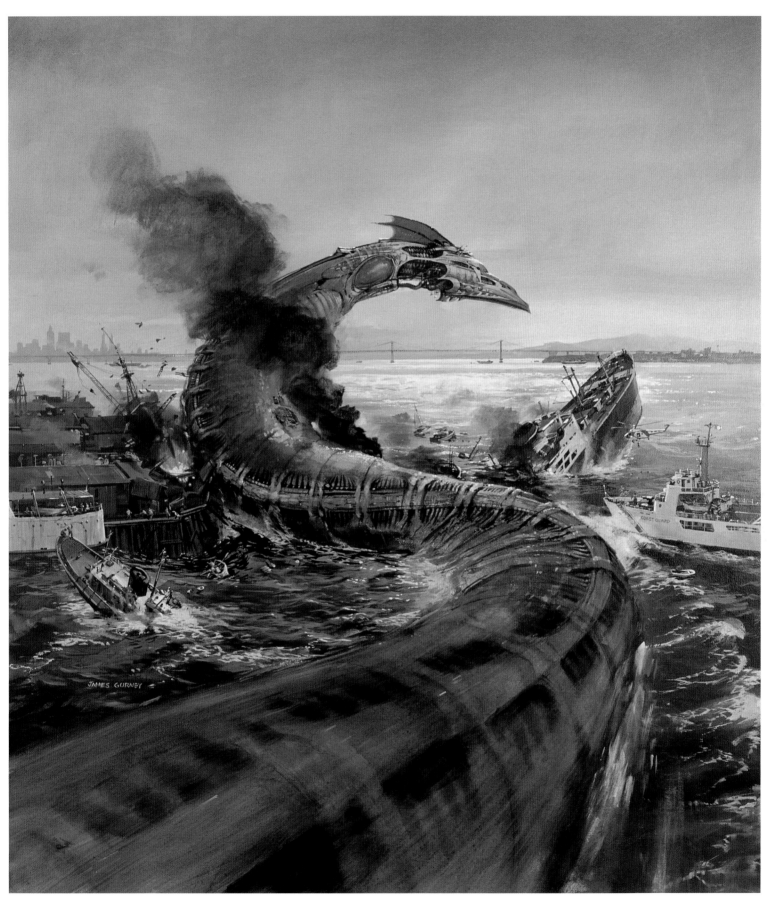

Above: Sea Monster, 1981. Gouache and acrylic on board, 40 × 30 in. Cover of *The Magazine of Fantasy and Science Fiction*, February 2001.

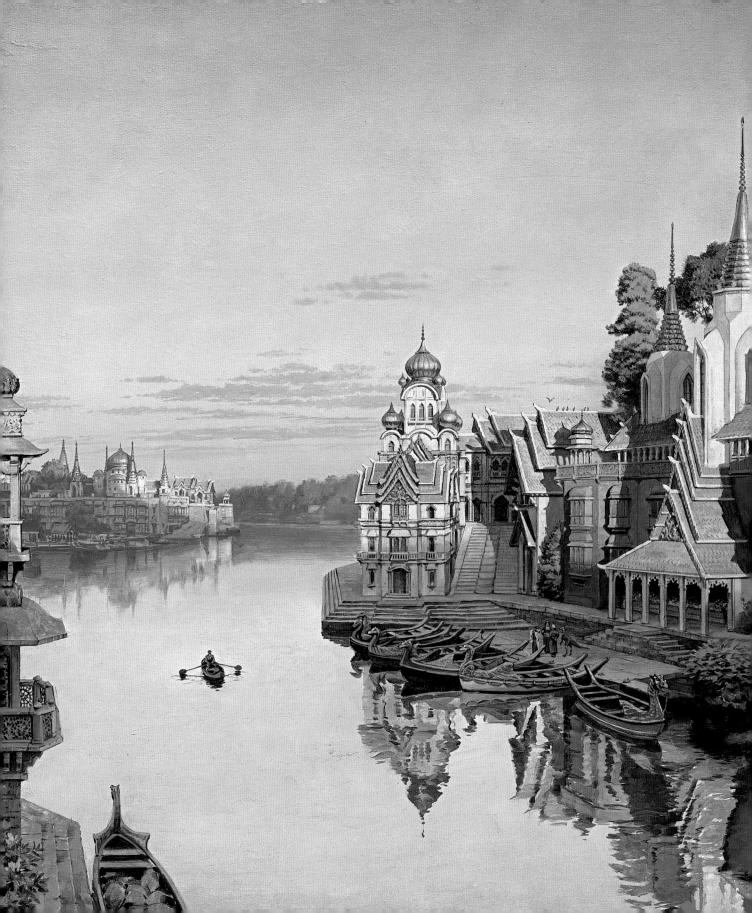

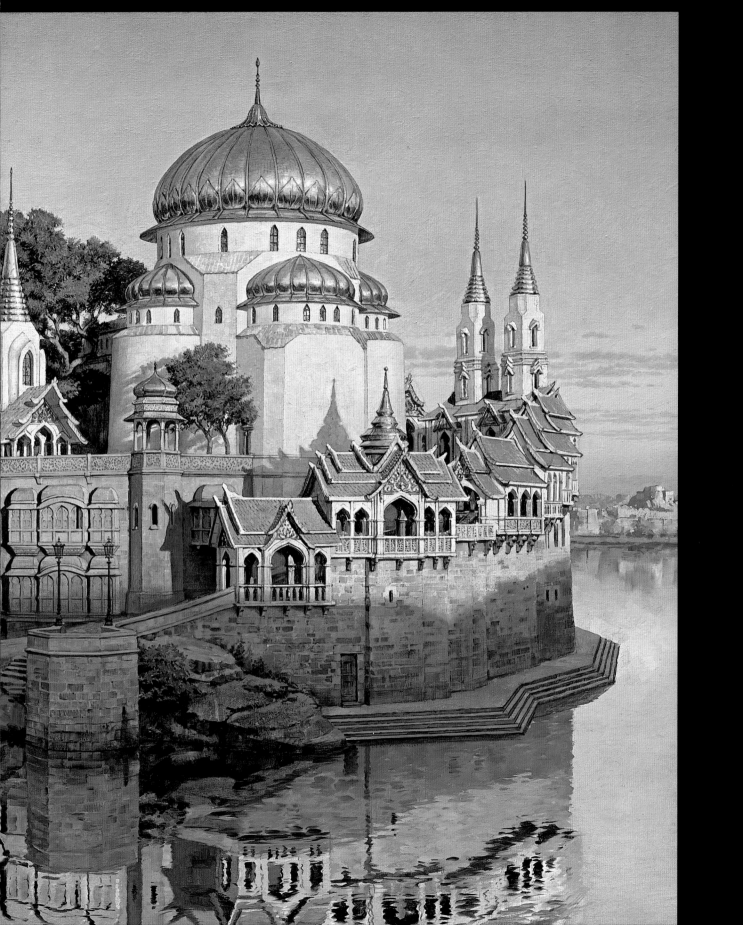

FOUR STEPS TO BUILD A CITY

If you want to paint a realistic image of an imaginary city, complete these four steps: (1) a color sketch from your imagination, (2) a maquette, (3) a perspective drawing, and (4) the final painting.

The benefit of following these four steps is that your city will extend back in space and will seem to exist behind the viewer.

The first step was the color study (opposite page). It's painted in oil and taken as far as possible without any reference whatsoever. Compositional ideas have a certain unity if they're guided purely by the imagination.

Next I built a quick architectural maquette from painted Styrofoam. The domes are surfaced with acrylic modeling paste, and the smaller details such as gabled rooftops and railings are made from thin strips of mat board attached with a hot glue gun.

The maquette is sitting on a mirror panel to simulate the reflections on still water. These mirror panels are 12 inches square, and they can be purchased at any home improvement store.

Based on photos of the maquette and on reference photos of architecture from India and Thailand, I drew the perspective line drawing (opposite). This step alone took several days.

Notice the lines in the sky that gently slope down to the right. These are the perspective grid (page 42), and they serve as guidelines when the vanishing point is too far away to reach with a yardstick. By establishing these evenly spaced lines across the whole picture, I can find the slopes of any other lines between them.

You might also notice vertical lines near the square towers at each side

of the painting. These are guidelines to standardize the proportions of the towers from one side of the picture to another, so that the towers seem to be the same relative size and height above the water.

This line drawing is projected onto the final canvas with an opaque projector. There's still room to improvise on the final oil painting. Notice how the shape of the main dome has changed from a circular shape in the pencil drawing to an onion dome in the final painting (preceding pages).

A section of the final painting is superimposed over the drawing so that you can see how closely I followed the plan of the line drawing.

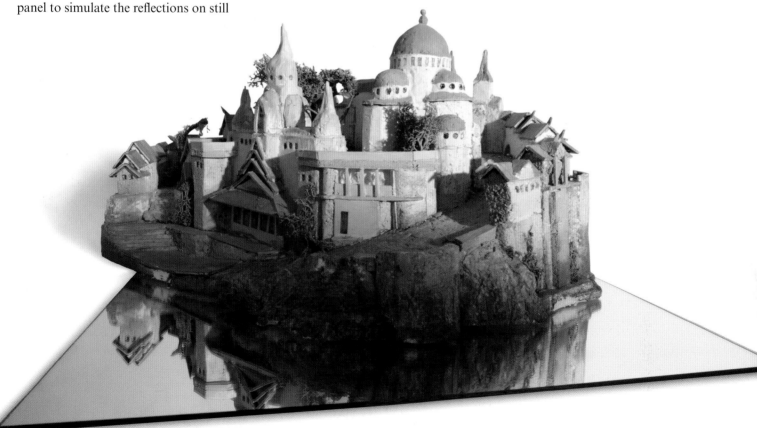

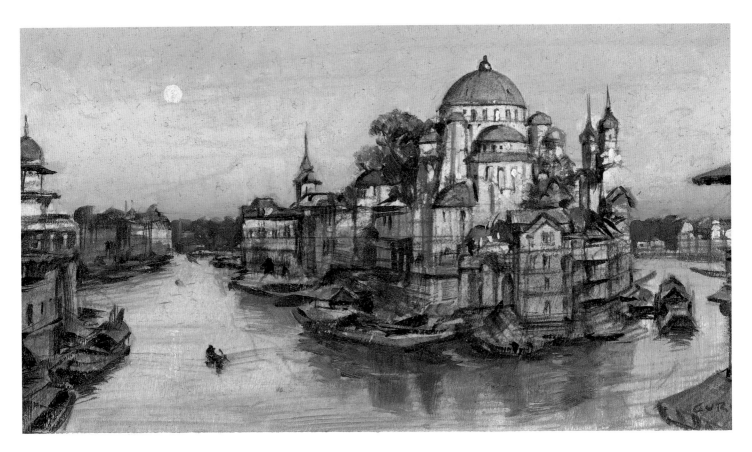

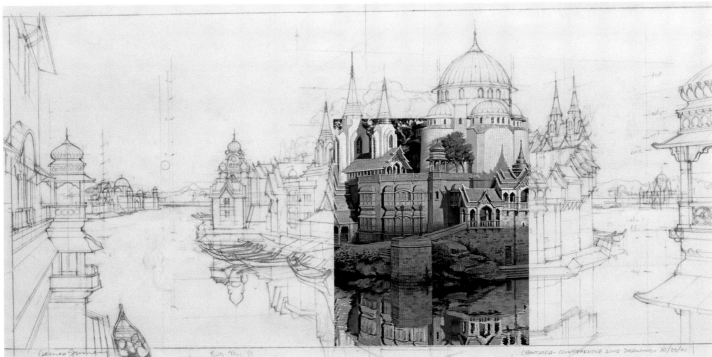

Opposite: *Chandara* maquette with mirror, 2001. Styrofoam and cardboard, 14 × 10 in.

Top: *Chandara* sketch, 2001. Oil on board, 3½ × 7 in.

Bottom: *Chandara* line drawing with finished art superimposed, 2001. Pencil on cotton drafting vellum, 9 × 19½ in.

Preceding pages: Chandara, 2002. Oil on canvas, 24 x 52 in.

VISUALIZING WATERFALL CITY

In a schematic maquette, you don't have to sculpt every single building, just a few characteristic geometric forms. By looking at photos of those representative forms as you do your drawing, you can add details and multiply them into the full city.

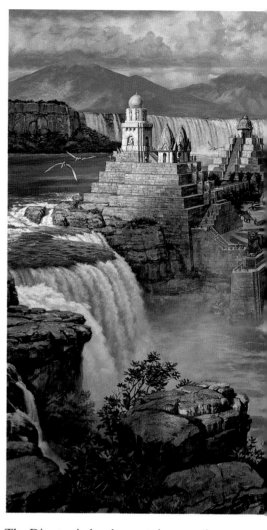

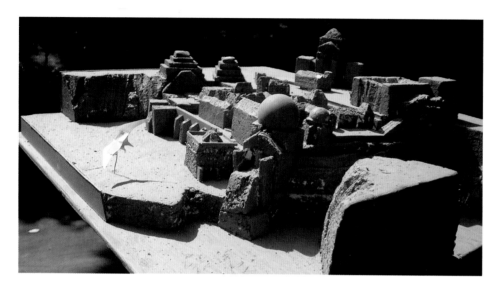

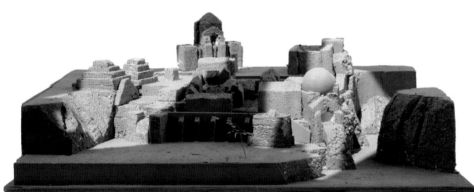

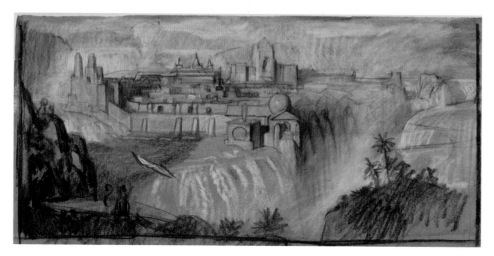

The Dinotopia books contain several views of Waterfall City, including the detailed overview above, which shows half of the city cast into shadow and the other half in full sunlight.

The challenge for me as a designer was to keep the city visually consistent as it appears from various angles. To do this I built a schematic maquette out of gray-painted Styrofoam (left).

The real benefit of such a simplified maquette is that you can view it from any angle and see how the light plays on it. Film directors often use schematic maquettes for planning the shots of a given sequence.

At the left is a study made on tone paper directly from the model, which I set up with artificial light. To figure out the cast shadows, I set up cutters, uneven shapes of cardboard held up with the C-stand to interrupt the light and plunge parts of the model into darkness.

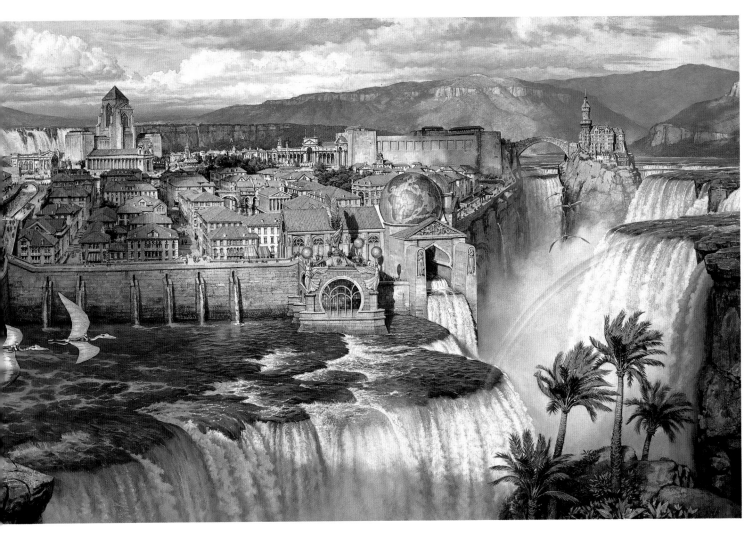

When it came to painting the final picture, I also relied on a more detailed maquette of the featured corner of the city that contains the globe and the gold statue, right. The waterfall is made from Styrofoam, and the sculpted elements are made from two-part epoxy putty.

Having models will often help you generate ideas for entirely new paintings that you didn't originally plan on creating, so it's worth investing a little time in this step.

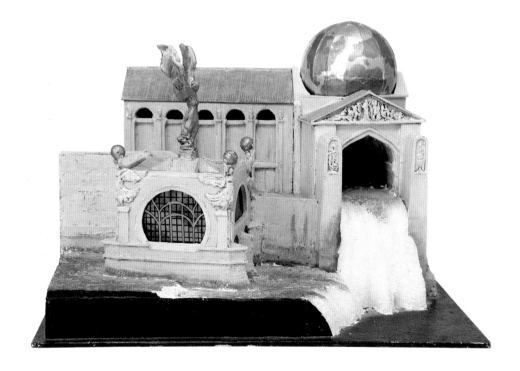

Opposite Top and Center: *Waterfall City* schematic maquette, 2001. Styrofoam and cardboard, 20 × 17 in.

Opposite: *Waterfall City* tone study, 2001. Charcoal and chalk on brown paper, 9 × 18½ in.

Above: *Waterfall City: Afternoon Light*, 2001. Oil on canvas, 24 × 52 in.

Right: *Waterfall City* maquette, 1993. Mixed materials, 14 × 11 in.

ARCHITECTURAL MAQUETTES

Architects planning real buildings construct maquettes to study the volumes and sightlines from different angles. Even if you're planning a purely fantastical building, a physical miniature helps you make the same kinds of choices. Maquettes are especially helpful if you need to figure out how your building should be situated on a dramatic or uneven terrain.

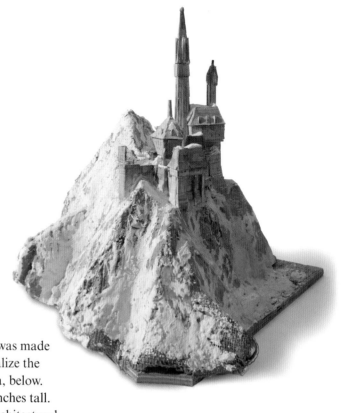

The little clay model at left was made in less than an hour to visualize the desert stronghold of Khasra, below. The model is only about 3 inches tall. Even a quick and sketchy architectural maquette can still give you plenty of lighting information. For example, notice the warm light bouncing into the shadows of the gateway on the right side. The shadow side of the last tower on the extreme right is much darker because it lacks reflected light.

When I photographed it, I tinted the light with a blue gel, and I also shifted the image with Photoshop. I took the photo with a digital single-lens reflex camera on a tripod. It was set to a high f-stop with a long time exposure to give it the maximum depth of field. Printed out on paper, the photo was just one of several that I used for reference.

The painting at right shows a mountain stronghold nestled on the very top of a snow-covered summit. It wasn't hard to find photographs of the Himalayas or the Alps, but the challenge was to understand how the structure would fit on the ridgeline site.

I built the mountains by first gluing big chunks foam into the rough shape of the ridge. I then soaked some pieces of burlap in plaster and draped them over the foam base. After it was dry I painted it with brown acrylic, and then splashed more plaster over the surface to suggest snow. I then cut up an assortment of interesting cardboard scraps, pre-ruled with lines to suggest the stone masonry, and began hot gluing them together into a cluster of buildings to match my color sketch.

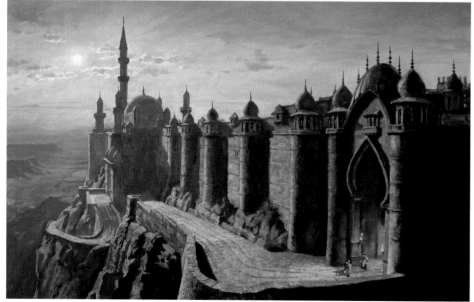

Above: *Khasra by Moonlight*, 2006. Oil on board, 12 × 18 in.

Top Left: *Khasra* maquette, 2006. Oil based clay.

Above Right: *Palace in the Clouds* maquette, 1989. Mixed materials, 17½ in. tall.

Opposite: *Palace in the Clouds*, 1989. Oil on canvas mounted to panel, 46 × 36 in.

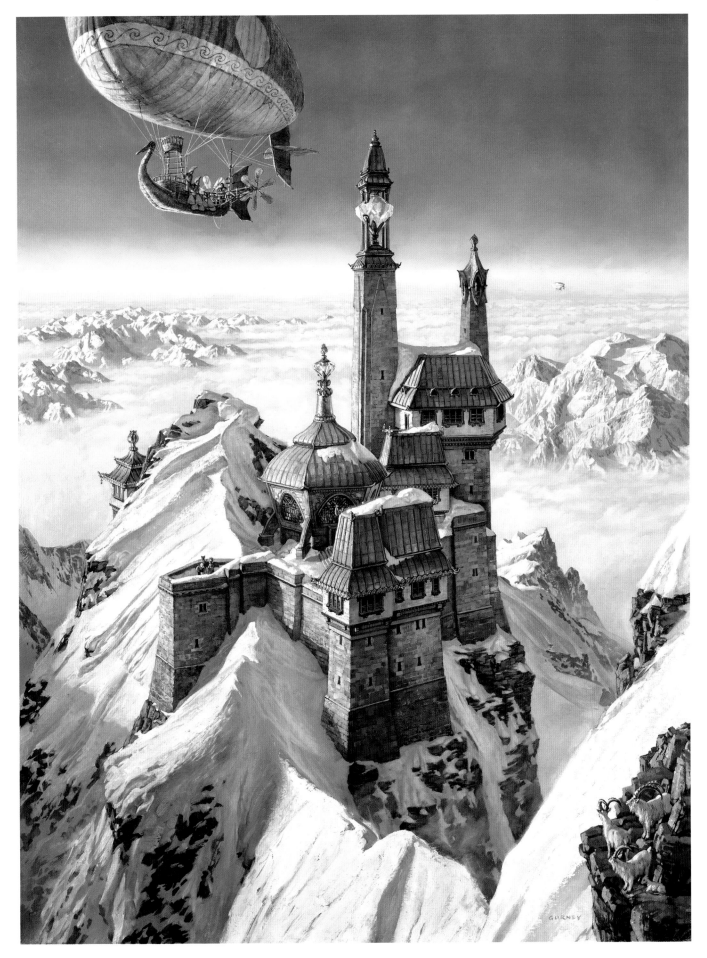

117

LIGHTING THE MAQUETTE

Once you have built a maquette, you can try a variety of lighting angles and colors until you get exactly the arrangement you were looking for and maybe a few surprises you weren't expecting.

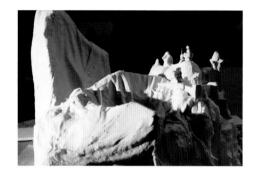

This maquette was made with the same materials as the alpine maquette on page 116, using plaster, burlap, cardboard, and foam. In the photo above, I lit it with a spotlight at a low angle to explore the play of shadows.

By placing a colored gel in front of the light, I gave the scene a golden hour lighting effect. The fill light from the right is from big overhead fluorescents. It looks purple-blue by contrast with the yellow key light.

Just to be sure I liked that lighting design, I took some photos with the light coming from other directions. In the end, I stayed fairly close to my initial conception.

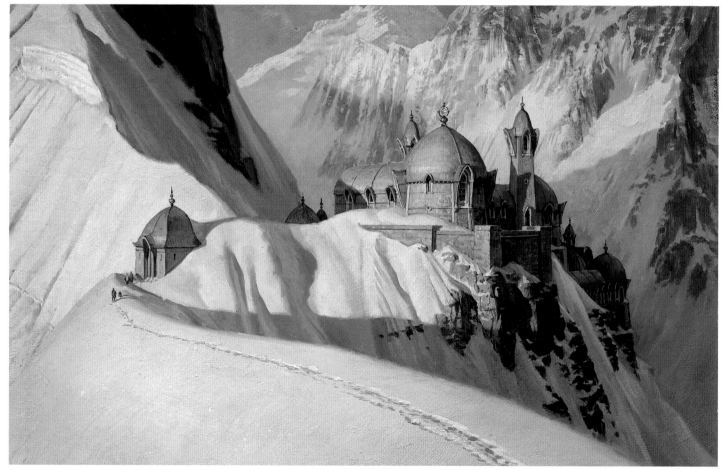

Above: *Thermala*, 2006. Oil on board, 12 × 18 in. Published in *Dinotopia: Journey to Chandara*.

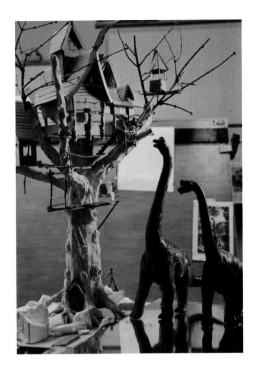

Treetown is a village built into an oak forest, composed of buildings and platforms linked together by swinging walkways. This is such an organic and three-dimensional environment that I knew I would have to sculpt it in order to really understand how everything fits together.

As a basis for the structure of the tree, I clipped off a branch from a real tree that had a good basic geometry. I beefed up the thickness of the trunk and branches with some oil-based clay. I then constructed a few structures out of twigs and cardboard held together with hot glue. To save construction time, I drew the shingles and planks with a pen and scattered chunks of Styrofoam around the ground to suggest boulders.

I photographed the model on a tabletop, with a mirror standing in for the lake. The incandescent light had a warm color compared to the bluish light from a skylight and window to the left.

After finishing both of these paintings, I discarded the maquettes but recycled the clay. They had served their purpose. They weren't made to last or to be exhibited. They were just a means to an end.

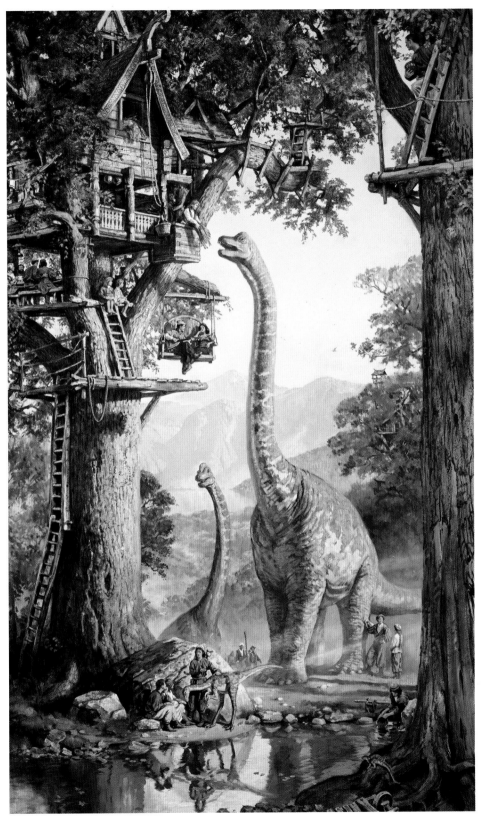

Above: *Morning in Treetown*, 1989. Oil on canvas, 40 × 30 in.

Above Left: *Treetown* maquette, 1989. Clay, cardboard, and tree branches, 18 in. tall.

CLAY AND STONE

We usually think of maquettes for characters, architecture, or vehicles. But they are just as useful for reference for landscape forms, such as sand dunes, mountains, and rivers. Artists often go to great lengths to get the figure right and forget about the importance of the setting.

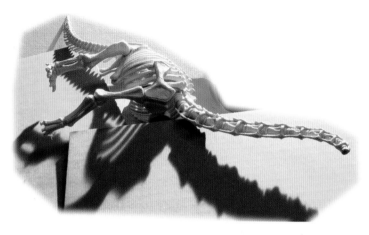

How would you go about painting a realistic scene of a sand dune? Short of scouting real locations, you might browse through stacks of photos of the Sahara Desert. I tried that but was disappointed. I had a specific composition and lighting idea in mind for this scene, and I couldn't find anything like it.

I knew that if I tried to invent the whole thing, it wouldn't be convincing. The key to verisimilitude is lighting.

Whenever you set up a natural form, there are little accidents of truth that may surprise you.

For the sand dune painting below I used some oil-based clay warmed up in the oven and shaped into a dune. I then arranged a small plastic model of a *Brachiosaurus* skeleton and photographed the two elements separately in the same lighting condition. The combination of references gave me what I needed for the final painting.

I also used oil-based clay to plan the shape of the amphitheater opposite. Although I had several photos of actual Greek theaters, I had a hard time figuring out how the shadow from a low sun on the left would slant down across the seats.

Would it touch the tops of the figures seated there? I wasn't sure, so I made a small clay maquette and found my answer. I also set up several dinosaur models in the same light to understand

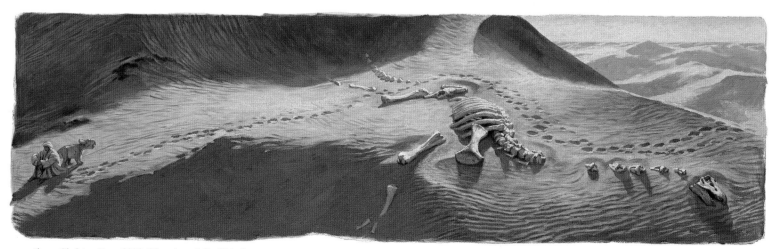

Above: Skeleton Dune, 2006. Oil on board, 9 x 28 inches.

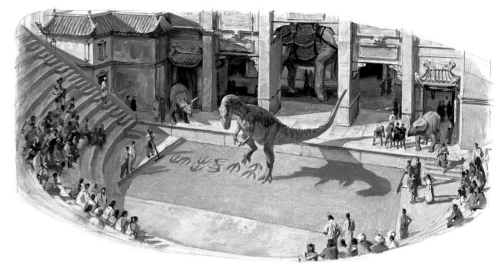

Above: *Theater* maquette, 2006. Clay and toothpicks, 6 in.

Right: *Footprint Amphitheater*, 2006. Oil on panel, 7 × 13 in.

Below: Anthracite coal, 3½ in. across.

Opposite Left: Plastic model skeleton of *Brachiosaurus,* 17 in. long.

Opposite right: Dune maquette, oil based clay, 8 in. wide.

how the cast shadow would interact with the edge of the stage.

The chunk of rock below is a piece of anthracite coal that I picked up along the shore of the Hudson River. What attracted me was the wonderfully complex form, with all the intricate planes and cracks.

I brought it home and spray-painted it with flat gray primer. The paint unified the surface so that I could really study the form. Now I've got a useful reference tool for the future, whenever I need to paint a jagged rocky mountainscape.

This idea comes from American painter Maxfield Parrish, who had a small collection of rocks to help him imagine his mountain backdrops. You can also find interesting bits of dried bones, old tree roots, gnarly bark, or even chunks of dead bushes that might suggest miniature trees.

It's hard to sculpt such intricate organic forms from clay or foam and not easy to find existing photos that meet your specific lighting needs. Why bother, when you can find beautifully detailed things in nature everywhere?

Next time you take a walk in a rocky place, keep an eye out for mountains underfoot.

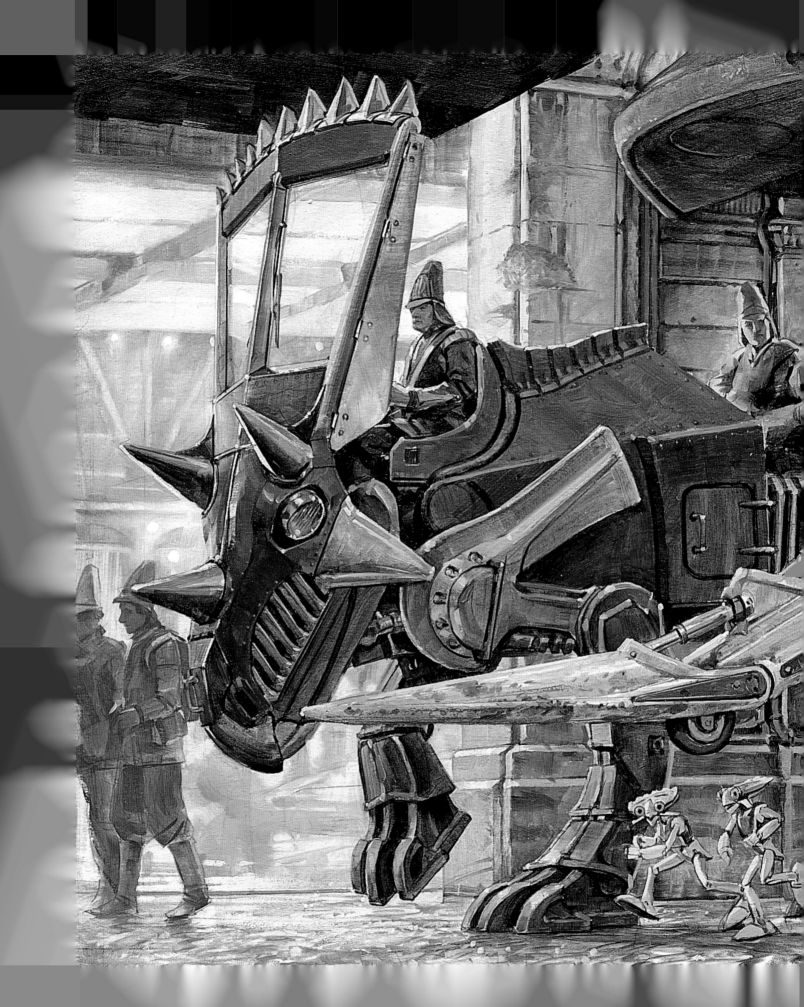

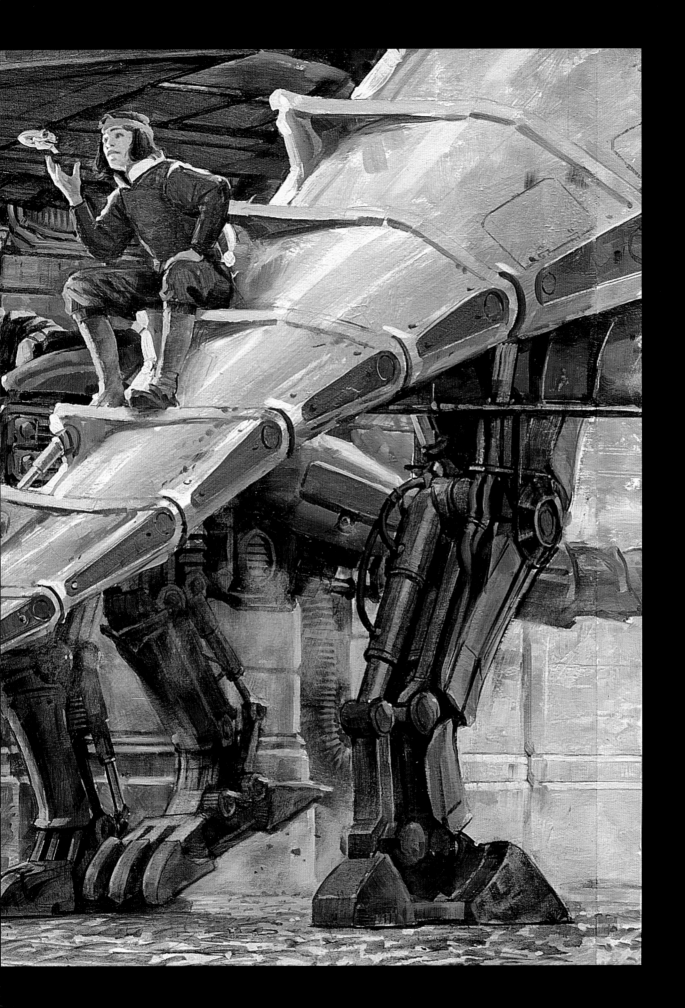

START WITH THE FAMILIAR

Ideas for imaginary vehicles are as close as the street outside your home. You can take apart the bicycles, tools, and automobiles and put them back together in a new way.

53 KAISER "DRAGON"

56 BUICK

55 OLDS

The painting below shows a digging machine made up from spare parts found in modern America. The young adventurer has cobbled together garbage cans, bicycles, umbrellas, and vacuum cleaner parts to make a fishlike vehicle that can dig into the ground in hopes of finding the hollow earth of Pellucidar.

It's a fun exercise to design a machine made up of ordinary parts, such as a robot made up of kitchen gear. Cars are a good place to start with vehicle design because they are like the family dog of our technological culture. They're around us all the time, and we're very familiar with their quirks.

On the opposite page, I did a sketch of a 1956 Chevy Corvette at a car show. When I got home I did some sketches in marker to imagine how that car might look if it was designed to fly or if it transformed into a monster, with the fenders becoming shoulders and the grill becoming a mouth.

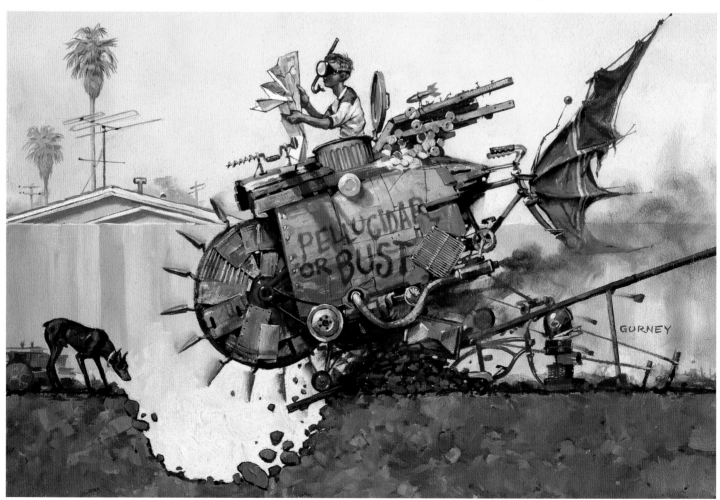

Above: *The Digging Leviathan*, detail, 1982. Oil on panel, 12 × 13½ in. Paperback cover for novel by James Blaylock.

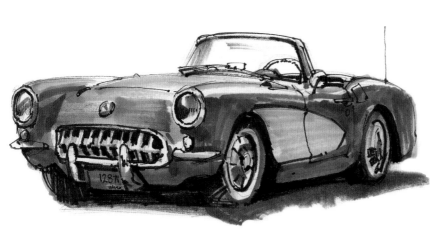

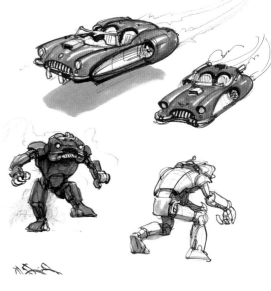

Other kinds of fantastic mechanical creatures have their inspiration in old cars. The "hoverhead" robots that I designed for Dinotopia's high-tech prehistory have the look of a 1950s car, especially the yellow one in the array of marker sketches.

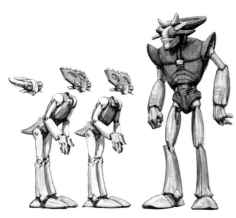

When you're sketching vehicles, it's good to draw them in three-quarter views but also in plan and elevation views (the bottom left sketches in the group at right). These engineering drawings help if you need to make a maquette, like the one below, constructed from a small piece of closed-cell sculpting foam and painted in enamel.

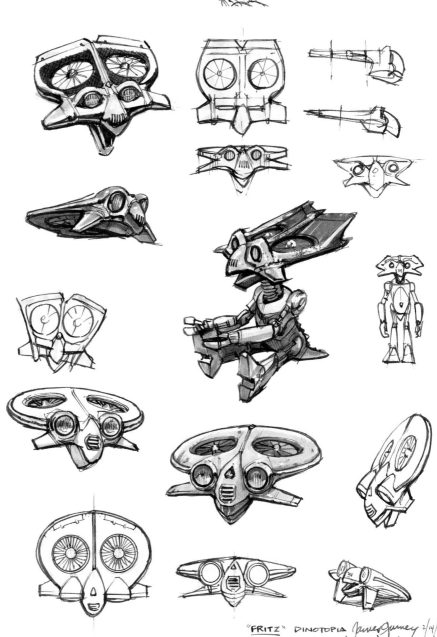

"FRITZ" DINOTOPIA James Gurney 2/14/98

125

EXAGGERATION

You don't have to dream up science fiction vehicles out of thin air. Start with a motorcycle and design the ultimate chopper. Take the arm of a backhoe and attach it to a robot's shoulder. Make everything bigger, bolder, and more dramatic.

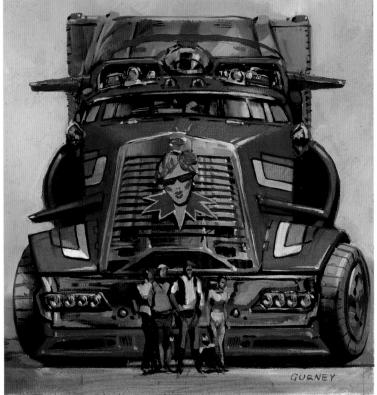

Above: *Truck Portrait*, 1982. Oil on panel, 7 × 10 in.

Above Left: *Truck Study*, 1982. Oil on panel, 6 × 5½ in.

Left: *Starrigger* comp, 1983. Oil on panel, 7 × 7 in.

Opposite: *Starrigger*, 1983. Oil on panel, 21 × 15 in.

The little oil studies of a semi tractor (above) and the old dump truck (above left), were painted on location in oil. I wasn't trying to make a picture to sell in a gallery. I just wanted to see how a truck is put together.

I had these studies kicking around the studio when I got an assignment to paint a futuristic monster truck for a science fiction paperback cover. The first color sketch (left) grew naturally as I looked at my studies. I showed the gigantic truck from the front, complete with a graphic of a girl on the grill, with figures standing alongside the bumper for scale. Eventually the idea evolved into something much larger, more neutral in color, going full speed alongside a 1957 Chevy.

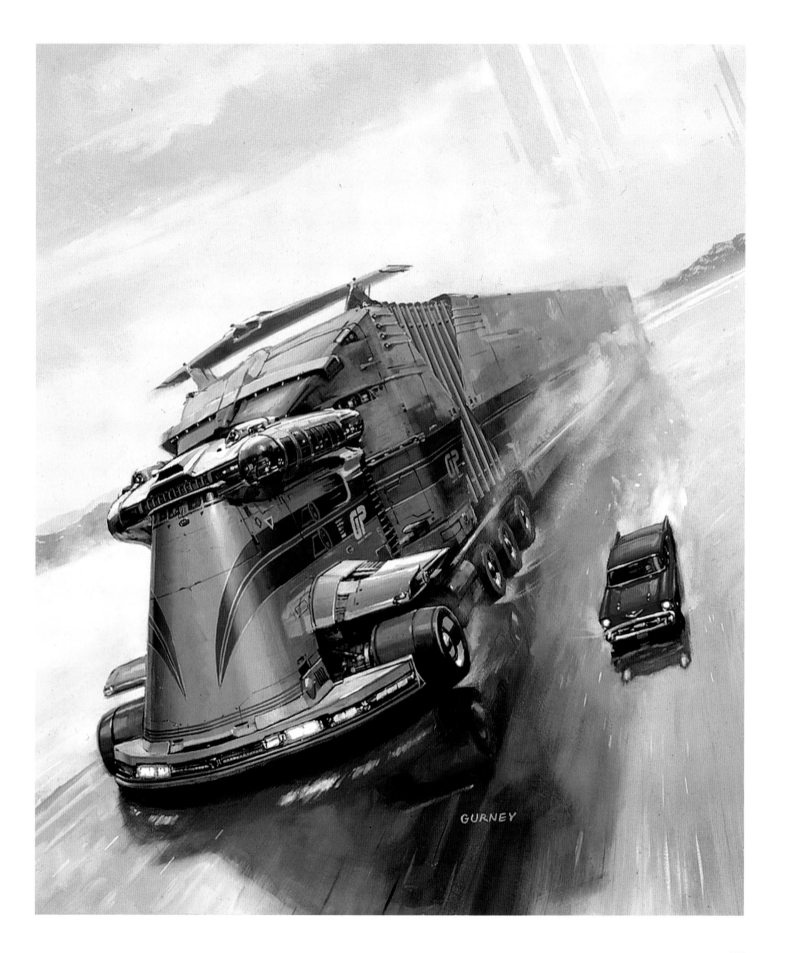

GURNEY

SKETCHBOOK AS SPRINGBOARD

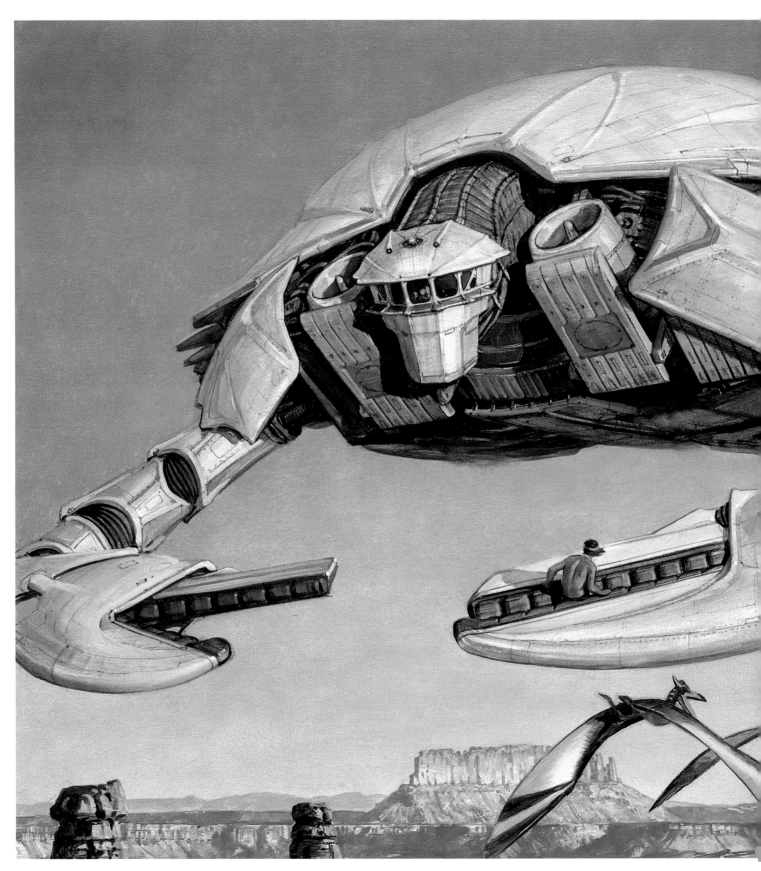

Above: *Airport Sketch*, 1995. Pencil, 6½ × 7 in.
Below: *Departing Cancun*, 1999. Pencil, 7½ × 3½ in.

The vehicle at left is called an air scorpion. I designed it for *Dinotopia: First Flight,* where it appears as the flying machine of the villain. I looked at creatures with exoskeletons for inspiration, but I also used plenty of sketches of jet airplanes that I had made while waiting for flights. I looked at studies of windows, riveted surface plates, jet engines, and accordion-like passenger boarding bridges. I even used the blurring effect in the air below the jets, caused by the superheated air.

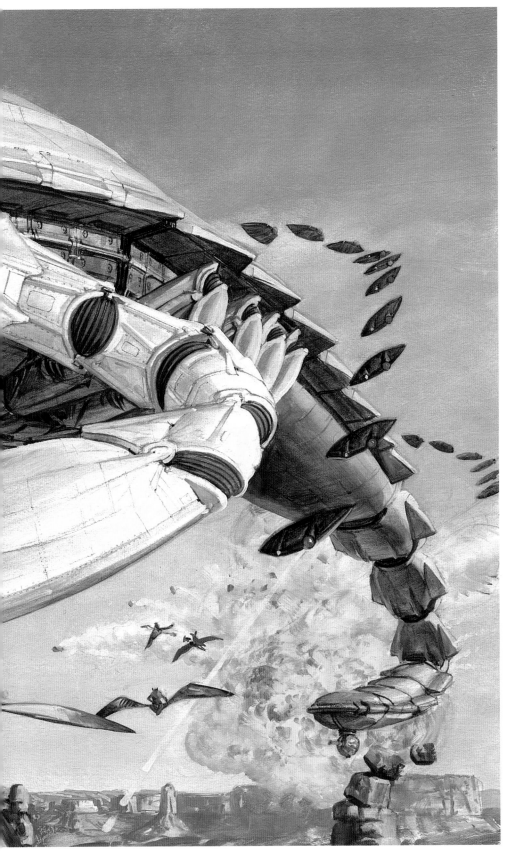

Left: *Air Scorpion*, 1998. Oil on board, 12 × 19 in.
Published in *Dinotopia: First Flight*.

INSECT VEHICLES

Insects are the only invertebrates that are capable of flight, and nearly all of the twenty-four orders of insects are successful fliers. Consider the skill of a butterfly as it navigates from one flower to another in a strong headwind, or a housefly dodging a well-aimed swat.

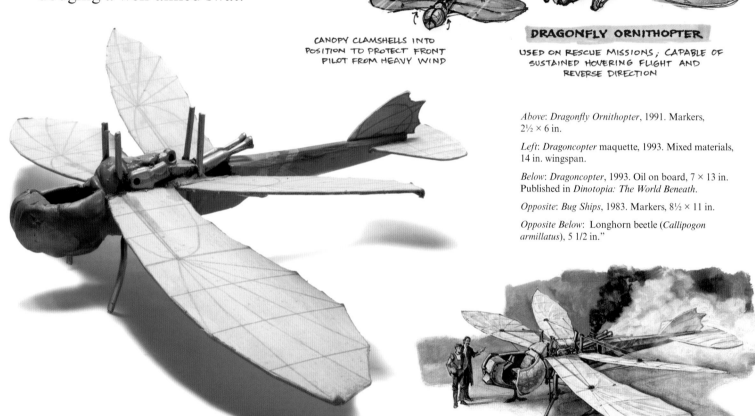

CANOPY CLAMSHELLS INTO POSITION TO PROTECT FRONT PILOT FROM HEAVY WIND

DRAGONFLY ORNITHOPTER

USED ON RESCUE MISSIONS; CAPABLE OF SUSTAINED HOVERING FLIGHT AND REVERSE DIRECTION

Above: *Dragonfly Ornithopter*, 1991. Markers, 2½ × 6 in.

Left: *Dragoncopter* maquette, 1993. Mixed materials, 14 in. wingspan.

Below: *Dragoncopter*, 1993. Oil on board, 7 × 13 in. Published in *Dinotopia: The World Beneath*.

Opposite: *Bug Ships*, 1983. Markers, 8½ × 11 in.

Opposite Below: Longhorn beetle (*Callipogon armillatus*), 5 1/2 in."

Throughout the history of engineering, designers have looked to nature for structural analogues: fish for ships, tortoises for armored vehicles, and birds for aircraft. From the time of Leonardo da Vinci onward, many concepts for ornithopters were based on birds. Today, scientists are learning more about insect flight to help develop micro air vehicles.

The dragonfly is a 350-million-year-old design, and it is a powerful and agile flier. The two sets of wings beat out of phase with each other, making for a smoother ride. The wing movements are controlled by direct flight muscles, unlike those of flies and bees, whose wingbeats depend on a pulsating vibration of the upper plates of the thorax.

Recent slow-motion photography has revealed the secret of how insects fly. They take advantage of vortices in the air to get extra lift; you can feel this effect by moving your hands back and forth underwater. In an air medium, insect designs can fly only at a small scale, for the physical laws change as you scale everything up.

The ornithopter on this page is based on the extinct dragonfly *Meganeura*, with some steampunk elements. Steampunk is a design philosophy that blends Victorian technology, especially steam power, with science fiction. I built the maquette, left, with a pine fuselage and cardboard wings, which were mounted over armature wire so that I could pose them at any angle.

The sketches opposite are of some insect-based aliens for a universe with sentient flying robots. I looked through lots of references and photos of insects,

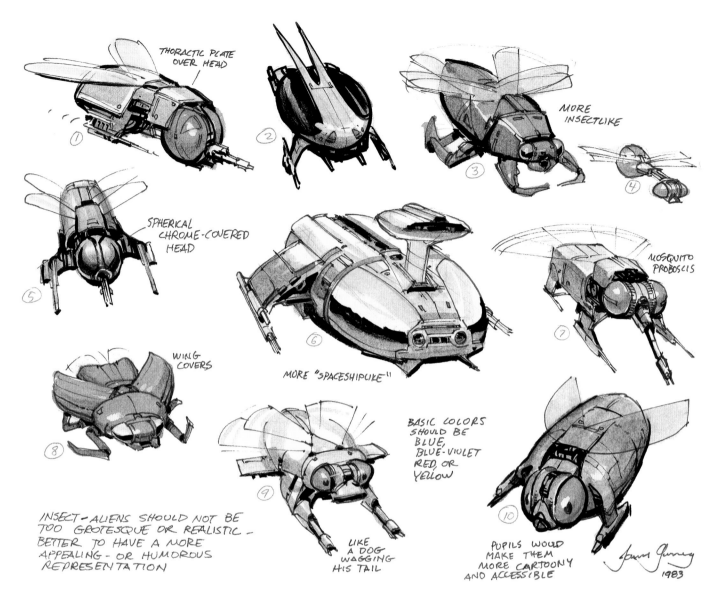

THORACTIC PLATE OVER HEAD

① ② ③

MORE INSECTLIKE

④

SPHERICAL CHROME-COVERED HEAD

⑤

⑥

MORE "SPACESHIPLIKE"

MOSQUITO PROBOSCIS

⑦

WING COVERS

⑧

BASIC COLORS SHOULD BE BLUE, BLUE-VIOLET RED, OR YELLOW

⑨

LIKE A DOG WAGGING HIS TAIL

⑩

PUPILS WOULD MAKE THEM MORE CARTOONY AND ACCESSIBLE

INSECT-ALIENS SHOULD NOT BE TOO GROTESQUE OR REALISTIC - BETTER TO HAVE A MORE APPEALING - OR HUMOROUS REPRESENTATION

James Gurney 1983

trying to dream up different ways to use the body plan of a fly or a beetle as a starting point.

A vehicle would need many of the same functional elements as a natural creature, namely optical sensors, landing gear, external armor, wings and wing covers, fuel intake tubes, and offensive and defensive weapon systems.

The design assumption we've had until recently is that industrial manufacturing processes will always yield a geometry of straight lines and constant circular curvatures. But recent advances in computer-aided design and manufacturing, and even computer-aided evolution, suggest that future vehicles might begin to mimic the organic lines and surfaces of real insects,

such as the longhorn beetle *Callipogon armillatus*, shown here about two thirds life size. Notice that no lines are perfectly straight, and no cross-sections are circular.

I don't actively collect insect specimens, but entomologist friends have given me a few amazing treasures, which I study when I'm trying to imagine new ways of constructing a vehicle with an exoskeleton. Because insects are part of the larger group of arthropods, you can learn a lot about the mechanics of hinged appendages and shell structure from studying the larger nonflying cousins, the crabs and lobsters.

WALKING VEHICLES

Vehicles that move across the ground usually have either wheels, tracks, or legs. Legs have an advantage over wheels on uneven terrain. You can base your design concept on many living analogues, for nature has no use for the wheel.

The painting below shows a Dinotopian walking vehicle along with the small scratch-built maquette used to develop it. The design is based on an extinct shrimplike invertebrate.

One reason wheels never arose in nature is the difficulty of designing a circulatory system that could pump blood across a turning bearing. Birds, humans, and a few mammals use two legs, but four, six, or more legs are more common. Odd-numbered arrangements have been tried successfully with robots.

Engineers who design the drive mechanisms for walking vehicles usually have to solve three problems: how to

Above: *Crabb's Strutter*, 1994. Polymer clay, 6 × 2 in.

Below: *Crabb's Strutter Attacks*, 1995. Oil on board, 8½ × 13 in. Published in *Dinotopia: The World Beneath*.

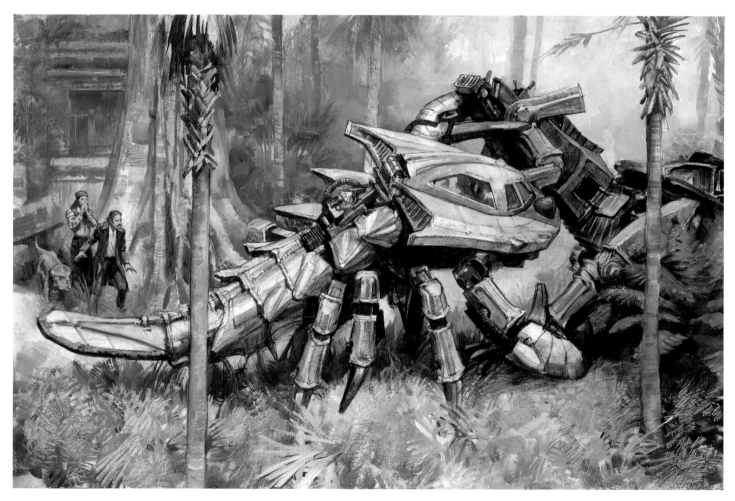

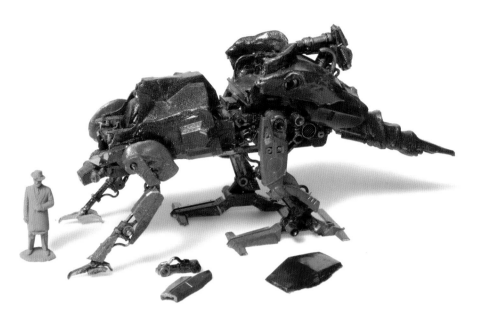

translate the energy of the motor to the movement of the leg, how to achieve balance, and how to steer and change direction. With six legs, balance can be achieved by moving the legs in two groups of three, always maintaining balance on a tripod, but modern engineers have developed systems to solve the balance problem, even for a pogo-stick vehicle with one leg.

The four-legged walking vehicle or "strutter" on this page is based on the design of a ceratopsian, in this case with the head/windshield removed.

I built the maquette by kit bashing, or combining parts from many different robot plastic model kits and filling in extra shapes with two-part sculptor's putty. You can often find unbuilt plastic models at yard sales.

The front section of the vehicle above was originally the torso of a Japanese robot. The section of the body alongside the back leg uses small kit parts for the "greebles," the small surface details used to break up the form and to suggest the drive mechanism.

Above: *Strutters*, 1991. Markers, 11 × 8½ in.

Above Left: Strutter maquette, 1994. Plastic model parts, 5 × 12 in.

Below: *Arthur's Strutter*, 1994, Oil on board, 12 × 20 in.

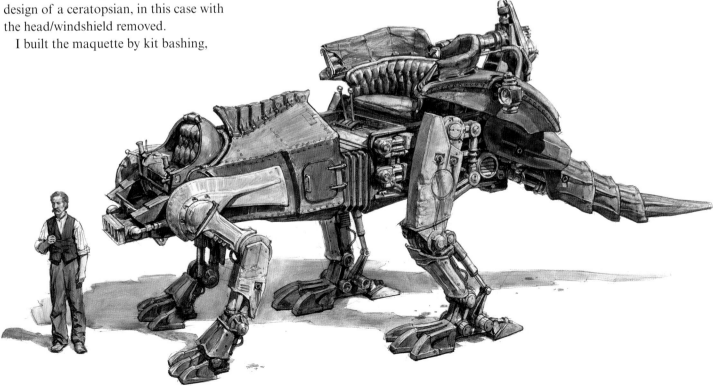

ALTERNATE HISTORY

Alternate history is a subgenre of science fiction that imagines what would happen if events followed a different course from some key point of divergence. For the vehicle designer, this opens up a rich vein of possibilities for plausible forms that might have been.

The paintings on these pages were paperback covers from a series of science fiction novels by Kirk Mitchell. His story began with the premise of Pilate pardoning Jesus instead of Barabbas, and the Roman army defeating the barbarians. From that beginning, a chain of events allowed Rome to flourish and develop advanced technology.

It wasn't easy to come up with a whole new configuration for an airplane. I tried a canard design with a pusher prop and a variety of design features that suggest the look of Roman galleys.

Many alternative histories are premised on Hitler winning World War II, or the Confederacy triumphing in the American Civil War, or the Spanish Armada conquering England. History would have taken another pathway. New technologies still would have been invented, but they would have followed different lines.

From the design perspective, an alternate history premise offers a lot of scope for invention. A good beginning point is to fill a few pages of a sketchbook with drawings of the culture you're starting with. Get a good understanding first of the actual costumes, weapons, vehicles, and architecture, noting their characteristic colors and symbols. Then you can extrapolate those features into hypothetical technologies. Be sure to consider what enemies they would be facing or what the dictates of fashion might be.

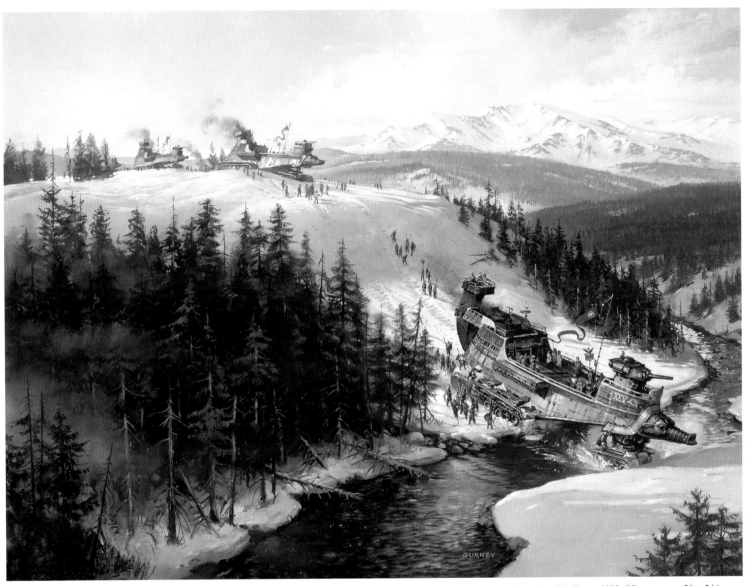

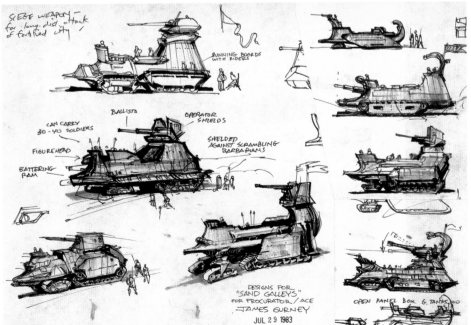

Above: *Land Galleons*, 1983. Oil on canvas, 20 × 24 in. Paperback cover for *Procurator* by Kirk Mitchell.

Left: Sketches of land galleons, 1983. Pen and markers, 8½ × 12 in.

Opposite: *Roman Biplane,* 1988. Oil on canvas, detail. Paperback cover for *Cry Republic* by Kirk Mitchell.

A LIVED-IN FUTURE

If you're painting a scene set in the future, it helps to consider the period of time leading up to it. Some of the vehicles and buildings might be brand new, but others might be holdovers from an earlier period in your world's history. Surviving elements from earlier times might show wear and tear, or they might reveal changes in the culture or even the government of your imaginary universe.

Early science fiction paintings, TV shows, and movies often showed a world where everything was in neat, new condition and with a uniform style. But in real life we're surrounded not only by the latest technology but also by antiques and out-of-date equipment that we keep using. Adding this sensibility can make your science fiction art much more believable.

The painting opposite shows a maintenance hangar for Skysweepers, flying vehicles that scour the grime off the clear dome that covers a city. The logo on the vehicle in front shows that the SOLAR company has the municipal contract, but its fleet is dented and rusty, with black tape holding on one of the

headlights. The shop is a mess of leaking oil. Mechanics are drinking on the job, and they've brought their dogs to work.

You can give your future a lived-in look by adding signs of decay: rust, dents, skid marks, potholes, chipped paint, broken glass, dead bugs, bent corners, peeling labels, faded lettering, graffiti, litter, trash, and weeds. In both digital and painted renderings, surfaces usually come out looking pristine and new, so adding these qualities takes deliberate effort.

But your world doesn't have to look decrepit or dystopian. You might show a city that had once been ruled by an authoritarian central government that is now in the hands of a vibrant local

economy; think of Le Corbusier's severe worker houses taken over by people who love flowers in window boxes. Or you might have a low-tech society reusing the parts of abandoned spacecraft for animal-drawn vehicles.

Another design strategy is retrofitting, modifying existing technology with updated elements, usually to adapt the system for modern uses, such as putting an outboard motor on a rowboat.

Remember that for most of the history of design, people have used decorative elements to evoke a civilization's past glories. This explains hood ornaments, ship figureheads, and the Venetian *bucentaur*.

Above: Buick Special, 1984. Pencil, watercolor and marker, 6 × 13 in. *Top: Fritz with Rust*, 1998. Markers, 2½ × 3½ in. *Right: Skysweepers*, 1982. Gouache and acrylic, 21 × 14½ in.

136

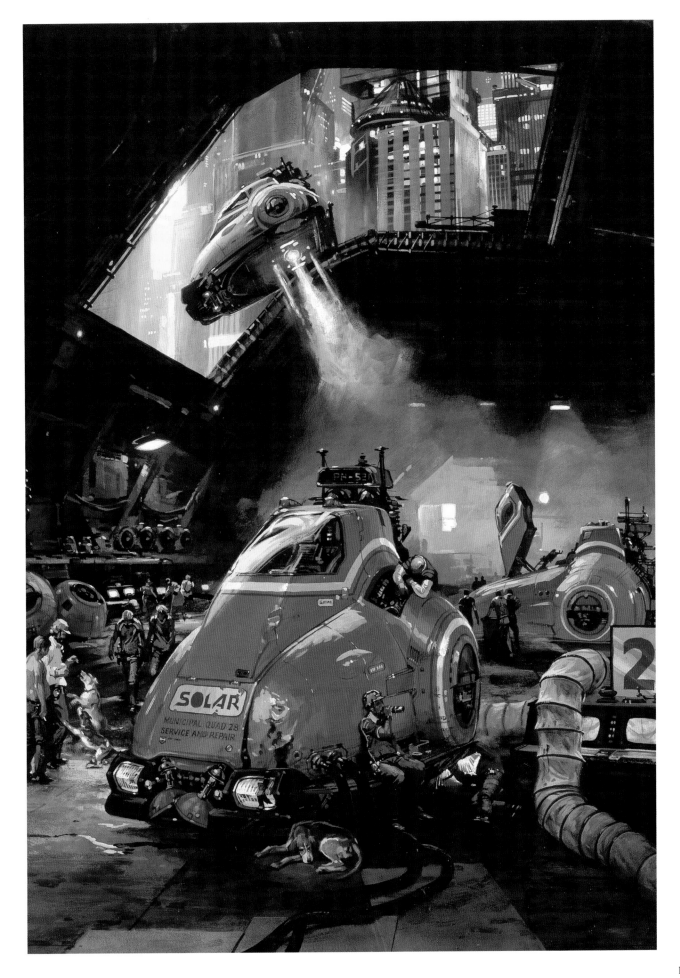

ENGINEERING

What would a Dinotopian fire engine look like? My own knowledge of engineering is fairly limited, so as a result my designs were not very practical. After brainstorming with a professional fire engine designer, I had a much clearer idea of how to solve the problems.

Below Left: Quest with Ernesto, 2006. Digital photo.

Below Center: Fire engine sketch, 1991. Marker, 6 × 6 in.

Below Right: *Fire Armor*, art by Ernesto Bradford, 2006. Pencil and pen, 11 × 8½ in.

Bottom: Photo of Ernesto with detail of final painting, 2006.

While I was busy on a new Dinotopia book, my friend Ernesto Bradford asked me about how Dinotopians would fight a fire. Ernesto is the senior product specialist for a firm that designs and builds modern fire engines. Here he is beside the brand new "Quest" model, which he helped create. I told Ernesto that I had done a little marker sketch a while ago. I dug it out of a file folder and showed it to him. He looked at it very carefully and rubbed his chin.

"Very nice," he said politely, "but it would never work."

When I asked him to explain, here were some of the things he pointed out about the sketch (above center):

• The extended ladder was unsecured and would toss the firefighter off the top whenever the dinosaur moved its head.

• The volume of water inside the hose at that height would weigh several hundred pounds. When it was spraying, it would be impossible to control. With such long hoses, there would be pressure losses.

• The dinosaur needs a breathing apparatus so he doesn't suffocate from smoke, and he needs some heat protection on the front of his neck.

• The pump is unnecessarily complicated and prone to failure. It doesn't take advantage of the strength of the dinosaur. Why not have the dinosaur use its front legs to pump the water?

Ernesto then offered to sketch up some ideas. His drawing (above, right) benefits from both his drawing ability and his knowledge of materials and physics. In this sketch he came up with the idea of the brachiosaur pumping the water. The heavy hose is supported on the dinosaur armor.

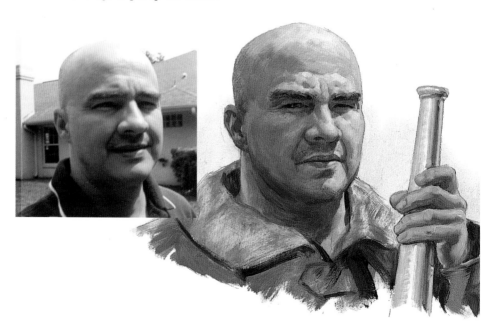

The helmet of the dinosaur has a swivel mount for the water cannon. It also has a breathing filter, so the dinosaur doesn't choke from smoke.

He suggested a modular cab designed to fit on the back of the dinosaur, which would carry up to eight firefighters to the scene. To get from the concept drawings to something that looks three-dimensional, I had to quickly build a model. That way, I could light it to see where the shadows go.

For the modular cab, I used a piece of old mat board and hot glue. The warm light from the right suggests a fire is happening nearby. At right is the painting of the cab with riders. I put lots of hand grips around the cab because of the amount of swinging that would happen on the way to the fire.

For the closeup of the firefighter, I started with a little brachiosaur head and saddle made from polymer clay and leather. On top of that I added hoses and attachments made from modeling clay, and I used an action figure for the firefighter. Based on that model, I designed the head gear (right).

I also photographed dinosaur maquettes with various accessories to help me understand the foreshortening and the lighting. For the final painting in oil (bottom right) I changed a lot of the details, but having built a model I found it easier to imagine the real scene.

To thank my friend for his contribution to the design of the fire equipment, I asked him to pose for the fire chief. He sent some photos of himself in various poses and lightings. If you study the photo and the painting together you'll notice a lot of little adjustments to develop the character of Igneus Vinco, which means "conqueror of fire."

Upper Left: *Fire Equipment* maquettes, 2005. Mixed materials.

This Page: Details of *Fire Equipment*, 2005. Oil on board.

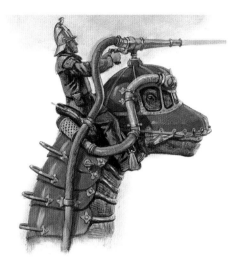

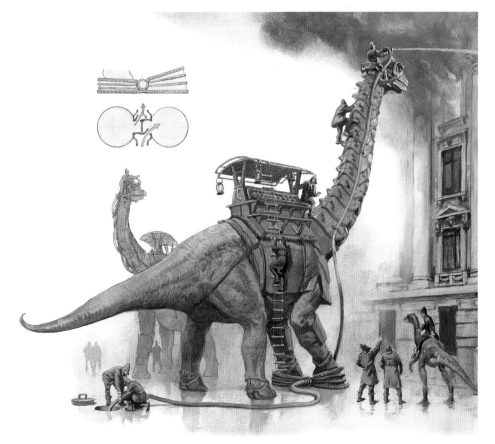

SCRAP FILE

In most fantasy or science fiction scenes, some things are completely invented, but the majority of elements—sky, land, and water, for example—are no different from what we see around us every day. You can study existing photos to help with these parts of your picture.

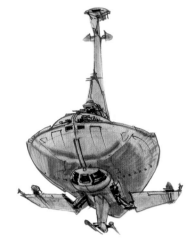

Here's a scene set in a barbaric post-plague alternate Earth, with neoviking horsemen challenging a low-flying spacecraft. This is an imaginary scene, and I had to design the space vehicle from scratch. But the rest of the scene—sky, grass, trees, dirt, and horses—are all basically the same as we would find today. For these details, I like to turn not only to plein-air studies but also to photo scrap, which I use indirectly rather than copying it exactly.

You can get the photos from anywhere. I rescue discarded magazines from the bin at the recycling center or pick them up at yard sales. Nature magazines, old *National Geographic* magazines, and architectural magazines are all treasure troves for light, color, and surface texture. Food and home magazines often have photos with interesting color schemes that can be turned upside down and used purely for their component colors.

I flip through stacks of magazines and cut out the photos that strike me as interesting. I also include photos that I've taken myself, particularly of things such as stones and roots that are hard to find in magazine photos. I also have some individual drawings of zoo animals and other special subjects mixed in with the photos.

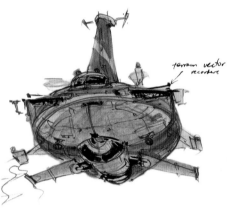

I store these images in file folders in a pair of strong filing cabinets. The labels include categories for particular forms such as animals, architecture, and vehicles but also more subjective categories such as light conditions, color schemes, atmospheric conditions, and photographic effects. The "people" category alone has fifty-four separate folders, including "Poses: pointing" and "Groupings: parades," for example. You should divide your file according to the categories that make sense to you.

Of course, you may want to use the Web to find your images. Internet-sourced images are really helpful, but consider the advantages of a traditional scrap file:

- When you do a Google or Flickr search for, say, "mountain stream," you and everyone else get the same fifty photos first, but in your own scrap file, you'll have images no one else has.

- Clipped photos are cheaper, better color, and higher resolution than images you print out from the Web or from your own digital photos.

- With printed scrap, the images will be in the same light as your painting, so you can compare the colors to your paint mixtures more accurately.

- With multiple photos, you can absorb many influences at once, taking a small influence from each one.

Above: *Homecoming* spacecraft sketches. Markers, 9 × 4 in.

Opposite: *Homecoming*, 1984. Oil, 22 × 13 in. The Frank Collection.

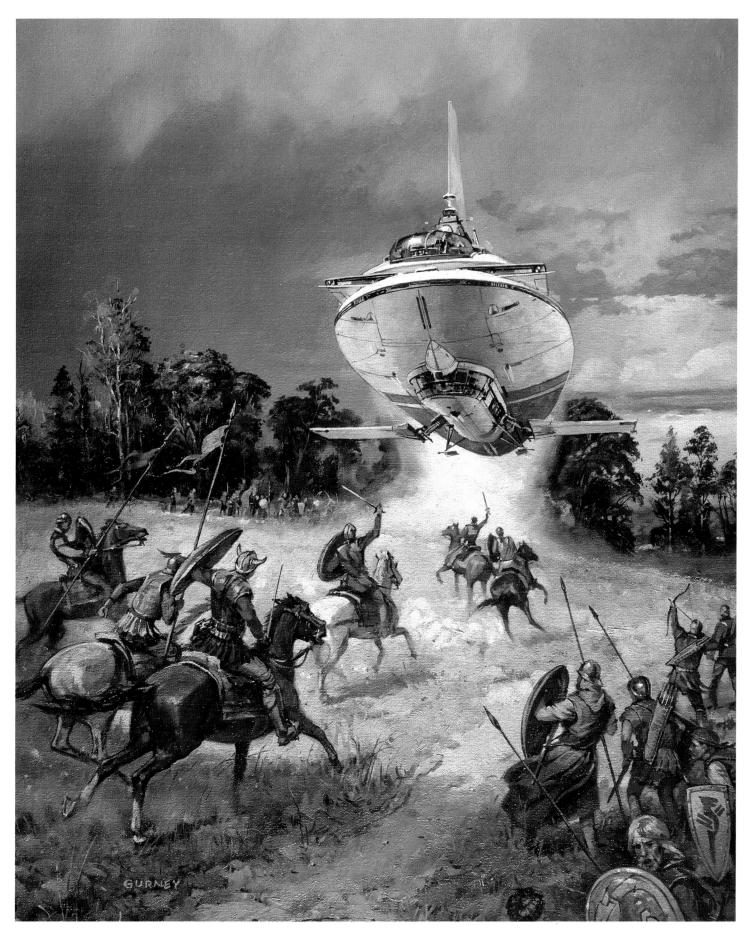

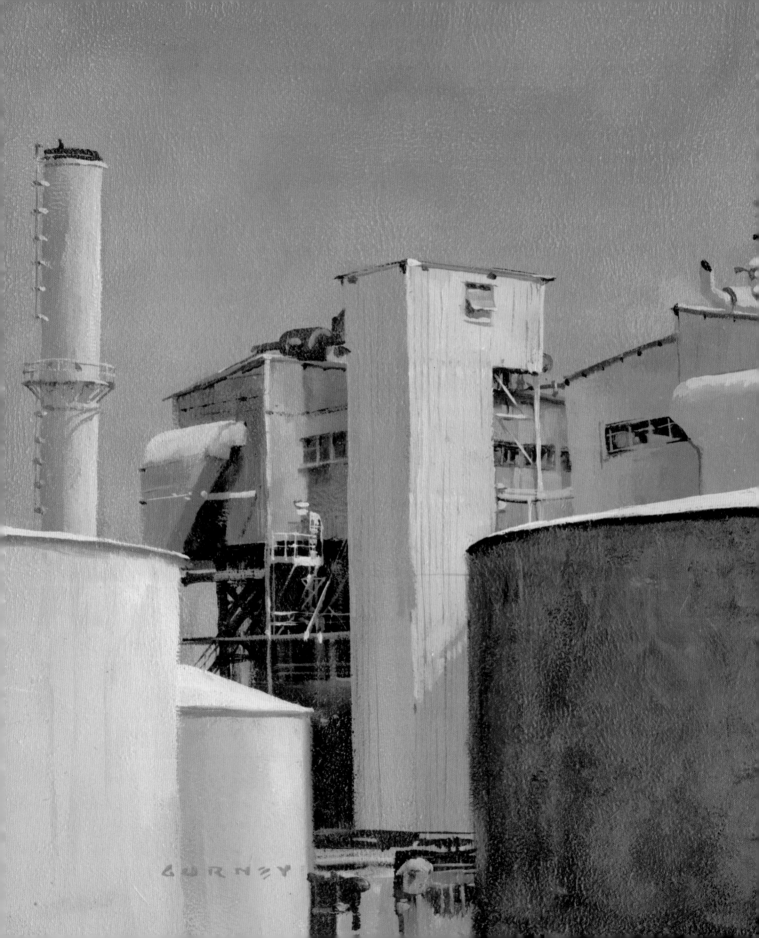

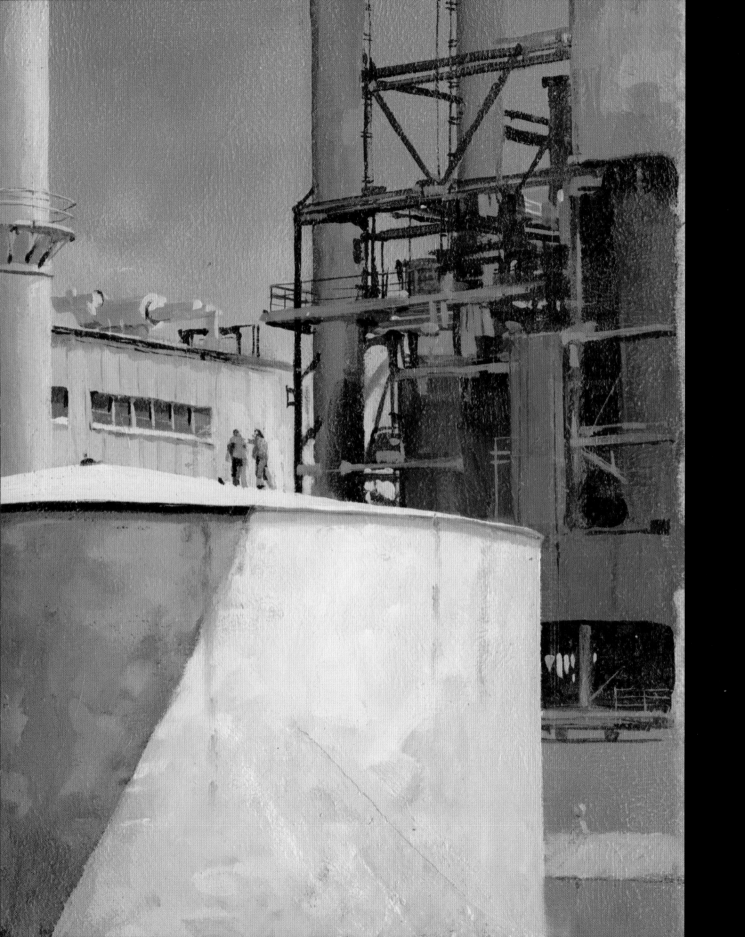

ON-LOCATION DRAWING

Your visual vocabulary gets bigger each time you sketch. It's not enough just to travel or to take photos. You really see and remember only what you've observed closely enough to draw. Your sketchbooks become a vivid record of your contact with the world and a rich source for ideas as you brainstorm imaginative pictures.

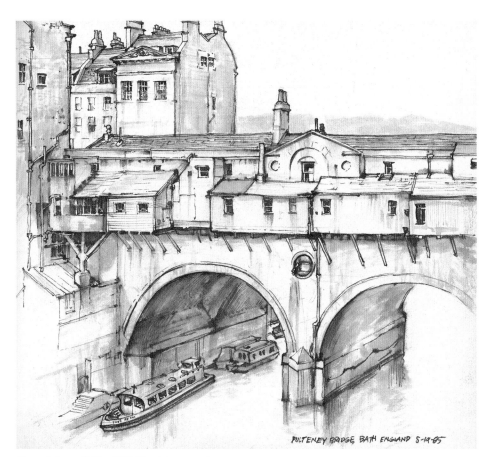

Above: Pulteney Bridge, 1985. Fountain pen and gray wash, 7 × 8 in.

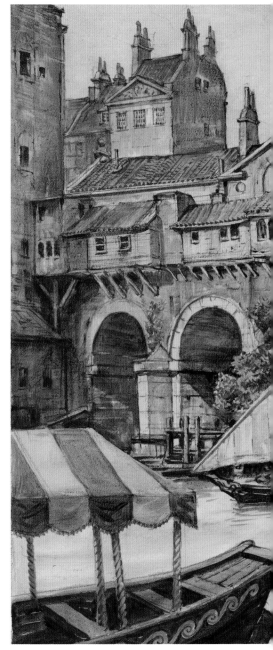

Preceding Pages: Industrial Pasadena, 1980. Oil, 10 × 16 in.

Above: Cell Tower, 2007. Fountain pen and waterbrush, 3½ × 5 in.

I never looked too hard at cell towers until I had to draw one. I was sitting in the parking lot of Benny's Coin Laundry in Geneva, Ohio waiting for my clothes to dry. Using a water brush and a fountain pen, I drew in the pharmacy, the utility poles, and the cell tower. This was the self-supporting kind, unlike the monopole or the guyed tower. A guy came out of the laundry and said, "I've lived here twenty-five years, and I've never seen an artist painting the CVS."

Another time I was sketching Pulteney Bridge in Bath, England. I had never seen a bridge like that before, with buildings built out over the top of it. As I sketched it in brown fountain pen and gray wash, I heard the sound of a brass band from far away. A parade moved closer and closer until I could see the shimmer of the tubas through the windows of the bridge.

All these impressions lodged somewhere in my imagination. When it came to inventing a bridge over a canal in Waterfall City, I remembered Pulteney Bridge and dug out my sketchbook. Of course I added vines, banners, boats, and dinosaurs, but the basic idea came from location sketching.

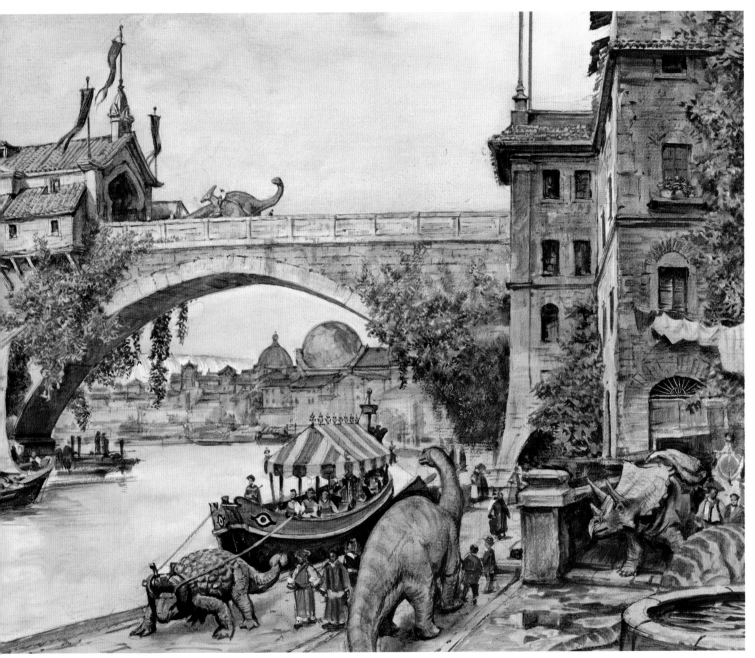

Above: *Archway Scene*, 1991. Oil on board, 12 × 18 in.

WEIRD AND WONDERFUL

Nothing that you can imagine really exceeds the wonderful and strange things that are already in the world. If you record them in your sketchbook, they'll turn up in your fantasy work.

Above: *Strange Tree*, 1998. Pencil, 7 × 8 in.

Above: *Piglets at the Fair*, 1984. Pencil, 5 × 8 in.

Below: *Caricatures*, 2005. Pencil, 2½ × 3 in.

BRUCE SAGAN

SAM Z.

I was hiking through the woods near Pine Plains, New York, when I stopped to sketch the strange tree, opposite. For the hour or so that I stood there, I wondered how the roots of the tree could be lifted up out of the ground so dramatically. Apparently, when it was a tiny sapling, the tree had rooted on a fallen log. The log eventually decomposed and disappeared, leaving the roots still surrounding the phantom form.

Like all artists, I get into habits of drawing, so that all the people I draw out of my imagination start looking the same. But with one glance through my sketchbooks I can find a galaxy of types: bearded old men, cerebral intellectuals, pouting children, glamorous women, and bored teenagers. These personalities are the raw ingredients for the character designer, regardless of whether your art is naturalistic or highly stylized.

You never know how your imagination is going to transform something from your sketchbook. I did the sketch above of a mother pig and her piglets at the county fair, and the idea of a mother nursing a lot of kids at once came up again in the painting *Glory Lane* (detail above). Notice the mother with six breasts and just as many children.

FACT INTO FANTASY

For the first century or so after plein-air painting was perfected in the late 1700s, the goal of the artist was not to create an attractive picture to sell in a gallery. The purpose was to make nature studies to bring back to the studio as reference. These studies are the seeds for future paintings, kept for the artist's personal use.

What happens when a cast shadow crosses a reflection over water? That's what I was trying to figure out in this 8 × 10 oil study of a bridge leading into Toledo, Spain (right). It was a tricky challenge of color mixing.

I was also attracted to the golden color of the stone and the way the light came from behind to illuminate the undersides of the arches.

I used the light, color, and basic composition of this plein-air study as my source for a fantasy painting of a ruined bridge (below). The main change was to add the tower covered with vines and a makeshift house. For a fantasy painting, there isn't much of a fantasy element or quality of magic to this one. It is only slightly enhanced from the real world.

Above: *Toledo Bridge*, 2002. Oil on panel, 8 × 10 in.

Left: *Ruined Bridge*, 2006. Oil on board, 12 × 18 in. Published in *Dinotopia: Journey to Chandara*.

Opposite Top: *Canal Rescue*, 2005. Oil on board, 13 × 14 in. Published in *Dinotopia: Journey to Chandara*.

Opposite Bottom: *Salamanca*, 2002. Oil on panel, 10 × 8 in.

The city of Salamanca in Spain is famous for its golden-colored stone. It's hard to capture that color in a photograph. So when I happened to be in Salamanca with a free afternoon and an oil paint kit, I did a quick study (left) to try to capture an impression of the unique architecture there, not knowing how I might use the reference in a fantasy painting.

A few years later, I propped up the sketch next to my drawing table while I painted this scene from Waterfall City in Dinotopia. The dome appears almost exactly the same, although I added some dinosaur motifs inside the pediment.

The other buildings are based on plein-air paintings from Venice. The studies from nature are immensely valuable to me because they evoke the smells and sounds of the location, and this helps me project myself into the fantasy world.

It doesn't matter whether you use oil, acrylic, watercolor, gouache, or drawing media. Keep your sketches and studies nearby in the studio and, if possible, label them or catalog them in some way so that you can refer back to them when you need to invent fantasy architecture or environments.

MUSEUMS AND ZOOS

If you live near a natural history museum or a zoo, a sketching trip can give you a wealth of reference to help you visualize extinct or imaginary creatures. If the material you're looking for is not on display in the public area, most museums will let you come behind the scenes and draw from their collection.

Jay Gould pointed out that the cave drawings show an unmistakable dark hump on the shoulder and a line running down the side, features that are not apparent from the skeleton alone.

The next thing I had to figure out was a pose, so I looked through a stack of old zoo sketches and found one of a bongo (above), painted from life at the Los Angeles Zoo. It's a different animal, but the basic pose was helpful.

When I needed to reconstruct an extinct Irish elk or *Megaloceros*, I began by studying the skeleton. The skeleton most resembles that of a fallow deer, but the antlers are gigantic, measuring as much as 12 feet across. But what about the muscles, skin, and fur, which don't fossilize?

Fortunately, the Irish elk lived in Eurasia during the Ice Age alongside humans. It must have impressed those early artists, because they sketched portraits of the creatures on cave walls.

Below is a copy of a drawing of a female Irish elk from a cave in Chauvet, France. Harvard paleontologist Stephen

CHAUVET CAVE · MEGALOCEROS

Above Left: Sketching *Irish Elk*, 2006. Photo by Jeanette Gurney.

Top: Whitetail deer skull, 10½ in. long.

Above middle: *Bongo*, 1981. Oil on panel, 6 × 8 in.

Above: Deer skull study, 1981. Pencil and white gouache, 12 × 14 in.

Left: Drawing of *Megaloceros*, 35,000 B.C.E. Colored pencil copies of artwork in Chauvet cave, France.

Above: *Irish Elk*, 2005. Oil on board, 12 × 13 in.

I also looked at studies I had done of a modern deer skull (opposite, top) and of other extinct deer skeletons (opposite, below).

The painting above shows an Irish elk resting in the mountains of Dinotopia with a human beside it. Guided by the cave drawings, I added the shoulder hump, which might have been a big clump of shaggy brown fur with a lot of muscle underneath, like that on a bison. And I guessed that the line along the flank represents a demarcation of countershading coloration, dividing the darker color of the back from the lighter belly fur.

151

ORIENTALISM

The exotic cultures of Africa and Asia have provided a wellspring for artists for several centuries. Many Orientalist paintings hover on the boundary line between reality and fantasy.

Above: *Damascus Gate*, 1987. Watercolor, 4.5 x 7 in.

Right: *Elephant Study*, 1982. Oil on panel, 6 x 4 in.

Below: *Near Jaffa Gate*, 1987. Pencil and ink wash, 5 x 5 in.

MONEY CHANGE

SEIKO

NEAR JAFFA GATE

Eastern cultures have always held a special fascination for artists from Western cultures. Orientalism grew from its roots in colonial expansion, beginning with Napoleon's expedition to Egypt in 1798. Napoleon brought with him artists such as Dominique Vivant Denon to record the details of the Egyptian ruins.

As a genre of European and American painting, Orientalism flourished throughout the nineteenth century, driven by romantic imagination and a fascination about camel treks, harem life, and colorful markets. In a time when academic painters were trying to imagine ancient Greeks and Romans, Eugène Delacroix declared he had found the "living antique" in the flesh. Before photography and tourism became widespread, art could provide a ticket to such exotic destinations, and the exploits of artist–travelers were followed avidly by the public back home.

In 1868, American landscape painter Frederic Church was one of the first artists to paint the lost city of Petra. An artist had been killed by the locals in the region not long before, and Jean-Léon Gérôme had been chased away by the Bedouins, who disapproved of graven images.

Throughout the twentieth century the lure of the East inspired filmmakers to make fantasies such as *Lost Horizon* (1937), *The Thief of Bagdad* (1940), and *The 7th Voyage of Sinbad* (1958).

Opposite: *Arabian Market*, 1983. Oil on panel, 30 × 20 in. Cover of *The Magazine of Fantasy and Science Fiction* for a story called "Five Mercies," by Mike Conner.

Following Pages: *Imperial Palace*, 2006. Oil on board, 7 × 13½ in.

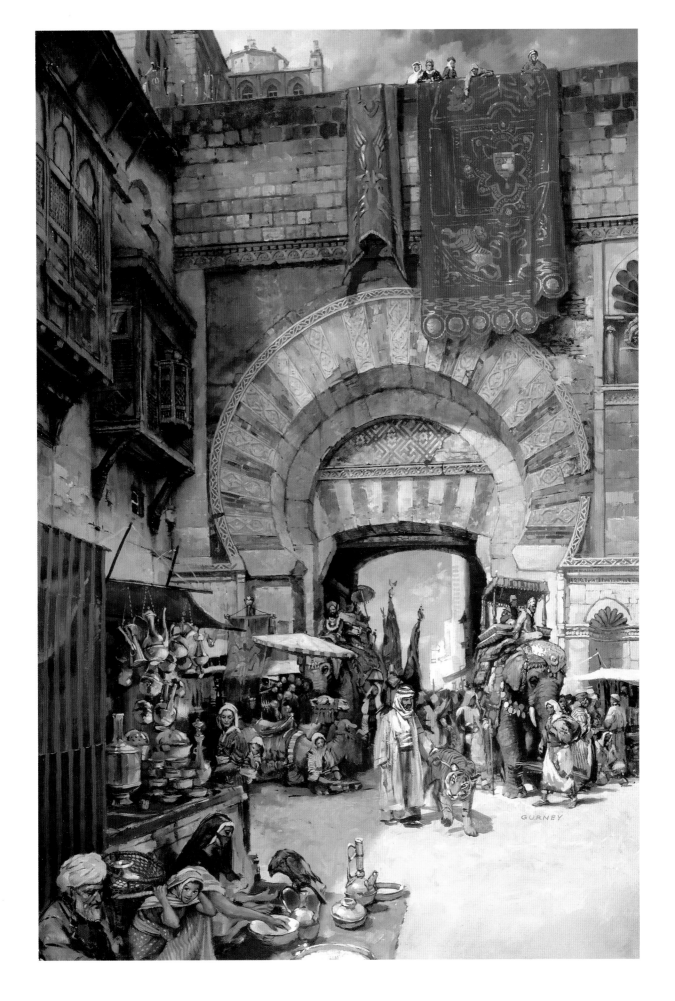

TWO VALUES

You can add both impact and photorealism to your compositions by increasing the contrast between the light values and the dark values. The tonal values are the degrees of lightness from white to black, and they're present in any painting, even one in full color. The exercises on this page are designed to encourage you to translate the complexity of a subject into just two extreme values, black and white.

Top: *Head in Black and White*. Oil on board, 12 × 9 in.

Above: *High Contrast Head*. Oil on board, 12 × 9 in.

Comic artists naturally think in black and white. Masters such as Roy Crane, Milton Caniff, and Hal Foster told epic stories with nothing else. This simplicity automatically lends power to their images.

But painters, especially oil painters, usually struggle to achieve contrast. Most paintings suffer from middle value mumbling, the tendency to paint everything in the middle of the tonal range. To cure yourself of middle value mumbling, do a sketch where everything in the light is rendered in white and everything in shadow is stated in black.

On this page, I've explored this idea in oil using fifteen-minute poses of a model at a sketch group. The model should be lit by a single strong light source, like the one shown on page 20.

For the first exercise you can use any opaque medium. The medium or technique doesn't matter as long as you use both white and black over an intermediate value. If you paint in oil, it's best to use pure titanium white and ivory black, each with its own brush, starting with the black, and then proceeding from large shapes to small.

It takes supreme determination to avoid the temptation to blend the colors into grays. Don't give in! And try not to outline everything. The viewer of your picture will not mind imagining the edges that you have to leave out.

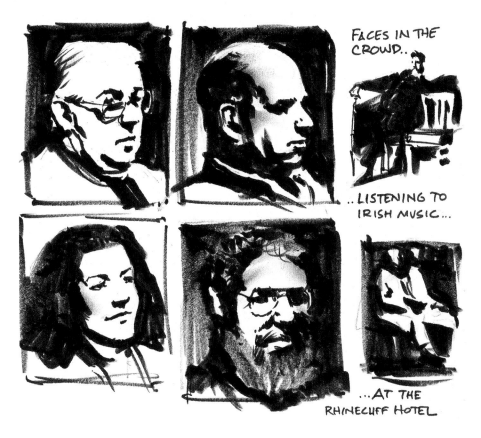

FACES IN THE CROWD..

.. LISTENING TO IRISH MUSIC...

...AT THE RHINECLIFF HOTEL

Above: Photoshop® Histogram of *Adriance*. © Adobe® Systems Inc. Used with permission.

Below: *Sketch of Adriance Library*. Pen and markers, 6 × 5 in.

If you evaluate the image below in the "Levels" window of Photoshop, the histogram looks like a wide flat valley (no middle tones) with tall peaks in the black and the white.

The quick sketches above show the faces of people in an audience listening to Irish music. They were lit by a single light bulb overhead. I used a felt-tipped brush marker with no pencil lay-in.

You can also try this idea with a subject lit by the sun. Try to ignore the actual local color. Push everything to dramatic extremes. Try not to use any lines. Define everything with shapes. For the picture of the library at right, that meant leaving off the vertical lines on the right of the columns and the horizontal lines defining the stairs.

I laid in the drawing in pencil and used a fine felt-tip pen for the small lines and a marker for the shadows. I drew it in daytime from across the street. I had a hard time deciding whether to make the sky white or black. It was also almost impossible for me to keep myself from drawing lines on the right side of the columns.

Sketches done in this way resemble early black-and-white photographs, where the limited latitude of the film resulted in strong contrasting areas of black and white with almost no middle tones.

5 MAY 2006 · ADRIANCE

SILHOUETTE

The silhouette is the outside shape of an object against a background. It helps us to immediately recognize animals, plants, or figures, and it conveys essential information about the mood and action of the pose. By carefully considering the silhouette, you can give your design more impact.

Above: Tree silhouettes. Brush and ink on paper, 8½ × 10 in.

A face in profile is a common kind of silhouette, often cut from black paper by a skilled artist.

The character Uncle Doodle (above left) is shown as he appeared fully painted. Beside him is the same figure converted to a black silhouette. The whole pose, including the face and both hands, can be understood from the silhouette alone. This kind of broad comic posing suggests pantomime stage acting from the Vaudeville era and was popular with Golden Age American illustrators, especially Maxfield Parrish and J. C. Leyendecker.

But silhouettes don't have to be seen in side view or against a white background.

All shapes have silhouettes, and vision research has shown that one of the first tasks of perception is to be able to sort out the silhouette shapes of each of the elements in the scene.

A good rule is that the most important part of the pose, often the hands or the face, should be brought into the silhouette rather than embedded inside the pose. Try to imagine the poses of your important figures converted into a silhouette. If the shape standing alone as black against white still conveys the action, it will probably translate to a fully rendered painting.

The most important part of the pose should be placed with the strongest contrast against the background. The background can be designed so that it gradates up to a bright halo behind that area, while the other parts of the silhouette can be left a bit closer in value. In the case of the artist above, painted during a sketch group, I chose to lighten the background the most behind her hand, rather than behind her head, because I thought her hand was more important. At right I contrived the shadows on the spaceship to bring the strongest light behind the pensive expression of the main figure.

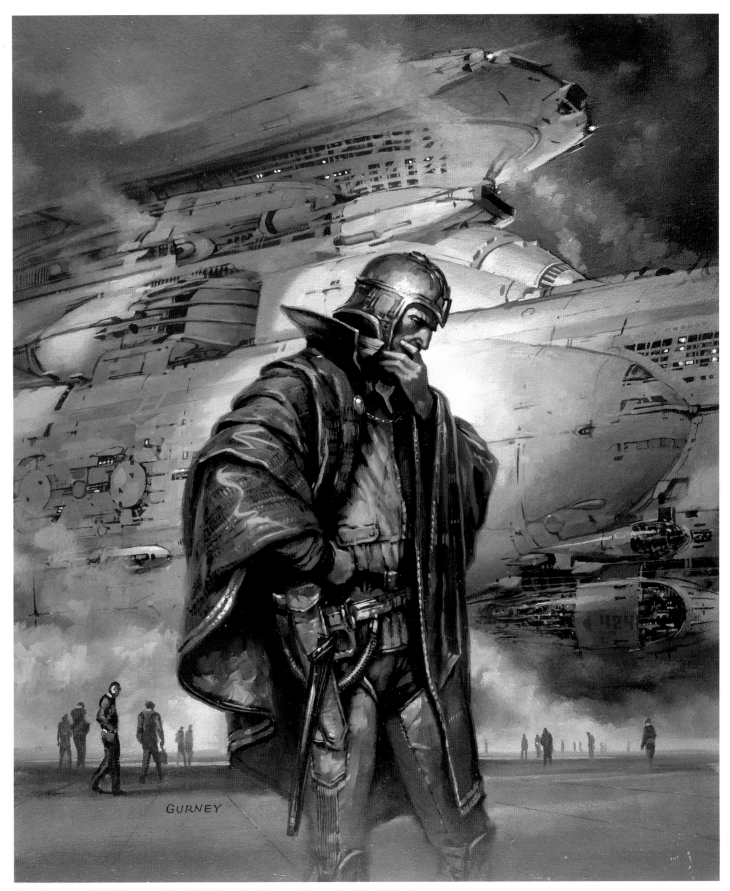

Above: *Spaceman*, 1983. Oil on panel, 24 × 16 in. Cover for *Salvage and Destroy* by Edward Llewellyn.

Opposite Left: *Uncle Doodle*. Oil on board, 11½ × 8 in. Published in *Dinotopia: The World Beneath*.

Opposite Right: *Artist*. Oil on board, 12 × 9 in.

CHIAROSCURO

The word *chiaroscuro* comes from Italian, and it literally means "light–dark." It refers to the use of bold contrasts between illuminated areas and shaded passages within a composition. It also can be used to describe the use of tonal modeling to convey three-dimensional form.

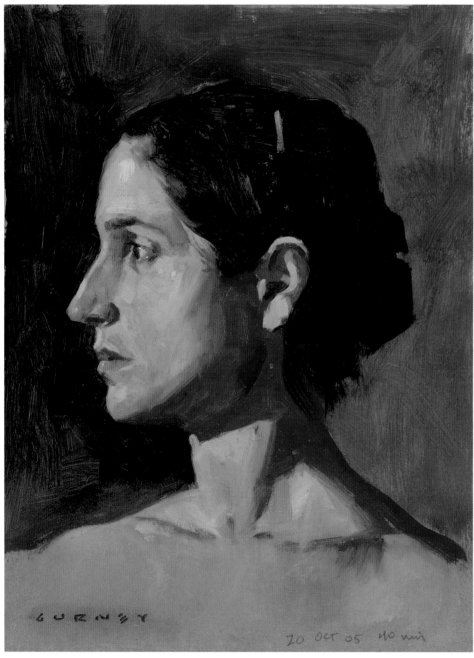

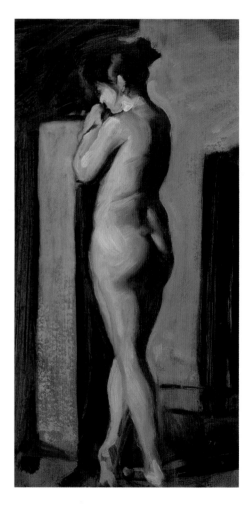

Above: *Dana*, 2005. Oil on board, 12 × 9 in.

Right: *Tonal Study*. Oil on board, 12 × 6 in.

In its broadest sense, *chiaroscuro* describes the management of light and dark tones in a picture. As an art term, it has a variety of specific meanings.

Originally it referred to a way of drawing on tone paper using white paint for the lighter areas and ink for the shadows. It also can describe a type of woodcut block printing in which separate blocks are used for different degrees of tone.

More often it describes a composition with dramatic contrasts of light and

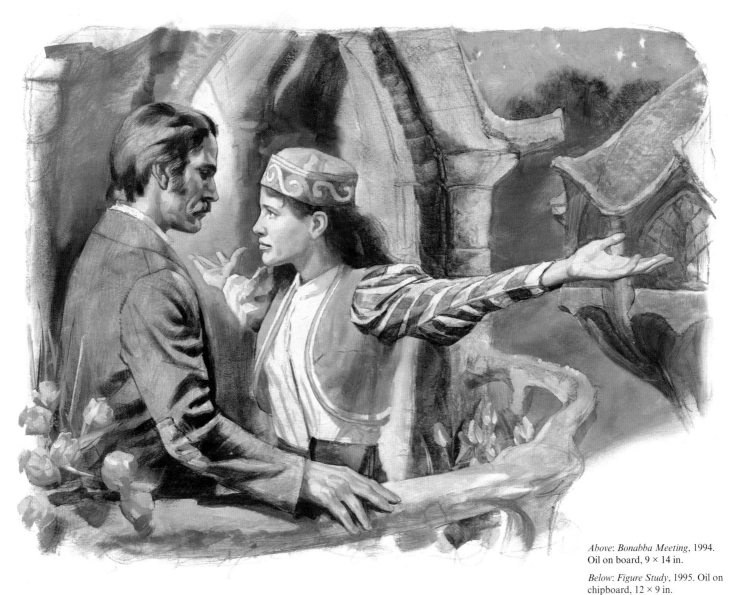

Above: *Bonabba Meeting*, 1994. Oil on board, 9 × 14 in.

Below: *Figure Study*, 1995. Oil on chipboard, 12 × 9 in.

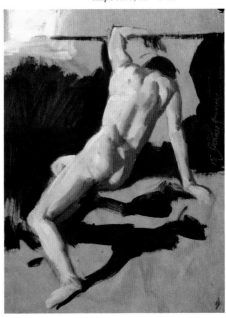

shade. The effect conveys not only verisimilitude but also psychological tension. Sometimes this way of painting is called tenebrism, especially in association with seventeenth-century followers of Caravaggio in Spain and Italy.

Note the separation of light and dark tones in the standing figure at opposite right. I downplayed transitional halftones and reflected light, trying to keep the light and shade as distinct as possible. To achieve this tonal separation with a posed figure, the model stand must be surrounded with dark cloth to suppress reflected light.

Chiaroscuro is also often associated with candlelit scenes, especially when the light source comes from within the picture and the overall effect is dark and dramatic.

In the painting above, the light comes from above and to the left. Where it shines on the man's back and the woman's profile, the background is arranged so that a dark shape accentuates the contrast. On the shadow side of all the figures, lighter shapes bring out the opposite arrangement.

SHAPEWELDING

By linking adjacent shapes of similar value or color you can create larger shape units, thus simplifying the composition.

If you want to make your composition memorable, make it simple. Simple shapes are easy to recognize and remember. Busy pictures with lots of little separate shapes have less impact.

Achieving simplicity doesn't always mean restricting yourself to just a few minimal forms, like one apple against a blank background. You can have plenty of elements or figures and still have an uncluttered picture. The trick is to arrange the elements so that adjacent tonal shapes fuse together into larger abstract patterns.

According to Charles DeFeo, Howard Pyle used to say, "Put your white against white, middle tones against grays, black against black, then black and white where you want your center of interest. This sounds simple, but is difficult to do."

You can unify shapes by losing them in an enveloping cloud of shadow, such as the figure at right, whose dark coat blends into the dark of the doorway. On the figure of Mark Twain, opposite on

right, I shapewelded the light tones on his shoulder to the sky behind and the dark tones of his leg to the cast shadow.

Leonardo da Vinci wrote in his notebooks, "Take care that the shadows and lights be fused in one another, without hard edges or lines. Just as smoke loses itself in aether so must your lights and shadows pass from one to the other without apparent separation."

Opposite Left: *Jeanette Reading*, 2000. Pencil, 5 × 4 in.

Opposite Right: *Lee Crabb in Doorway*, 1993. Oil on board, 12 × 6 in.

Above: *Time Travelers*, 1987. Oil on panel, 22 × 13½ in. Cover for *Never the Twain* by Kirk Mitchell.

COUNTERCHANGE

Counterchange is the reversal of tonal relationships between a form and its background that occurs from one end of the form to another. It's a useful way to generate a feeling of tonal movement.

I exaggerated the effect of counterchange when I painted the view of Segovia at left. Clouds were passing over the scene, throwing sections of the city in and out of shadow. I tried to capture the moment when the top of the tower fell into shadow, while the middle section remained in light. I then adjusted the sky tones lighter or darker to bring out the contrast.

Left: Segovia, 2002. Oil on panel, 10 × 8 in.

Below: *Attack on a Convoy*, 1994. Oil on board, 14 × 29 in. Published in *Dinotopia: The World Beneath*.

Right and Below: Attack on a Convoy Thumbnail Studies,1994. Pen and pencil, 1½ × 3¾ in. and 4 × 9 in.

In the painting below, the rearing dinosaur is fully illuminated on the center of his body, and the light level drops off gradually as you approach the rider on his neck. The sky meanwhile is undergoing an opposite transition from dark at left to light at right.

Counterchange doesn't always have to be a complete reversal of tones. You can also get a striking effect by switching from a dark-against-light relationship in one part of the form to a light-against-light relationship in another.

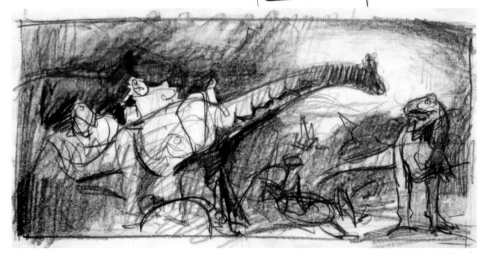

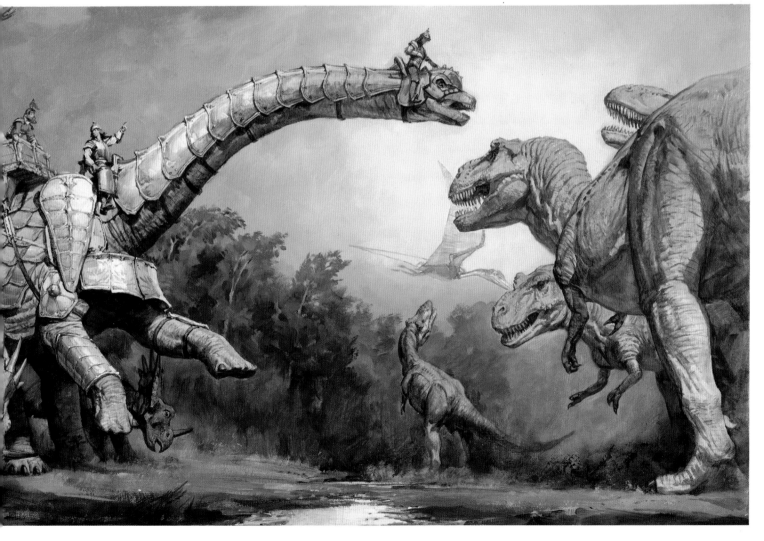

WINDMILL PRINCIPLE

The windmill principle is a way of thinking about tonal arrangement that will help you integrate a form into its background. It can help you avoid the pasted-on look that happens if you don't concentrate on losing some edges and accentuating others.

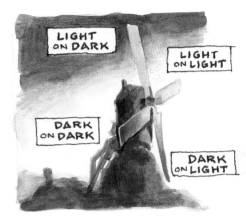

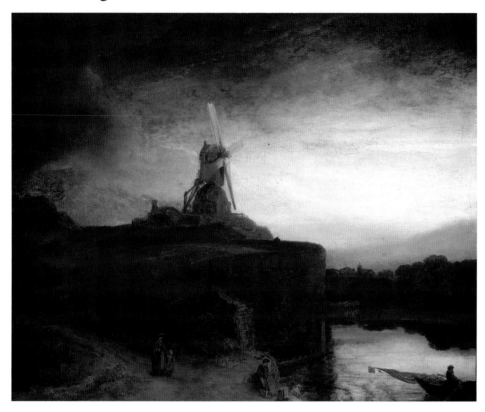

For many years I had a print of this painting by Rembrandt on my wall. I looked at it often. Something about the tonal arrangement gave me a strange feeling of satisfaction that I couldn't quite identify.

It's a simple design with a majestic feeling of fading light. But what was it about that windmill that kept grabbing my attention?

All at once it dawned on me. The vanes of the windmill have been painted with great attention to tonal relationships. The upraised vane is light against a dark sky. The one opposite it is dark against light. The other two are subordinated. The one pointing toward us is dark against dark, and the far one is light

Above: Rembrandt van Rijn, *The Mill*, 1645–1648, oil on canvas, 34½ × 41½ in. Widener Collection, Image courtesy of the Board of Trustees, National Gallery of Art, Washington.

against light. Each vane of the windmill represents one of the four possible tonal arrangements.

It's like a Bach fugue that puts the subject through every possible variation. The resulting effect marries the subject to the background in a way that both separates it and embeds it.

As I looked at paintings from the history of art, I found that the principle turns up over and over again, particularly among painters who are conscious of tonal relationships, such

as Velázquez, Zorn, and Sargent. Did they do so intentionally? Were these artists aware of what they were doing? Although we can't ask them, I believe they were all very aware of this principle, whatever they called it.

In my own experience, tonal designs such as this take conscious planning. It doesn't just happen.

In the painting below, called *The Excursion,* I wanted to be sure the dinosaur was integrated into the landscape and didn't float off the picture. The first deci-

sion was to split the background into a dark section at upper left and a light section at lower right. That way I could arrange for the head and neck to be light against dark. The tip of the tail and parts of the underside of the body are dark against light.

Next I needed to plan other areas to be light against light. I found them in the front of the left leg and the top of the canopy. Finally, the dark against dark passages appear around the right front leg and the back of the carriage.

These four tonal relationships are best planned in the pencil thumbnail stage. Your decisions will affect your choices in lighting and background treatment.

You may find that it's easier to plan the contrasting edges and that you have to force yourself to make other edges close in value so that they get lost. But the whole silhouette is not equally interesting or relevant to the story, and you might as well let parts of it disappear.

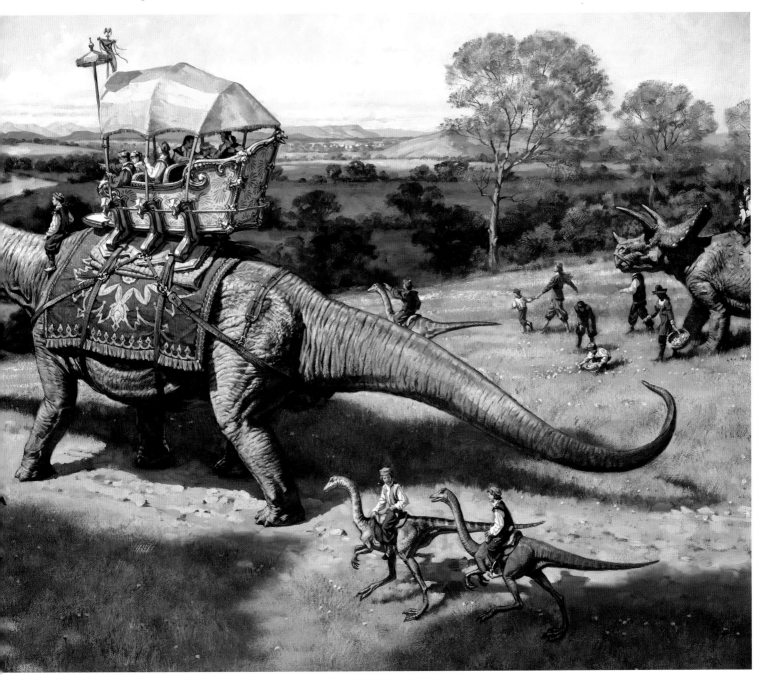

EYE TRACKING

Eye-tracking scanpath studies show how individual viewers actually explore an image. This information can be valuable for us as artists, because it allows us to test our assumptions about how the design of a picture influences the way people perceive it.

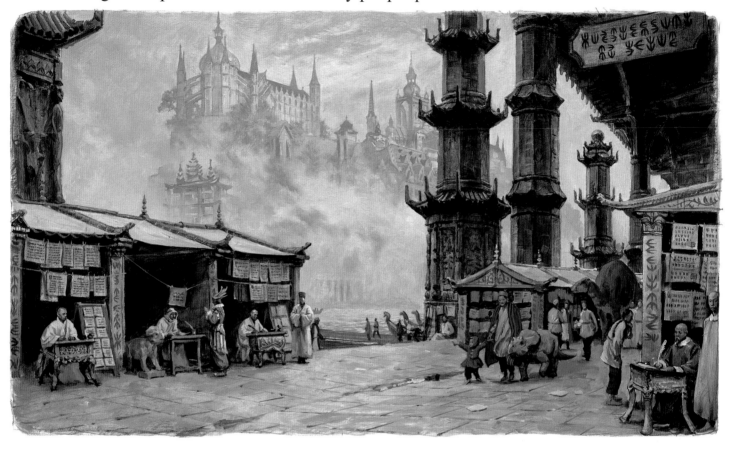

Above: *Marketplace of Ideas*, 2007. Oil on board, 12 x 18 in.

Most books on composition seem fairly sure about how people's eyes move over pictures. Henry R. Poore's influential book *Pictorial Composition* presents the notion that the eye moves in a flowing, circular way through a design. "One's vision involuntarily makes a circuit of the items presented," Poore claims, "starting at the most interesting and widening its review toward the circumference, as ring follows ring when a stone is thrown into water."

In his book *Composing Pictures*, Donald W. Graham argues that the artist "must find graphic controls so strong that they will force most of his audience to see the elements of his picture in the order he has planned."

Does the eye really move in flowing concentric circles? Is it possible to design a picture so that it forcefully controls the eye?

Scientists have developed technology to record how a viewer's gaze actually travels over a picture. Sensitive instruments track the pathway of the center of vision, or fovea. The eye movements are input into a computer, which then outputs a map called a scanpath, superimposed over the image itself.

Above are two scanpath images produced by an eye-tracking company called Eyetools. Each scanpath represents the behavior of a different individual who, with no prompting, looked at the artwork on a computer screen for a fifteen-second period. The computer recorded the path

Above: Scanpath images of *Marketplace of Ideas* from two test subjects, 2009. Courtesy Eyetools, Inc.

of the eye as circles, indicating where the eye paused momentarily, connected by a thin blue line.

The scanpath reveals that the eye darts unpredictably in straight jagged leaps known as saccades. Saccades occur between three and five times per second, alternating with brief periods of rest called fixations. The white glow around each circle represents the subject's peripheral vision. The heavier blue and orange lines are not important for the study of artwork.

The numbered black boxes are time markers, indicating the position of the eye at each passing second. The session begins at the green dot and ends at the red dot, the last point of rest before the image disappeared. By following the blue line second by second, you can precisely reconstruct the viewer's experience.

The first test subject's eye enters the composition at the top center and zigzags down to the figures at left center. This happens within the first second. In the next three seconds, it swoops to the right, leaps upward to glance at the upper right corner, and then moves across the center of the picture in large strokes, pausing briefly to look at the near and far buildings. For the remaining ten seconds, the subject's gaze slides back and forth in smaller saccades, examining the people in the scene.

According to Greg Edwards, president and CEO of Eyetools, "During the first 3 1/2 seconds, this particular person was getting the lay of the land. How long people take to get this initial overview will depend on each picture. They're trying to understand the basic structure or the context of the picture." After that, they usually settle into finer eye movements. "If they make a big movement," he said, "they're typically searching for context. If they make a smaller movement, they're looking for detail."

The second person's scanpath both resembles and differs from the first one. The eye also makes large orienting moves initially, taking in the far vista and the full array of people below. But this scanpath shifts between large and small movements throughout the session and spends more time looking at the distant vista and the surrounding architecture.

Experiments like this force us to reject a few of our cherished dogmas about composition and picture gazing.

1. The eye does not necessarily flow in curves or circles, nor does it follow contours. It leaps from one point of interest to another.

2. Two people don't scan the same picture along the same route. But they behave according to an overall strategy that alternates between establishing context and studying detail.

3. The viewer is not a passive player continuously controlled by a composition. Each person confronts an image actively, driven by a combination of conscious and unconscious impulses, which are influenced, but not determined, by the design of the picture.

HEATMAPS

By aggregating the eye-movement data from a group of test subjects, we can learn where most people look in a given picture.

For this experiment, eye-tracking technology recorded the scanpath data of sixteen different subjects and compiled the information into these composite images, called eye-tracking heatmaps. The red and orange colors show where almost all of the subjects halted their gaze. The bluer or darker areas show where hardly anyone looked.

The image to the left shows the heatmap for the painting *Marketplace of Ideas*, which we discussed on the preceding pages. The array of red splotches reveals a concentration of interest in the figures. This interest in people, especially faces, appears to reflect a hardwired instinct to understand our fellow humans.

The heatmap for the painting *Camouflage* shows that everyone noticed the dinosaur's face. They also spotted the hidden man and the small pink dinosaur. Statistically, these three faces drew almost everyone's attention within the first five seconds.

I was surprised that the two patches of lichen on the tree above the man scored near 100 percent attention. Evidently viewers noticed these strange shapes in their peripheral vision and checked them to make sure they weren't important, or somehow a threat to the man. The sunken log and the detailed patch of leaves in the lower left drew 70 percent of the viewers, perhaps because those were likely places for other dangers to hide.

Above left: Heatmap for *Marketplace of Ideas*.
Left: Heatmap for *Camouflage*. Courtesy Eyetools, Inc.

0% 50% · 100%

But just because an element has sharp detail or strong tonal contrasts, it doesn't necessarily attract the eye. The dark branches behind the dinosaur's head drew almost no attention because they fit into the natural schema of a forest scene. Apparently the viewers developed a search strategy based on the threatening situation of a hungry dinosaur looking for a bite to eat.

The lesson to take away from these studies is that abstract elements play a role in influencing where viewers look in a picture, but the human and narrative elements are far more powerful. As Dr. Edwards puts it, "Abstract design gets trumped by human stories." The job of the artist in composing narrative pictures is to use abstract tools to reinforce the viewer's natural desire to seek out a face and a story.

Above: *Camouflage,* 2006. Oil on board, 13 x 14 in. Published in *Dinotopia: Journey to Chandara.*

SPOKEWHEELING

Lines that converge to a single point of a picture are like spokes around the hub of a wheel. They pull the eye toward the center point. Because this compositional device needs a name, let's call it spokewheeling.

For centuries, artists have used spokewheeling to attract attention to a face or an eye.

This picture shows a *Triceratops* pulling a turnip cart. The lines point to the eye of the dinosaur. The arrows on the detail below show how the two brow horns, the horizontal bar of the wagon, and the top of the dinosaur's back all converge on the eye.

Spokewheeling lines are of two types: two dimensional and three dimensional. Two-dimensional lines are in a single plane, like hands on a clock face or

Above: Wagon wheel. Photo by James Gurney.

Left and Below: *Turnip Cart*, 2006. Oil on board, 6½ × 15 in.

spokes on a wheel. Three-dimensional converging lines are the lines leading back to a vanishing point in perspective. Our eyes instinctively follow the lines of train tracks, for example, to see whether a train is coming.

At right is a character I've named

Goldsworthy Marlinspike. There are a lot of lines converging on his left eye. The lines come from the top of the window, the telescope, both of his arms, and the top of the map. As viewers of a picture like this, we'd be drawn to the face anyway, but the spokewheeling lines reinforce the point.

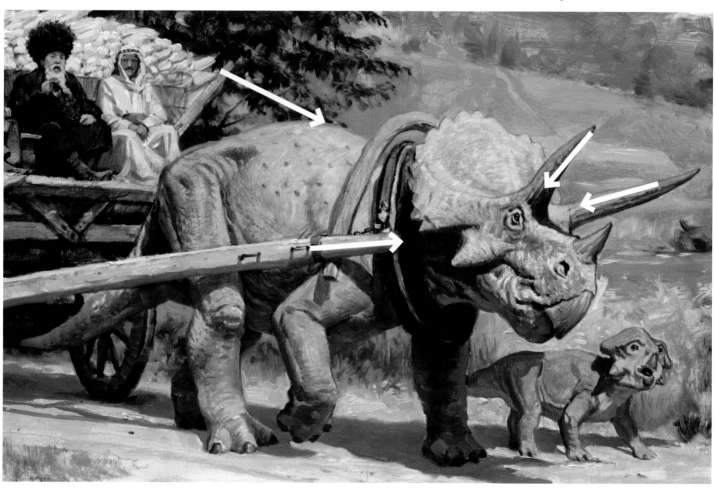

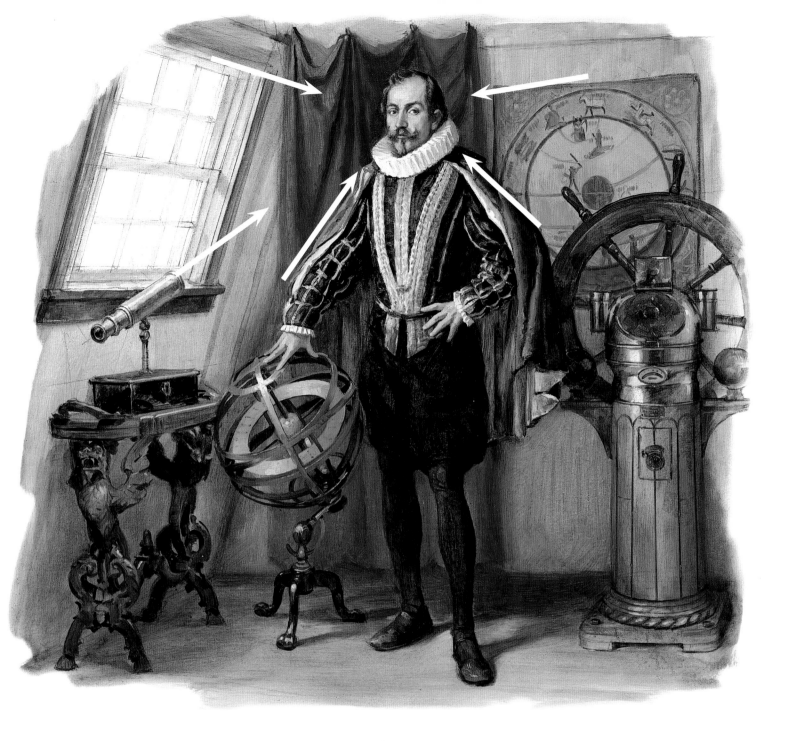

At left is a painting of a sinking ship. As the vessel sinks goes down, the young man tries to save his father. To attract attention to the young man, I arranged the elements of the scene to maximize the effect of spokewheeling, including the lines along the top of the cabin, the rope in the foreground, and both outstretched arms.

If you look at the archway scene on page 153, both the perspective lines and the cast shadow lines lead to the central figure.

It's helpful to think about spokewheeling from the very first thumbnail sketches. You can begin the charcoal comprehensive sketch with a set of light radiating lines, even if you don't know how they'll end up being used in the composition. Later, as you build the elements of the picture, you'll get ideas for other figures, props or architectural elements to coincide with your lines.

CLUSTERING

Clustering is the arrangement of a tight group of detail in one area of a composition, in contrast with large empty areas. A basic goal of any design is to create variety and interest, and a tight grouping of faces invites the viewer to look closer.

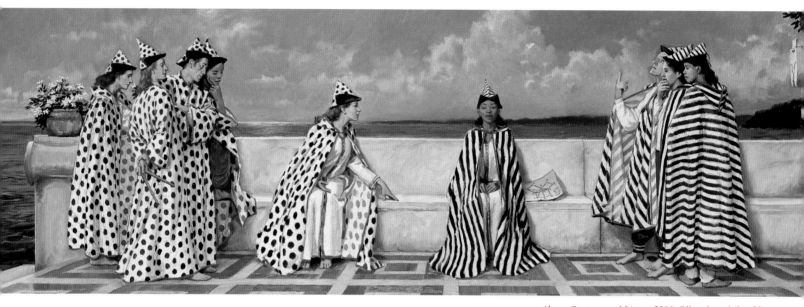

Old masters such as Velázquez practiced the principle of clustering, but it also became a favorite device of Howard Pyle and his students and contemporaries.

Below is a discarded sketch that suffers from a lack of clustering. The figures are spaced out evenly, each silhouette is separate from the others, and the heads are spaced well apart.

When the heads are clustered together as in the composition above, the eye sees them as one shape first and then goes in and sorts them out.

Clustering looks easy, but in my experience it takes conscious effort to make it happen. I have to fight the instinct to line up the toy soldiers, spread them out on the table, give everything equal importance, and define every edge in the same way.

Above: *Spotters and Liners*, 2006. Oil on board, 9 × 28 in. Published in *Dinotopia: Journey to Chandara*.

Below Left: Storyboard from *Dinotopia: Journey to Chandara*, 2002. Pencil, 3¾ × 7 in.

Below: *Spotters and Liners*, detail.

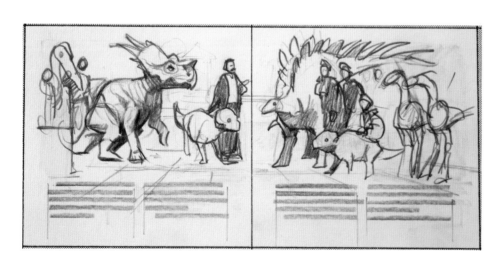

FLAGGING THE HEAD

It often helps to place a white shape behind the head of the most important character in a figural composition. This device brings the viewer's attention exactly where you want it, especially when your subject is set against a busy background.

In the oil sketch of an artist, above, I arranged my angle of view so that the artist's head and hand appeared against simple white shapes. Because our eyes usually are attracted to areas of maximum contrast, we're drawn to those areas of the figure.

In the painting of a holographic workstation at right, I was concerned that the hero would be lost in all the clutter, so I flagged his head with a slanting white table. Empty space around a face gives it a chance to breathe.

With the flagging shape in place, I felt free to fill the other areas with plenty of interesting details. I kept the background shapes somewhat abstract, suggesting information rather than delineating it. This kind of paint handling I call confetti. The idea is to place small, colorful paint strokes within your system of perspective, which tricks the eye into seeing it as more finished than it really is.

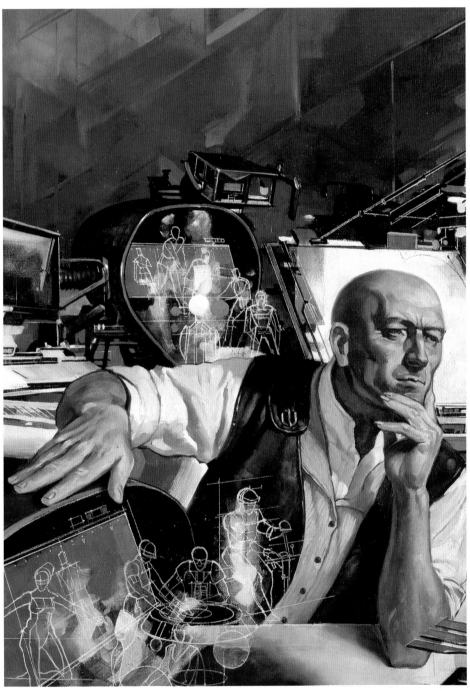

Above: *Hologram*, 1986. Oil on panel, 20½ × 13 in. Cover for *Michaelmas* by Algis Budrys.

Above Left: *San Diego Comic Con*, 1995. Oil on board, 10 × 8 in.

VIGNETTING

When you want to compose a picture on a white page, you can always place the whole scene inside a rectangular composition. But it's often more exciting to let the picture flow informally into the white of the page.

Illustrators have invented many different design strategies for vignettes or spot illustrations.

SOFT BLUR VIGNETTE

The most basic kind of vignette is the soft blur, where the full subject appears against a background that gets lighter and lighter until it melts into the white of the page. The shape of the vignette is often oval, like an old photograph.

THE TORN PAPER VIGNETTE (RIGHT)

You can give the impression of a ragged fragment torn out of a larger composition. In the painting at right, the vignette edge could have followed the silhouette of the figure. Instead the figure is shown against a warm sky. The vignette line cuts randomly through the sky, isolating the object the man is throwing.

THE FORM-LINK VIGNETTE (LEFT)

In the vignette of the conquistador Alvarado, the figure is linked to props or background elements. Together they create a larger shape.

THE REAL WHITE VIGNETTE

If you stage a scene so that part of it consists of a white material, the vignette looks natural and unforced. The white element might be a snowy field, a sandy beach, or a white bedsheet.

THE WRAPAROUND VIGNETTE (OPPOSITE TOP)

A wraparound vignette sets up the detail around the outside edge of the design, leaving the white of the page open for

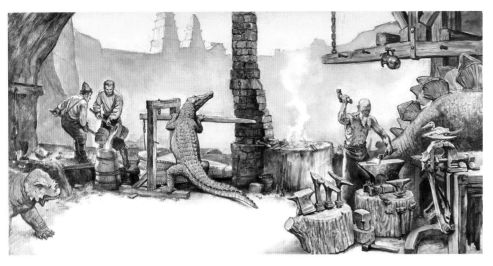

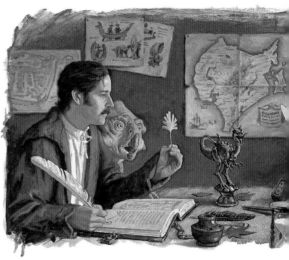

type. The blacksmith shop of Volcaneum in Dinotopia was conceived in this way, with the white space used for text.

BREAKAWAY VIGNETTE (BELOW)

In the vignette strategy below, the pterosaur pops out of the background panel. It's perfect for explosive action, but it calls attention to itself, so it should be used sparingly. This one appears in *Dinotopia: The World Beneath*.

SKETCHY EDGE VIGNETTE (TOP RIGHT)

A painting can dissolve into sketchy lines, paint strokes, or drips, as does the illustration from *Journey to Chandara,* (above right), where I wanted to draw attention to the artifice of picturemaking and to give us the feeling of an informal sketchbook page.

The vignetted montage below uses

a sketchy edge on the entire right side of the picture, blending the dark areas into a single brushy mass to suggest the smoky darkness around a campfire. The feather cloak also dissolves into soft brushstrokes. These softer areas help set up for the center of interest in the eyes and the fingers of the hand.

THE CUTBACK VIGNETTE

In this vignette strategy, the white is added last. The design shapes are painted first on a toned canvas. Then you "cut back" with white paint, allowing the priming to show between strokes. This method was made famous by J. C. Leyendecker.

FADEAWAY VIGNETTE

Golden Age illustrator Coles Phillips invented the "Fadeaway Girl," who was often vignetted in such a way that the colors of her outfit matched the background color. Phillips left off the outline so that your eye has the fun of filling in the missing boundary.

Opposite Top: *Arthur Throws the Sunstone*, 1994.
Opposite: *Alvarado*, 1986. Oil on panel, 10 × 13 in.
Top Left: *Blacksmith Shop*, 1994. Oil on board, 14 × 28 in.
Top Right: *Closing the Book*, 1994. Oil on board, 14 × 28 in.
Above Left: *Breakaway*, 1993. Oil on board, 6 × 7 in.
Above Right: *Maori*, 1987. Oil on canvas mounted to board, 12 × 9 in.

177

REPOSE AND ACTION

A painting presents itself to the viewer in its entirety, with everything visible at once. Without multiple panels or animation, you can show only a single moment. The viewer scans the composition for clues about what has just happened and what might come next. If you want to show action, consider which part of the narrative has the most suspense, what Howard Pyle called the "Supreme Moment."

To an extent, a painting can avoid showing action and can downplay the passage of time. Most of Vermeer's paintings seem to exist in a kind of eternal present. Edward Hopper's paintings often depict people waiting in an enigmatic suspense.

In a painting for a book jacket, like the one at left, I showed the main characters standing ready for action, leaving the threat for the reader to imagine. The design is stable, with all the figures fitting neatly into a triangle, the most stable shape possible.

By upsetting the balance and turning the triangle onto its head, you can energize a pose. The figure above, striding forward while carrying a lion, is now top-heavy. He can't hold that pose for very long, and he is dealing with forces that we don't normally encounter.

Most dramatic sequences build suspense toward a climax. N. C. Wyeth often chose to portray the moment right before the dramatic apex, recalling Pyle's advice that "to put figures in violent action is theatrical and not dramatic." He advocated to his students that "in deep emotion there is a certain dignity and restraint of action which is more expressive." The terror before the murder or the remorse afterward is more interesting than the act itself.

But there are times when it's effective to show what animators call the keyframe pose, a telling moment of extreme action that conveys a continuous movement. In the scene opposite, top,

Will Denison, pursued by a *T. rex,* is leaping into the saddle of his pterosaur, who has just taken off. It would have been less interesting to show him about to jump or to show him flying away safely in the saddle.

Often the Supreme Moment happens during a fateful encounter. It could be the meeting of hero and villain, prisoner and captor, or lover and betrothed. The meeting need not be a violent one, but ideally the characters should be contrasting and evenly matched. In the book cover painting at right, the poet Shelley is going down with his schooner in Lake Geneva, haunted by a vampire-like lamia. I painted the wraith in pale, bright colors and Shelley in black and white, and I used diagonals throughout the picture to suggest instability. To help draw attention to his face, I used spokewheeling with the tiller, the wraith's arms, and the lines on the back edge of the cabin.

Opposite Top: *Lion Handler*, 1983. Oil on board, 7 × 6 in.

Opposite Bottom: *Imaro*, 1983. Oil on panel, 22 × 13½ in.

Top: *Dive to the Saddle*, 1994. Oil on board, 9 × 15 in.

Above: *Shipwreck*, 1989. Oil on board, 16 × 24 in.

REPOUSSOIR

The French word *repoussoir* refers to an object placed in the foreground of a composition that enhances the illusion of distance.

The word conveys the sense of pushing, as if the foreground object helps to push back the far spaces. Repoussoir elements are often trees or poles planted in the extreme foreground of the scene. The lamppost in the painting above is close to the viewer, making the beach seem farther back by contrast.

The word repoussoir also conveys the sense of strong or vigorous color in the foreground to make the more neutral passages retire into the distance. The stop sign in the scene at right was really there, but as I painted it, I was conscious of its role in pushing back the far trees.

In a scene with a lot of figures, a standing figure can serve as a repoussoir element, especially if he or she is facing into the scene. It gives the feeling of an actor standing at the proscenium of a stage.

Top: *Playland at Dusk*, 2004. Oil on linen, 16 × 20 in.

Above: *Disappearing Snow*, 2008. Oil on panel, 10 × 8 in.

In the scene above, the dead tree overlaps the deepest part of the vista, with its branches pointing back toward the rider on the *Styracosaurus*.

Above: *Alpine Tribesman*, 2005. Oil on board, 12 × 18 in. Published in *Dinotopia: Journey to Chandara*.

CUTAWAY VIEWS

A cutaway view is a rendering that removes the outer layers of a vehicle or a building to reveal its interior structure. It gives the viewer a chance to see how something is constructed or how it works.

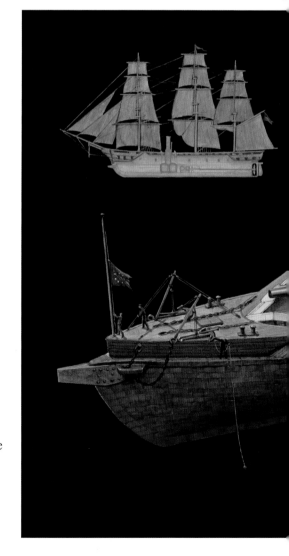

Left: *Bilgewater Cutaway*, 2005. Oil on board, 12 × 13 in.

Above: *Submersible Cutaway*, 1993. Oil on board, 9 × 14 in.

Opposite: *Windmill Details*, 2006. Oil on board, 14 × 28 in.

Sometimes an earthquake takes away the wall of a house and leaves a person's living space open for inspection. Such a situation arouses our curiosity. We want to know what goes on inside and how things fit together.

To make a cutaway view, you take an imaginary knife and remove whatever outer layers you need in order to show the key parts of the interior. Generally, the cuts follow flat planes, but they can also be jagged. The section of wall through which the cuts were made can be shown as either white or black for the sake of clarity, unless it's important to show what material it is made from.

The whole form, inside and out, can be lit with a single, consistent light source. Alternatively, the inside spaces can be lit with a different colored light than the light on the outside. Building a quick maquette can be a big help with lighting.

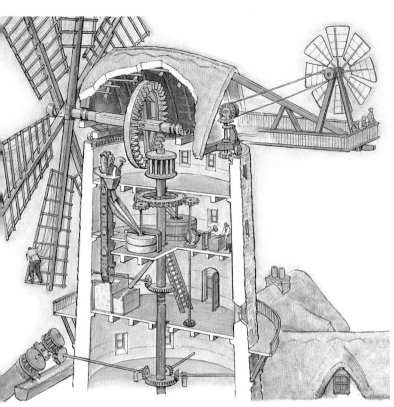

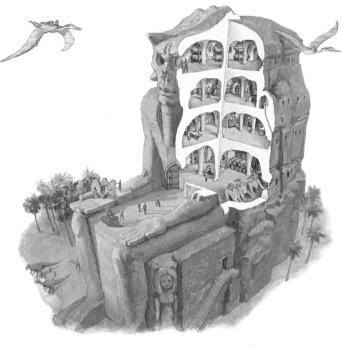

Above: *Ebulon Cutaway*, 2006. Oil on board, 12 × 13 in.

Below: *Virginia (Merrimac) and Monitor Comparison*, 2005. Oil on board. On loan to the Mariner's Museum, Newport News, Virginia.

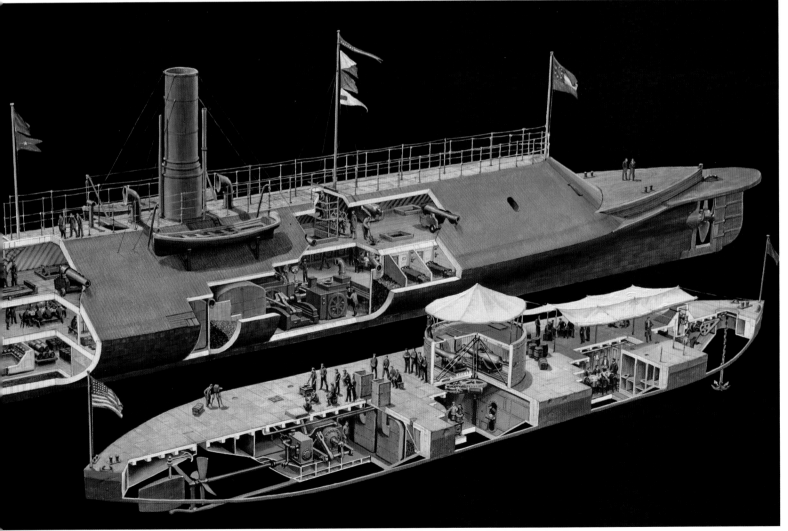

AERIAL VIEWS

Also known as a bird's-eye view, the aerial view presents the spatial relationships of buildings and streets while still showing the facades. It's a cross between a map and a landscape painting.

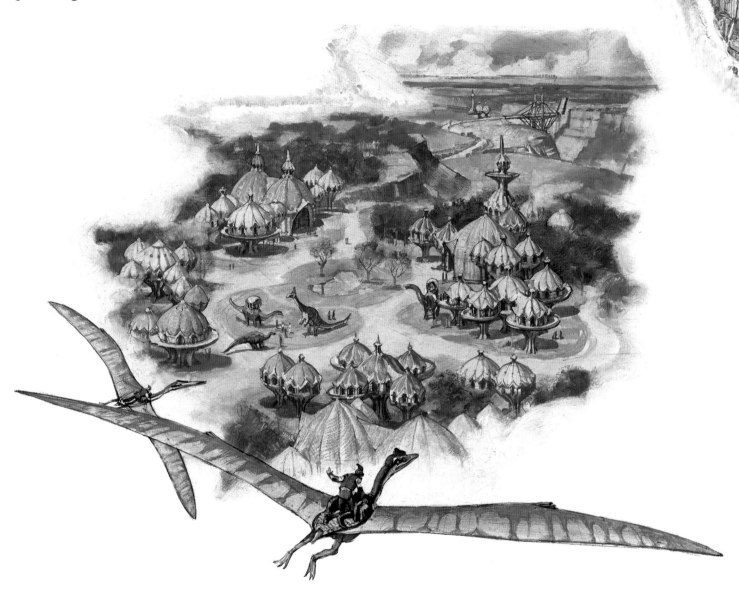

This aerial view serves as an establishing shot for a sequence in a Dinotopia book. Riders on giant pterosaurs see the whole pod village below them. I vignetted the edges of the scene with clouds to blend into the white of the page. It was important to show not only the cluster of dwellings but also the distant drawbridge, where the story continues.

The panorama of Waterfall City (opposite top) helped explain the layout of streets and canals, and by painting it, I solidified my own understanding. Drawing and painting each building didn't take as long as it might appear. It's painted in transparent oil wash over a tight pencil drawing, which is much faster than an opaque treatment.

The sketch at right is a pipe dream of a Dinotopia theme park, complete with a hatchery, sporting area, water ride, and exhibition area. In this case, the purpose of the aerial view was to present the concept to entertainment companies. Having a rendering of this kind, even a quick one, goes a long way toward making an idea seem more tangible.

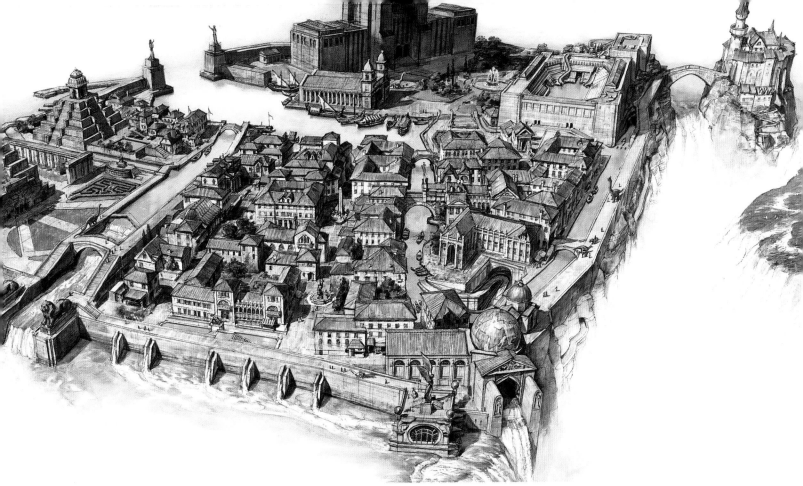

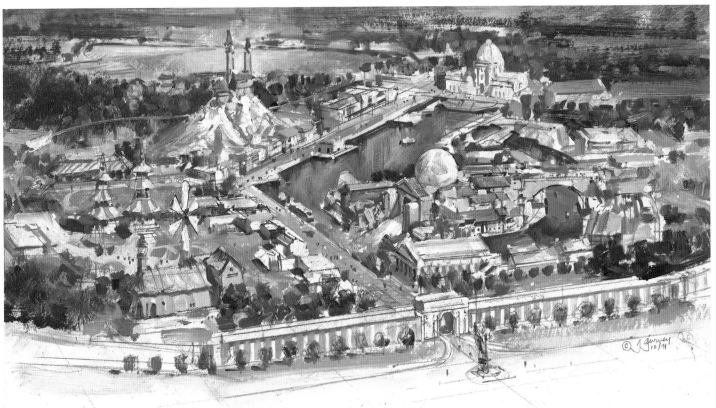

Above: *Dinotopia Theme Park Proposal*, 1991. Oil on board, 6½ × 12 in.

Top: *Waterfall City Overview*, 1994. Oil on board, 14 × 29 in.

Opposite: *Bonabba Overview*, 1994. Oil on board, 12 × 14 in.

MAPS

A map is a helpful tool if you want to make an imaginary place seem real. Maps can emphasize different things: topography, road systems, history, or settlement patterns.

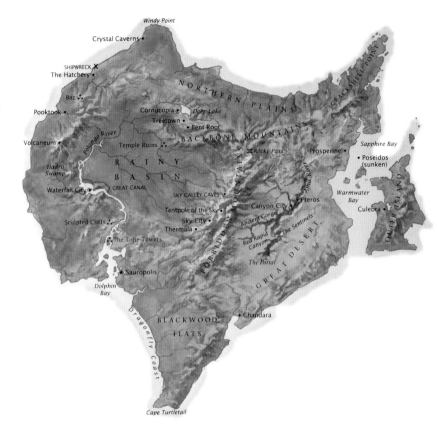

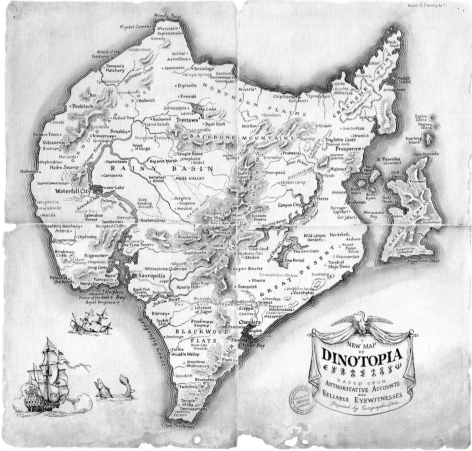

Treasure Island began with a map that Robert Louis Stevenson sketched for his nephew on a rainy day. *Dinotopia* also began with a map, although on the first map I called the island Panmundia. Once I had an idea of the overall shape and the kind of physical geography I wanted for the island, I rendered the map in oil. The mountain and canyon relief is accentuated by an imaginary light source from the upper left.

It's a good idea to add more place names than the ones you're planning to use in a given story. This gives the feeling that the world exists beyond the boundaries of what you have revealed so far. In the most recent map, left, drawn with a dip pen in a mid–nineteenth-century style, I added dozens of new town names, many of them borrowed from obscure words and names that I have been collecting over the years.

Top: Dinotopia Map, 1991, oil on board, 14 × 14 in.

Top Left: First Sketch of Dinotopia, 1989. Markers, 8 × 8 in.

Left: Antique Map, 2005. Pen and ink on board, 16 × 16 in.

The design for the city of Chandara began with a lot of quick sketches like the one above. I was interested in the ordered randomness of cities such as Paris and Amsterdam, whose street grids include broad, straight avenues and little winding side streets left over from the medieval period.

After completing the overall city map, right, I developed a building plan, which shows a closeup of one section of the city. The plan shows the foundations of each building, with the walls filled in black. Thick lines represent thick walls, columns are dots, and round towers are circles.

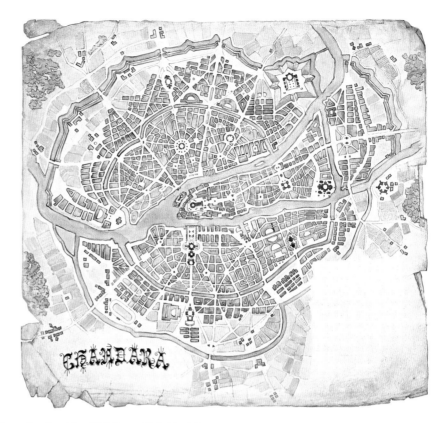

Above: *Chandara Map*, 2007. Pen and ink, 14 × 14 in.

Below: *Chandara City Map*, 2007. Pen and ink, 10 × 17 in.

Following Pages: Working on *Shiver Me Timbers*, 1987. Pencil, 6 × 9 in.

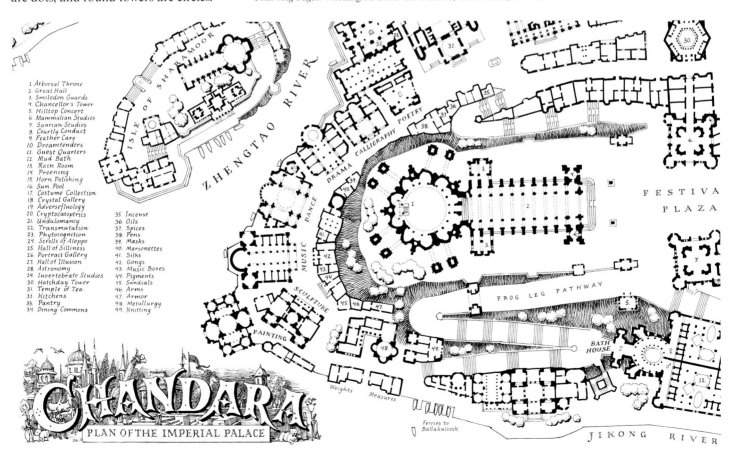

1. Arboreal Throne
2. Great Hall
3. Smilodon Guards
4. Chancellor's Tower
5. Hilltop Concert
6. Mammalian Studies
7. Saurian Studies
8. Courtly Conduct
9. Feather Care
10. Dreamtenders
11. Guest Quarters
12. Mud Bath
13. Rain Room
14. Preening
15. Horn Polishing
16. Sun Pool
17. Costume Collection
18. Crystal Gallery
19. Adversefluology
20. Cryptocatoptrics
21. Undulomancy
22. Transmutation
23. Phytocognition
24. Scrolls of Aleppo
25. Hall of Silliness
26. Portrait Gallery
27. Hall of Illusion
28. Astronomy
29. Invertebrate Studies
30. Hatchday Tower
31. Temple of Tea
32. Kitchens
33. Pantry
34. Dining Commons

35. Incense
36. Oils
37. Spices
38. Pens
39. Masks
40. Marionettes
41. Silks
42. Gongs
43. Music Boxes
44. Pigments
45. Sundials
46. Arms
47. Armor
48. Metallurgy
49. Knitting

CHANDARA
PLAN OF THE IMPERIAL PALACE

STEP BY STEP

Here are some general rules for painting procedure:

- Use the biggest brush possible for a given passage.
- Paint large shapes first, followed by small shapes.
- Save your tonal and chromatic accents until the last.
- Try to soften any edge that doesn't need to be sharp.
- Take time to get the center of interest right.

In the initial thumbnail sketch, all I knew was that there would be two figures sitting near a bright window with lots of details scattered around the margins. I wasn't sure of those details yet, and I hadn't brought in models yet.

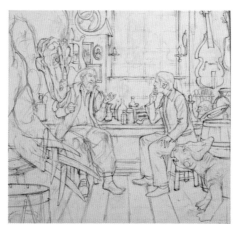

The line drawing is in pencil on illustration board. This step comes after all the time invested in research, models, props, and color sketches. The pencil drawing is sealed with acrylic matte medium before the finished paint is applied.

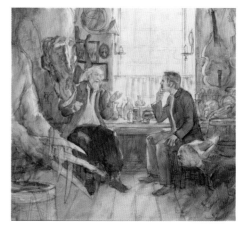

I covered the surface of the painting with a quickly stated layer of acrylic colors. This block-in or ébauche is meant to cover the surface and to begin to suggest the overall tonal design. The darkest value is no more than 60 percent, saving the punch for last.

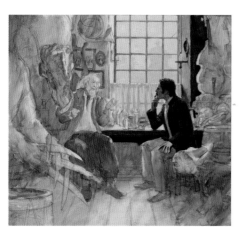

I then render the scene area by area, starting with one of the centers of interest, the face of Arthur Denison. It's a good idea to solve the most difficult parts of your picture first. Once you do, the rest of the picture will follow naturally.

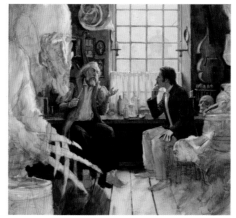

Now the heads of both principal characters are established, and I have begun to paint the details in the environment around them. In general, I try to finish background elements first before painting the foreground.

The right-hand edge of the picture and the drum at the lower left are now finished. The *Therizinosaurus,* with its 2½-foot-long claws, is the last character to paint. The whole painting took more than a week to do, from start to finish.

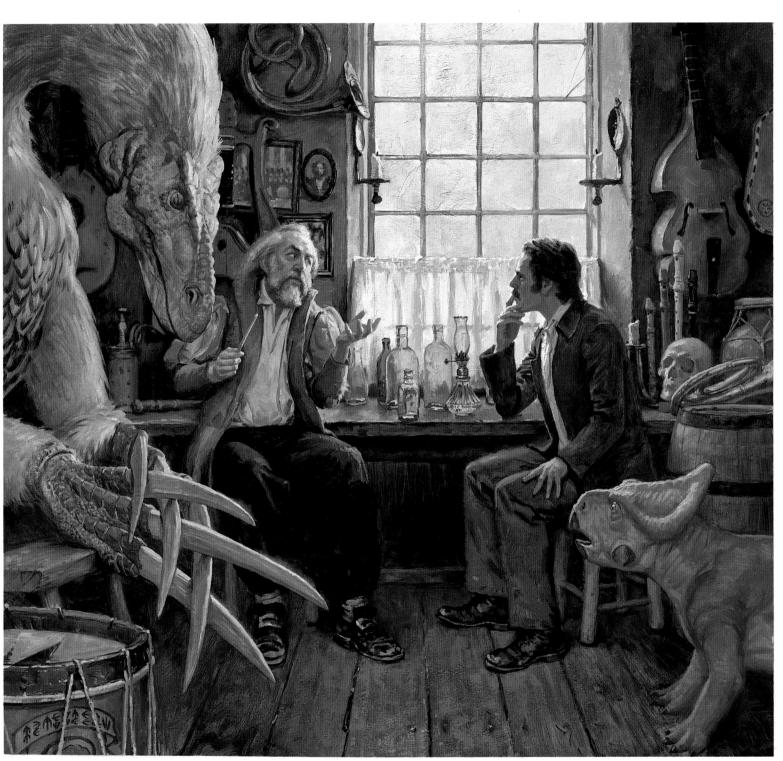

Old Conductor, 2006. Oil on board, 13 × 14 in. Published in *Dinotopia: Journey to Chandara*.

GROUNDS, MEDIUMS, AND TECHNIQUES

We all arrive at our own painting methods by trial and error until we find out how best to express our ideas. When I was starting out, I wanted to learn everything I could about how the academicians and Golden Age illustrators painted. I picked up a little here and there until I found a way that made sense for me. So give this a try if you want, but keep experimenting!

All the paintings in the Dinotopia books are done with traditional oil paints. I use an odorless turpentine to thin the paints. To improve the flow of the paint, I sometimes add an alkyd painting medium. This medium accelerates drying time, but it dries to a matte surface, which needs varnishing at the end. I use a synthetic damar replacement spray varnish for the final gloss coat after the painting has completely dried. I use kerosene in a wide-mouth jar for cleaning the brushes.

For some of the larger paintings, I use an acrylic-primed cotton canvas glued to quarter-inch birch plywood, but most of the paintings are painted on heavyweight 100 percent rag illustration board. I use three different textures: smooth, medium, and rough surface.

As discussed on page 190, I either do the drawing in graphite pencil directly on the illustration board or project a preliminary line drawing onto a gessoed canvas.

When I'm happy with the line drawing, I seal the drawing, first with spray workable fixative and then with acrylic matte medium. The latter can be applied thinly with a brush and then squeegeed off with a piece of mat board. That thin layer of acrylic medium will keep the oil paint from soaking into the board or disturbing the drawing. It's at this point

that I may pretexture the surface with acrylic modeling paste. You can see the texture next to the orange figure below.

Over that sealed pencil drawing I sometimes block in with acrylic in the first layer to save time. I then begin with thin washes of oil paint. I often cover the entire surface with a complete tone, called an imprimatura, to get rid of the white and to set the basic color mood of the scene. Sometimes I do an imprimatura in the complementary color of the final painting, which can set up a vibrancy of color.

The detail at above left shows the canvas primed with a tint of light red gesso, with the sealed pencil drawing and partial oil block-in. A good rule of oil

painting is that you can always paint in oil over acrylic but never acrylic over oil, or there will be problems with adhesion.

I then proceed with a quick ébauche. The idea is to cover the entire canvas with a preliminary layer of semitransparent oil color to quickly establish the light and dark masses. With two or three basic colors, you can establish not only the tonal design but also the basic color statement. The ébauche is usually painted with looseness, vagueness, and freedom.

I can then proceed with the final rendering, proceeding area by area, starting with the center of interest.

The nice thing about this way of painting in oil is that you can lay down the paint transparently, opaquely, or a combination of the two.

I don't usually use accelerators or fast-drying mediums, except for the alkyd medium itself. Rarely, if I'm building up a light impasto with thick paint that has to dry by the next day, I'll add a drop of cobalt drier to the supply of white paint. Because white paint insinuates itself into all the opaque mixtures, the drying agent takes action on all the paint, and the whole thing is dry to the touch within twenty-four hours.

My only general piece of advice about technique is to paint in a way that doesn't draw too much attention to the surface. It's easy to make a painting look like paint but a challenge to convince viewers that they are looking at genuine light and atmosphere.

Above: Small Wonder, 1993. Oil on board, 16 × 16 in. Published in *Dinotopia: The World Beneath*.

TEXTURE AND IMPASTO

A painting is not just an illusion of reality, it's also a physical object whose surface makes an appeal to the eye and to the sense of touch. The word *impasto* refers to the parts of a painting that are raised above the normal surface texture of the canvas.

Above is a detail of the painting *Thermala*, showing the impasto texture. The white strokes are made with thick paint at the end of the painting process, and the swirling texture around the edges was applied when the surface was primed, before the painting process really began.

The machine-made textures that come with illustration board, canvasboard, or stretched canvas can get a bit monotonous on their own.

You can create interesting textures in the priming or ground before beginning the final painting. Even if you paint thinly in oil in the final stages, it will appear to have lots of impasto. You can put a rough textural surface over the whole panel or just in the areas you want it.

I pretextured the entire board after the finished drawing was sealed with workable fixative and acrylic matte medium.

To do this, you can use a mixture of modeling paste and matte medium (both acrylic based, both fairly transparent). Brush this over the entire surface. The texture doesn't have to follow the details of the drawing very closely.

A good general rule is to build more impasto texture in the foreground areas and the light areas. Dark shadows, smooth skin, and faraway misty regions tend to look better with a smoother surface, which avoids picking up reflections and highlights. As in everything in painting, beauty results from variety, and the surface texture should not be all smooth or all textural.

Rembrandt was a master at using impasto in the light areas of the picture, such as a necklace, a collar, or a forehead. He used two devices to accentuate an area of impasto: "glazing in the pits" and "top-dragging."

Glazing in the pits means dropping pigment into the hollows, nooks, and crannies of your impastos. You can see it, opposite right, in the foreground of the painting *Market Square*. To do this, build up your impastos first with acrylic modeling paste or with oil paint mixed with a little cobalt drier to help it set up faster.

When it is completely dry, you can quickly glaze a thin layer of raw or burnt umber thinned down with turpentine. Most of it will sink naturally into the pits.

When that layer is dry, remove the remaining thin film of the umber layer from the ridges and bumps by using a smooth cotton rag with just a hint of turpentine. This will take away the glaze from the tops but leave it in the pits. But don't try either of those last steps unless the surface is bone dry.

Top-dragging is another way to bring out an impasto. Of the two rocks in the detail at opposite center, the rock on the left is an example of top-dragging. To do this, I first painted the stone a bit lower in value over a pretextured base. When that was dry, I loaded a bristle brush with thick, light paint and dragged it over the base, allowing the paint to come off on the crests of the little mountains of impastos. In a couple of quick strokes, you can achieve a random quality of rock texture without a lot of

fussy rendering. The flat rock on the right of the detail uses glazing in the pits to bring out the impasto.

Another quick method for suggesting texture involves scratching through the paint to the white board or canvas behind (below right). This technique depends on keeping the board white and not coating it with an imprimatura first. With oil, the paint stays wet long enough to scratch through with the brush handle to get light accents.

Once you have gone to the effort to bring out impasto textures in your original painting, you may want to bring them out in the reproduction as well. The way to do that is to light the artwork properly when it is being photographed. The standard way to light artwork for photography is to set up two lights directly across from each other. This arrangement tends to flatten out the ridges and bumps in the paint surface.

If the lights are placed so that they sweep directionally across the surface, they will bring out the textural surface. This more directional approach to lighting more effectively simulates the way the art would look if it were displayed on a wall beneath a skylight.

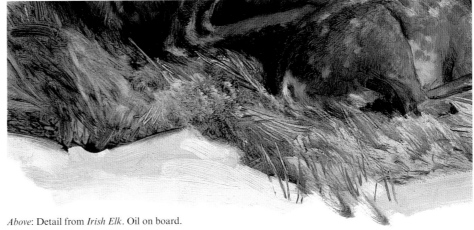

Above: Detail from *Irish Elk*. Oil on board.

Opposite: Detail from *Thermala*. Oil on board.

Top: Detail from *Market Square*. Oil on board.

Above Center: Detail from *Desert Crossing*. Oil on board. All are from *Dinotopia: Journey to Chandara*, 2007.

COMBINING THE ELEMENTS

So far in this book we've looked at all the components in the process: sketches, models, photo references, maquettes, composition, and paint technique, and we've applied them to various subjects. Here's a case study of a single painting, with a sample of the various elements that went into its making.

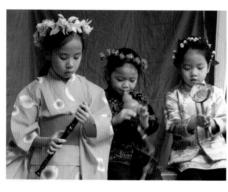

The pencil thumbnail is about two inches square, drawn without references. I had remembered seeing elephants half-sitting with a front foot raised, and I tried to capture that kind of pose to suggest that the dinosaur was enjoying the music in the garden.

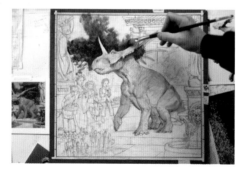

I asked some friends whether their three daughters might like to pose, and it turned out they had some authentic Chinese and Japanese costumes and musical instruments. I made the tiaras from artificial flowers. The photo session was an improvisation, with just a loose idea of poses.

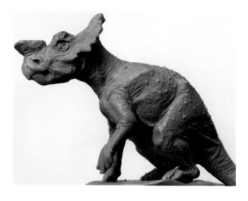

This ¹/₇₂-scale maquette by Dave Krentz is of an *Anchiceratops*, a related type of dinosaur. I also looked at maquettes of *Styracosaurus* and other ceratopsians to understand how the head and body would look from that angle and with that lighting. I photographed this maquette with a digital camera at f22 on a tripod.

Here are all the visual references spread out on my drawing table. At upper center are the photos of maquettes. At the lower left are the photos of the girls posing. In the center is a drawing I made from the original fossil skull. All around the table are scrap photos of plants, animals, and sculptural elements, which are used indirectly, mainly for colors and textures.

I taped off the edge of my board and carefully drew the whole scene in pencil, sealed it, and tinted the board a very light pinkish brown. Using a small color sketch to the left as a guide, I began blocking in the color with big brushes in a semitransparent oil ébauche to quickly establish the overall appearance of the painting.

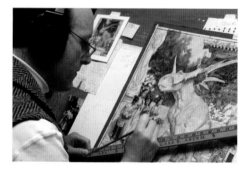

With the block-in or ébauche in place, I used smaller brushes and started painting the figures first because they are most important. For such details, I typically rest my hand on the mahl stick. As the painting progresses, I listen to music or books on tape to help me focus, but in the earlier stages I often need silence. The whole painting from posing models to final art took about fourteen days.

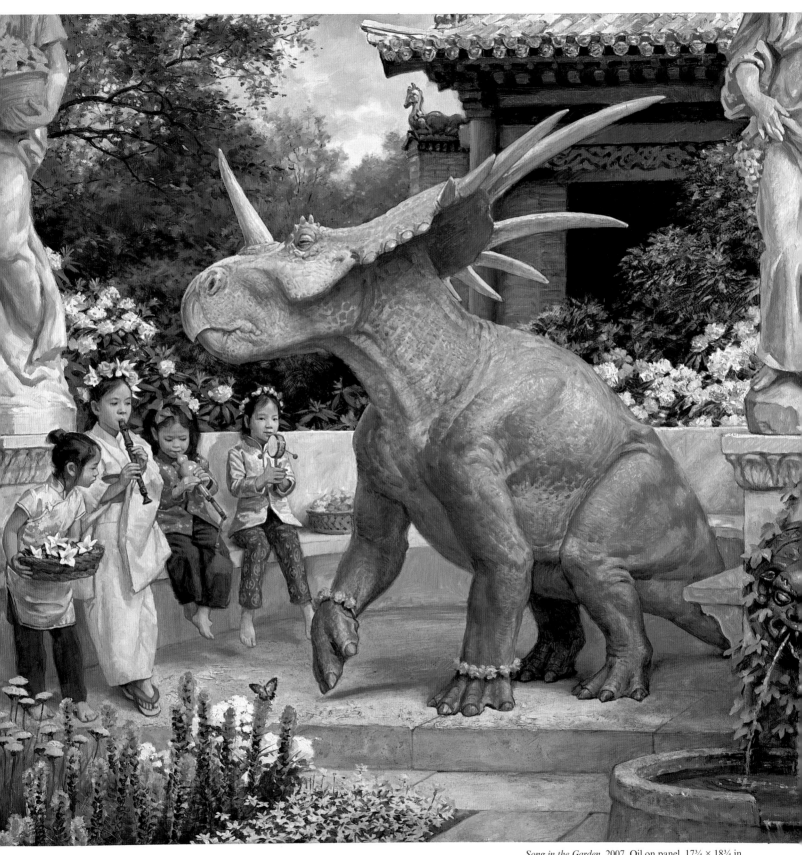

Song in the Garden, 2007. Oil on panel, 17¾ × 18¾ in.
Winner of the gold medal in the institutional category in
Spectrum 16: The Best in Contemporary Fantastic Art.

PAPERBACK COVERS

Paperback covers are one of the last vestiges of the Golden Age of illustration. Artists are given a manuscript and trusted to come up with the best image to convey the scope of the story.

If you want to paint covers for paperback novels, especially in the speculative fiction (science fiction and fantasy) genre, you will be expected to read the entire manuscript and represent the story accurately. Readers in this genre are an alert bunch, and they will notice any discrepancies from the manuscript.

Some art directors suggest a cover idea; others leave it open for you to come up with three or more color concepts, often at the size of the finished 7 × 4-inch book. Be sure to leave space for the graphics, which often take up a third or more of the composition.

This is a good field for the versatile artist who is equally at home with faces, figures, architecture, creatures, and vehicles. It's also an ideal profession for a person who likes to toil away for long hours alone. Artists usually own the copyright to their images, allowing you to use it in other ways later.

Deadlines for finished art usually are one to three months after the commission. The cover proof follows a few months after delivery of the artwork, and it is often the only thing that the salesperson has to sell the book to the trade, so your cover is pivotal to the success of the book.

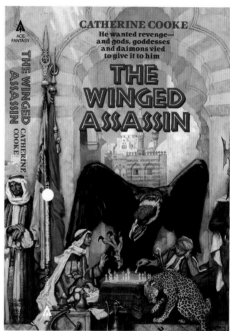

Above Left: *Winged Assassin Sketch #2*, 1986. Pastel and charcoal on tracing paper, 7 × 5 in.

Above Right: Cover proof of *The Winged Assassin* by Catherine Cooke. Graphics © 1987 Ace/Berkley Publishing.

Preceding Pages: *Spaceport Bar*, 1989. Oil on canvas mounted to panel, 18 × 24 in. Wraparound paperback cover for *Cowboy Feng's Space Bar and Grill*, by Steven Brust.

Above: Sketches for *Phaid the Gambler*, 1985. Markers, 8 × 10 in. overall.

Above: *Bird in Oriental Interior*, 1986. Oil on canvas mounted to panel, 24 × 16 in.

MOVIE DESIGN

In both live action and animated films, artists contribute on many different levels, bringing visual form to the entire project.

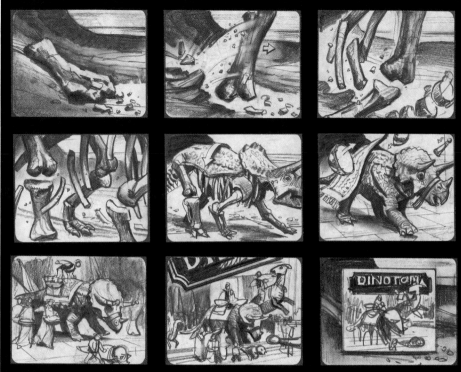

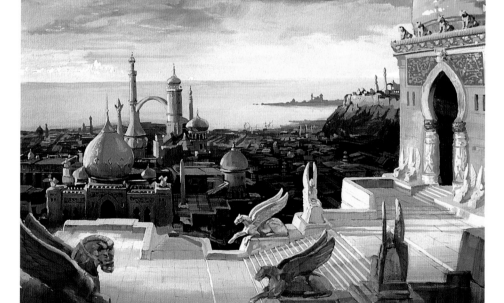

Above: *Fire and Ice Background*, 1982. Cel vinyl acrylic on board, 10 × 16 in. Establishing shot from the animated film *Fire and Ice*, directed by Ralph Bakshi and produced by Frank Frazetta. Image courtesy Ralph Bakshi Productions.

Top: *TV Spot Storyboard*, 1992. Pencil, 10 × 13 in.

STORYBOARDING

In a computer-generated or cel-animated film, every shot is planned in small sketches (see page 32), but most effects-heavy live action films are also extensively boarded. The storyboards not only help plan the cinematic art but also serve as the director's map for how all the separate elements will fit together. Many films now use animated storyboards or animatics to allow the director and the effects supervisor to see how the parts of the scene will move.

CHARACTER DESIGN

All characters in the script must be thoroughly imagined, whether they will be performed by live actors, animatronics, computer-generated models, or hand-drawn animation. If an actor has been cast, the character models are often made based on their features. Costumes and hairstyles, in all their various changes throughout a feature film, also need thorough planning.

CREATURE DESIGN

Dragons, elves, centaurs, and dinosaurs are born on the sketchpad and the graphics tablet. Specialists in this area of design usually have a good understanding of animal anatomy. Often many different sketches and renderings must be created to show the range of expressions that are needed.

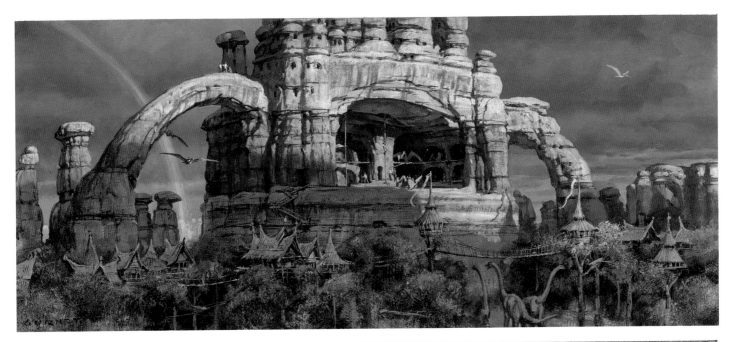

PRODUCTION DESIGN

Also called concept art or "vis dev" artwork, these images can be used early in the development process to help define the look of a film and to attract cast members or financial backers. Typically they're created digitally, which allows for adjustments and for color matching. The script is analyzed for key locations or scenarios, with an eye toward pacing and variety.

Visual development artists have staff positions with movie studios, development companies, or post-production effects houses, but some designers contribute on a freelance basis. Because films cost a lot of money to produce, initial designs usually have to be scaled back to make them affordable.

MATTE PAINTING

Once the specialty of traditional oil painters, matte painting is now entirely digital. In live action films, matte artists create photoreal settings that can be intercut with principal photography. In traditional animated films, background paintings, like the Orientalist city opposite, function as establishing shots or scenic backdrops to the animated action.

WILL DISCOVERS TRICERATOPS SKULL ACT I SEQ 2

WILL ENCOUNTERS GIGANOTOSAURUS.

Top: Skybax Academy, 1996. Oil on board, 6½ × 15 in.

Above: Movie Production Sketches, 1992. Oil on board, 3 × 6½ in each. Based on the unproduced Lynda Woolverton script for Columbia Pictures.

VIDEO GAME DESIGN

In terms of total dollars spent, the video game industry is larger than the movie business. It has generated a demand for all sorts of artists who can bring imaginary worlds to life.

Interactive companies are located all across North America and the world. Artists tend to work on staff rather than on a freelance basis because so much communication is needed between the various members of the team.

Developing the visuals for video games includes many of the same kinds of specialties required in the motion picture field. Artists are needed to design characters and costumes, creatures, vehicles, and weapons. The backstories of the characters and vehicles generally need to be developed conceptually as well, so artists and writers collaborate closely to effectively build the world.

Because the environments tend to be so complex, immersive, and interactive, they require levels of mapping and planning that aren't needed in film. Generally every element seen in the

background of a game—cars, buildings, trees, fences—must be created from scratch, using only as much detail and rendering time as is necessary for the gameplay.

Surface texture, lighting, and color must be considered as a complete artistic statement. Sometimes surface details such as skid marks, dents, and other qualities of the "lived-in future" can be introduced as the game progresses or as the result of the gameplay.

From sequence to sequence the color schemes can vary according to color scripts that are planned in early stages. As home entertainment technology evolves, there will be new forms of entertainment that blur the traditional boundaries between motion pictures and interactive entertainment, but whatever forms they take in the future, they will need artists who can translate concepts and ideas into tangible reality.

Above: *Domebacks*, 1998. Pen and markers, 2½ × 7 in.

Top: *Skimmer Dodging Traffic*, 1998. Oil on board, 12 × 19 in.

Opposite Left: *Bug Spaceships*, 1984. Markers, 5 × 4 in.

Opposite: Comp for *Nintendo Power* magazine advertising *Dinotopia: Timestone Pirates*, 2002. Oil, 11½ × 5½ in.

TOY DESIGN

Toy design is a lot of fun, but it's also a serious business, part of a global industry that hires skilled designers and illustrators. The main categories are hard toys, plush or soft toys, games, and dolls.

Toy designers are every bit as imaginative as concept artists in other fields, but they have to accept somewhat stricter parameters, given the limitations of safety regulations, durability requirements, and manufacturing realities.

Designers usually have a very clear idea of the age and gender for which the toy is intended. The large companies employ child psychology experts and commonly test prototypes with focus groups.

Many presentation renderings are made in markers or digital media to develop the look of the toys. The designs take into account the relative size or scale of the toy and the kinds of manufacturing processes. Great care is

Top: Arthur's strutter prototype, 1997. Mixed materials, 18 × 7 in. Sculpted by Hasbro Toys.

Above: Action figure prototypes, 1997. Mixed materials, 3½ in tall. Sculpted by Hasbro Toys.

Below: Dinotopia toy concepts, 1991. Marker and pastel, 6½ × 9½ in.

given to the logos and packaging, which are considered just as carefully as the products themselves.

The presentation sketches on these pages are mostly in marker with pastel and colored pencil, made in consultation with professionals at a major toy company.

Artists with skills in modelmaking and pattern drafting translate the concept drawings into handmade prototypes for presentation or play testing. These one-of-a-kind models look indistinguishable from production samples, far more finished and durable than the maquettes I would make for art reference.

BIX HAND PUPPET

Above Left: Bix puppet prototype, 1997. Mixed materials, 21 in long. Sculpted by Hasbro Toys.

Above Right: Bix puppet sketch, 1993. Pen and marker, 5½ × 9½ in.

Below Left: Dinotopia doll sketch, 1991. Markers, 9½ × 8 in.

Below Right: Sylvia doll prototype, Hasbro Toys, 1997, mixed materials, 11 in. tall.

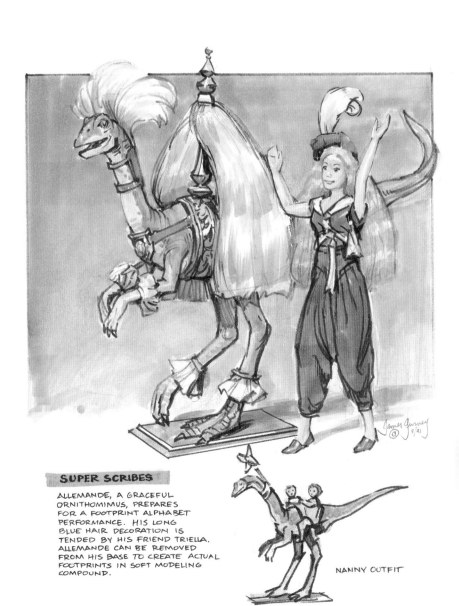

SUPER SCRIBES

ALLEMANDE, A GRACEFUL ORNITHOMIMUS, PREPARES FOR A FOOTPRINT ALPHABET PERFORMANCE. HIS LONG BLUE HAIR DECORATION IS TENDED BY HIS FRIEND TRIELLA. ALLEMANDE CAN BE REMOVED FROM HIS BASE TO CREATE ACTUAL FOOTPRINTS IN SOFT MODELING COMPOUND.

NANNY OUTFIT

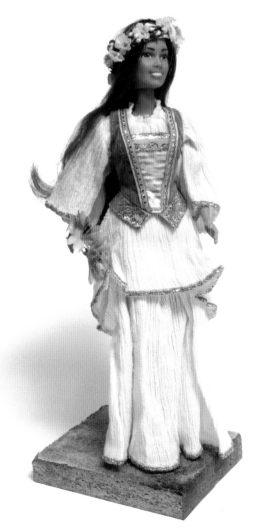

THEME PARK DESIGN

Theme park design is part of the broader field of location-based entertainment, which includes such things as hotels, casinos, and themed retail establishments.

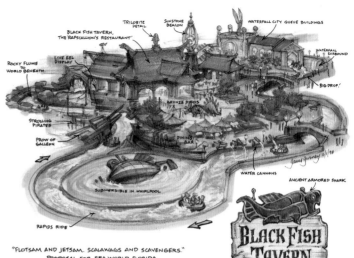

"FLOTSAM AND JETSAM. SCALAWAGS AND SCAVENGERS." PROPOSAL FOR SEA WORLD FLORIDA

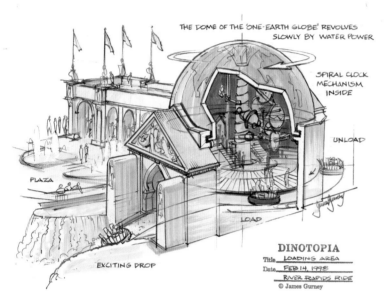

DINOTOPIA
Title: LOADING AREA
Date: FEB 14, 1998
RIVER RAPIDS RIDE
© James Gurney

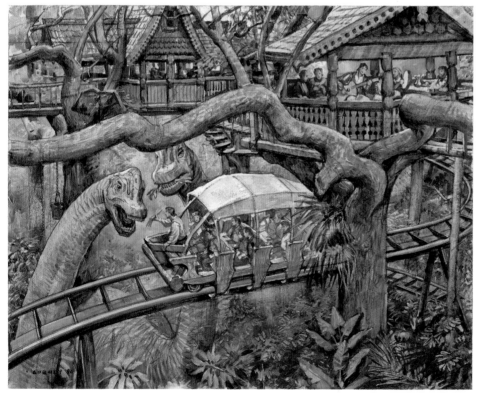

The design process for themed attractions typically begins with a site selection, budget, and a general theme. Writers and artists team up immediately, often covering a wall (called an image board or idea board) with clippings and sketches.

After the team gathers ideas and narrows the concept, blue pencil sketches and a preliminary written treatment begin to flesh out ideas for the story. Rough "mass models," similar to the maquettes you've seen in this book, help to define how people will flow through the attraction.

The sketches must reflect an awareness of many different disciplines: engineering, architecture, landscape design, crowd dynamics, set design, and most of all storytelling. It's important always to keep in mind what you hope the audience will absorb at each stage of the experience; it's easy to overload people with too much information or conflicting stories.

There are many different kinds of ride technologies, from dark rides to river rapids rides to traditional roller coasters. A reality of the business is that although sketches serve their purpose in presentation, very few of them are actually built. The sketches on this page are a few of the many sketches I did of possible Dinotopia attractions for a theme park client.

On the opposite page are presentation sketches designed for a live animal park, mixing learning with fun.

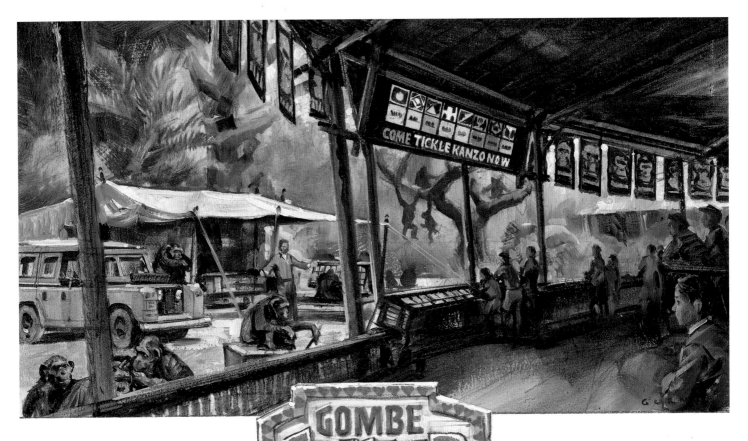

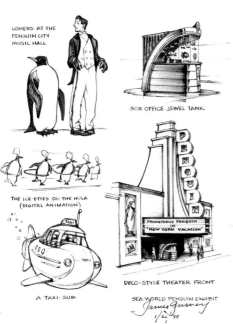

USHERS AT THE
PENGUIN CITY
MUSIC HALL

BOX OFFICE JEWEL TANK

THE ICE-ETTES DO THE HULA
(DIGITAL ANIMATION)

A TAXI-SUB

DECO-STYLE THEATER FRONT

SEA WORLD PENGUIN EXHIBIT
James Gurney
1/2/98

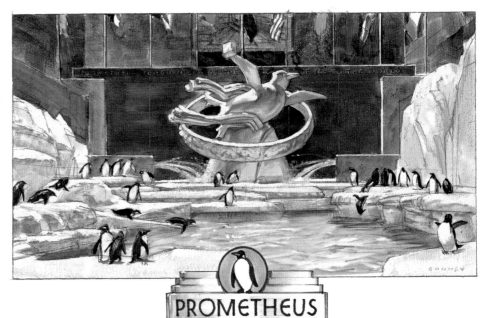

Top: *Gombe Chimp Encounter*, 1998. Oil on board,
7½ × 10 in.

Right: *Prometheus Penguin*, 1998. Oil, 7½ × 10 in.

Above: *Prometheus Penguin Details*, 1998. Markers,
11 × 8½ in.

Opposite Top: *Black Fish Tavern Rapids Ride*, 1998.
Markers, 7 × 9½ in.

Opposite Middle: *Waterfall City Rapids Ride*, 1998.
Pen and markers, 7 × 10 in.

Opposite Bottom: *Treetown Attraction*, 1996. Oil,
8 × 10 in.

AFTERWORD

I hope this book has given you all the tools you need to bring your dreams into the light. The secret to making those dreams real is to put some effort into the planning stages of picturemaking.

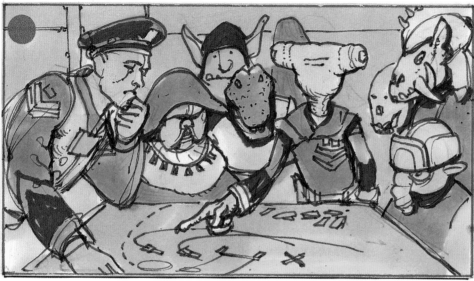

STUDY FROM COSTUMED MODEL

Making realistic pictures from the imagination is one of the most exciting areas for artists today. It has always been at the center of what artists have done through history, whether they were painting pictures of Athena and Zeus or aliens and zombies.

People in the business may complain from time to time about the changes in the art market, changes in the technology of making art, or fluctuations in the economy, but there will always be a demand for artists who can make realistic pictures of things that can't be photographed. The basic principles outlined in this book have changed very little in hundreds of years, and they won't change, even though the tools and techniques may evolve through time.

One piece of advice I'd give to a young artist today is to forget about style. A lot of art schools advocate developing a unique personal style, but I think that is absolutely backward. The artist—the young artist especially—should try to

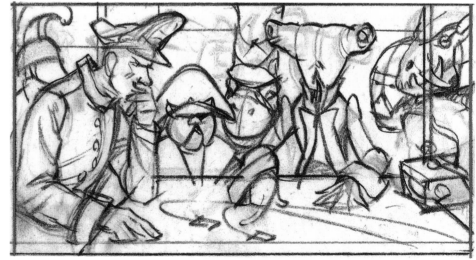

study nature as faithfully as possible and portray it with as few mannerisms and conventions as possible. Those stylistic mannerisms will make your pictures look dated in the future, and the more you can avoid them, the more timeless your work will be. As long as you look for inspiration from many different schools and eras of painting, your personal way

of painting will come naturally to you, as naturally as your way of speaking or walking.

If you want to go to an art school, choose it carefully. Make sure it teaches the fundamentals of drawing and painting. Consider the portfolios of the faculty and of the students. Don't choose a school just for its name. In the art field,

résumés don't matter, only portfolios do. Never be afraid of teaching yourself. You are the best judge of what you need to learn, and there's a wealth of good information out there.

Always try to be curious about the world around you. Think like a reporter: Take notes, keep a sketchbook, and interview people. Study more than art. Learn about history, drama, astronomy, archaeology, and music, and let it all feed your art. Art grows better in rich soil.

Whatever kind of imaginative art you do, put everything you've got into it. I have a little wooden plaque above my display rail that says "100%." It reminds me to put the full measure of effort into every painting and to avoid the temptation to do it the easy and comfortable way. The harder I have tried to reach that 100 percent goal on a given painting, the happier I've been with the results. The paintings that have gone into the gallery flambeau are the ones I tried to pull off without doing the preparations first.

Arnold Böcklin, the nineteenth-century artist who was famous for his stunning canvases of centaurs and mermaids, once said, "Nothing in art is created without effort, and the painter's ideas don't come to him on wings while he dreams, either. The one may be more talented than the other, of course; but without untiring diligence, single-mindedness and a combative spirit, there can't be any good result. All this talk about 'inspiration' is nonsense."

Anything that we imagine can be transformed, through love and effort, into a visually convincing truth. But even as we strive for verisimilitude in our imaginative pictures—building maquettes, hiring models, and studying photos—it is really the invisible quality of believability that we're ultimately trying to capture. As Harvey Dunn said, "The only thing that's true about anything is the spirit of it."

If you want your paintings to touch the heart as well as to win over the eye, you must make them real on many different levels: optically, emotionally, and spiritually. Art that lives in the memory and stands the test of time mixes earthiness with mystery, containing both a fistful of clay and a feather from an angel's wing.

Opposite Left: *Strategy Session* concept sketch, 1989. Markers, 2½ × 4 in.

Opposite: *Hammerhead*, 1989. Charcoal and chalk on tone paper, 8 × 6 in.

Opposite Bottom: *Strategy Session* line drawing. Charcoal on tracing paper, 2 × 4 in.

Below: *Strategy Session*, 1989. Oil on board, 6 × 11½ in.

GLOSSARY

alla prima (Italian): Literally "from the beginning," a method of painting in which the entire canvas is covered and finished in one session.

alternate history: A subgenre of science fiction involving speculation about an imaginary but plausible world that has developed from a given point of divergence in actual history.

analogue: A relationship between the similar features of two things, used as a basis for invention, such as a heart and a pump.

animalmorphism: Animal characters with real, organic, entertaining personalities that aren't just human surrogates.

anthropomorphism: The human tendency to imbue animals, plants, or nonliving forms with human qualities.

apophenia: The phenomenon in which meaningful patterns seem to emerge from random sets of data.

art by committee: A group sketch game in which people illustrate a written excerpt taken out of context.

art pompier (French): Literally "fireman art," used in nineteenth-century French painting as an affectionate put-down to describe a certain kind of painting that was regarded as brash, tacky, gaudy, extravagant, melodramatic, and overblown.

believability: The quality of conforming to the observer's experience or understanding of the world.

brainstorming: A method for generating ideas by exploring as many variations and combinations of a concept as possible, with an unrestrained, spontaneous, nonjudgmental mindset.

breakaway vignette: A vignette design in which one element emerges from the rectangular border.

camouflage: The use of surface patterns or colors on an object or animal to make it blend in with the surroundings, concealing it from view.

capriccio (Italian): An architectural fantasy that combines different buildings, ruins, or landscape elements into an extravagant juxtaposition.

charcoal comprehensive: A preliminary drawing on paper, usually at the same size of the final painting, that establishes the design. Also called a cartoon.

chiaroscuro (Italian): Literally "light–dark," the use of bold contrasts between illuminated areas and shaded passages within a composition; also the use of controlled modeling to convey three-dimensional form.

clustering: The arrangement of a tight group of detail in one area of a composition, in contrast with large empty areas.

color rendering index: A measure of how accurately a given light source replicates the color of a test object, compared with a natural reference source of light; the index is measured as a percentage, with 100 being the best.

color scripting: The planning of the limited range of color within each given sequence of a comic or film. The designer is concerned with the mood of each sequence and the transitions between them.

confetti: Small, colorful paint strokes that resolve into believable detail in the viewer's eye.

counterchange: The reversal of tonal relationships between a form and its background occurring from one end of the form to another.

countershading: A system of camouflage in animals in which the back is more darkly pigmented than the belly, offsetting the effects of shadowing.

croquis (French): A small copy sketch of a composition by another artist used as a way of learning.

C-stand: A tripod designed for gripping an object at a particular angle and position.

cutaway view: A rendering that removes the outer layers of a form to reveal its interior structure.

cutback vignette: A vignetted composition in which the background color is painted last in opaque strokes so that the shape of the silhouette is influenced by the positive background shapes.

cyborg: A cybernetic organism that blends natural and artificial systems.

easel: A stable base for holding a work in position for painting, usually vertical.

ébauche (French): A preliminary layer of semitransparent oil color to quickly

establish the overall chiaroscuro or color statement. Usually painted with looseness, vagueness, and freedom.

écorché (French): A figure with the skin removed, used to help with the understanding of skeletal and muscular anatomy. Also called a flayed figure.

entertainment design: Sketches or renderings created to help visualize the final look of a motion picture, video game, or other form of entertainment.

extrapolation: A form of conjecture in which a picture of something unknown is developed from what is known.

eye level: The height of the viewer's eye above the ground, usually represented by a horizontal line running across the picture, even if the horizon itself is not visible in the scene.

eyestripe: A system of camouflage in which a dark facial line or bar runs along the snout and through the eye, usually in birds and mammals and presumably in some dinosaurs.

eye tracking: A technology that records the movement of the eyes while a subject is looking at a composition.

fadeaway vignette: A vignette in which some parts of the silhouette match the background color, eliminating contours.

fantasy element: The thing or quality that takes an imaginative painting out of the realm of common experience. It might be a bizarre juxtaposition, an invented creature, or a change in the laws of physics.

fixative: A spray coating over a pencil or charcoal drawing that keeps it from smudging.

fixation: A point where the gaze of a test subject halts for at least a fraction of a second in an eye-tracking study.

fovea: The point at the center of the eye's vision.

flagging the head: The placement of a white shape behind the head of the most important character in a figural composition, usually to draw attention to the head or to separate it from a complex background.

gallery flambeau: A solar-powered device for eliminating unwanted paintings.

glazing in the pits: A paint technique that leaves pigment in the hollows of impastos.

greebles: Small surface details used to break up a large form, usually to give a sense of scale or to make an invented object more believable.

halftone: The darkest areas in the illuminated side of the form.

haloed silhouette: A gradation of tone in the background leading up to the greatest contrast behind the most important part of the silhouette.

heatmap: A compilation of eye-movement data from a group of test subjects showing what percentage of people viewed each part of the composition.

hero maquette: A maquette made with additional detail, special accessories, or posable parts that serves more than one painting or provides a standard reference for a major character.

hominin: A creature that paleoanthropologists believe is a human or a human ancestor, formerly known as a hominid.

illustration: Art that tells a story or references ideas beyond purely aesthetic content; often, but not always, art that is commissioned or intended for reproduction.

image board (also called an idea board): A wall display that explores a conceptual theme with a loose assortment of sketches, clippings, photos, and words, usually with many people contributing.

imaginative realism: A convincing portrayal of something that cannot be observed directly.

impasto: A texture made with thick paint, which raises bumps or brushstrokes above the normal surface of the ground.

imprimatura: A thin, transparent, staining color applied evenly over the entire ground to establish the basic color mood of the scene and to eliminate the glare of a white canvas.

keyframe pose: A pose occurring at an extreme position of any action, especially when the single pose hints at the entire action.

kit bashing: The use of plastic model kits as spare parts for constructing unique miniatures.

mahl stick: A rod with a padded or cork tip held in the nonpainting hand and used to steady the brush hand.

maquette: A miniature or model of a building, creature, or character constructed to explore form, lighting, or texture before proceeding to paint.

middle value mumbling: The tendency to paint everything in the middle of tonal values.

mirror ball: A sphere positioned in the light environment of the subject, used to reflect and register the surrounding light environment.

mirror studies: Drawings that an artist makes of himself or herself while posing in front of a mirror.

mise en scène (French): The placement of figures, scenery, or props on a stage or the arrangement of elements in a composition.

naturalism: Art that conveys the appearance of nature rather than appearing to be an artistic fabrication. Also, a movement in art to represent the world according to objective scientific principles.

Orientalism: A genre of art from Western cultures that evokes the East, especially the Islamic, Oriental, or Asian world of the nineteenth century, usually with favorable or romantic associations.

ornithopter: Aircraft propelled by flapping wings, as opposed to fixed-wing aircraft or helicopters.

paleoart: Art that reconstructs extinct life.

pareidolia: A specific kind of apophenia in which faces or other patterns seem to arise from random shapes.

perspective grid: A series of sloping lines marked across the picture to guide the perspective.

photodependent: The effect that comes from copying a photograph too closely.

photorealism: The resemblance of a work of art to particular qualities of photographic representation.

plein air (French): Literally "open air," art that is created outdoors, usually alla prima, and usually directly from the observation of nature.

polymer clay (or polymer modeling compound): A sculpting material made from polyvinyl chloride that remains pliable at room temperature but hardens when heated to oven temperatures. Air-dry polymer clays are also available.

première pensée (French): A small, rapidly executed sketch, usually in oil, that captures the first concept of the compositional idea.

pretexturing: Establishing the impasto surface before beginning the final painting.

Prix de Rome (French): A scholarship competition in French art, architecture, and sculpture in which the award was a sponsored trip to Rome to study the old masters.

pyramid of vision: The angle of the entire field of view that the artist chooses to represent in a picture, typically about 20 degrees, whereas the full visual field (often called the cone of vision) is normally about 60 degrees.

realism: Art whose goal is to represent the real world truthfully and objectively, based on close observation of common details and contemporary life. See also *believability, imaginative realism, naturalism, photorealism, surrealism, trompe l'oeil,* and *verisimilitude.*

reflected light: Light that bounces off of a nearby form, usually adding illumination to shadows.

repoussoir: An object placed in the extreme foreground of a composition that helps push back other elements to enhance the illusion of distance.

retrofitting: A design strategy in which existing technology is modified or overlaid with updated elements, usually to adapt the system for modern uses.

saccades: Largely involuntary jumping movements of the eyes.

scanpath: A map of the movement of the viewer's center of vision, or fovea, as it travels over a composition.

schematic maquette: A simplified reference miniature made to represent basic or characteristic geometric forms.

scrap: Photos clipped from magazines or downloaded from the Internet for use as an indirect reference in an imaginative painting; also photo reference, morgue.

sequence: A narrative unit in a work of sequential art that tells a finite portion of the story and conveys a particular mood.

sequential art: Art composed of a series of images that add up to tell a story

or convey an idea, especially comics, graphic novels, illustrated books, or storyboards; more broadly, animation and film.

shapewelding: The linkage of adjacent shapes of similar value or color to create larger tonal shapes, thus simplifying the composition.

silhouette: The flat shape or outline of a figure or object, usually filled in with a solid color, which conveys essential information about the entire form.

sketchy edge vignette: A vignette that dissolves into loose lines, giving the feeling of an informal sketchbook page.

soft blur vignette: A vignette whose outer edge gets gradually lighter until it blends into the white of the page.

soft morphology: Skin, muscle, hair, cartilage, or other perishable tissues that don't fossilize as readily as bones and teeth.

speculative fiction: The genre of imaginative writing or visual art that encompasses science fiction, fantasy, and horror.

spokewheeling: Lines of a composition that converge on the center of interest, usually a face or an eye.

steampunk: A design philosophy that blends Victorian technology, especially steam power, with science fiction.

storyboard: A series of images or illustrations, usually displayed together on a wall, to help visualize a film, website, or other sequential art form.

stroke module: The scale of brushstrokes, usually varied to give a sense of focus or a priority of detail.

surrealism: An art movement that developed in the 1920s, using illogical juxtapositions or fantastical situations to suggest dreamlike states of mind.

tableau: An artful arrangement of three-dimensional objects on a stage-like surface.

taboret: A small drawer unit, usually on wheels, that typically holds the palette, paints, brushes, pens, and pencils.

three-quarter view: A viewpoint halfway between a side view and a front view, especially with bilaterally symmetrical objects such as faces or vehicles.

thumbnail sketch: A small preliminary drawing with an especially loose or tentative statement of form.

top dragging: A method of achieving texture by dragging a loaded brush with light paint over a darker pretextured surface.

torn paper vignette: A vignette whose ragged edge cuts across a variety of forms, like a part of a picture torn out of a magazine.

value: A measure of the degree of tone from white to black, often measured with 100 percent being the darkest; also the measure of tone as a component of color, along with hue and saturation.

2D-to-3D maquette: A maquette that uses a flat shape (often a top view or a side view) as a starting point.

verisimilitude: The close resemblance between the object or scene and its portrayal; truthfulness or illusionism.

vignette: Also called a spot, an informal illustration in which elements fade into the background with an uneven edge rather than being confined inside a rectangular border.

visual vocabulary: The sum total of the forms and effects that you have memorized well enough to generate out of your imagination.

windmill principle: A tonal arrangement in which the contour of a given form meets all four conditions with respect to its surroundings: light on light, light on dark, dark on dark, and dark on light.

THE LIFT · FOUNTAIN PLAZA AT DUSK · THE QUEUE COMPLEX

trompe l'oeil: Art whose purpose is to deceive the viewer into believing he or she is looking at an actual, three-dimensional scene.

wraparound vignette: A vignette in which elements are arranged around the outside edge of the design, leaving the white of the page open for type.

RECOMMENDED READING

Here are the books that have influenced my approach as a painter of imaginary subjects.

Abbott, Charles D. *Howard Pyle: A Chronicle.* New York: Harper & Brothers, 1925. The chapter "Schools and Theories of Art" quotes extensively from Pyle's papers about his philosophies of teaching and picturemaking.

Ackerman, Gerald M. *Charles Bargue Et Jean-Léon Gérôme: Drawing Course.* New York: ACR Edition, 2003. A collection of engravings, cast drawings, and figure drawings based on Greek or Roman models, presented as standards for emulation. Originally published in the late nineteenth century and used as part of academic training.

———. *Jean-Léon Gérôme.* London and New York: Sotheby's Publications, 1986.

Allen, Douglas, and Douglas Allen, Jr. *N. C. Wyeth: The Collected Paintings, Illustrations and Murals.* New York: Bonanza Books, 1972.

Boime, Albert. *The Academy and French Painting in the Nineteenth Century.* New Haven, CT: Yale University Press, 1971, revised 1986. A detailed study of the methods and aesthetics of the late-nineteenth-century French painters.

Bouguereau, William Adolphe, Musée des beaux-arts de Montréal, Musée du Petit Palais, Montreal Museum of Fine Arts, Wadsworth Atheneum. *William Bouguereau, 1825–1905.* Catalog of the 1984 exhibition. One chapter covers Bouguereau's sequential steps for creating his images.

Bridgman, George. *Bridgman's Complete Guide to Drawing from Life.* New York: Weathervane Books, 1952. Bridgman, a teacher at the Art Students League, influenced several generations of comic artists and illustrators with his chunky and dynamic analysis of form.

Brodner, Patricia Janis. *Dean Cornwell: Dean of Illustrators.* New York: Balance House, Ltd., 1978.

Byrnes, Gene. *A Complete Guide to Drawing, Illustration, Cartooning, and Painting.* New York: Simon and Schuster, 1948. Short articles on a variety of mid-twentieth-century popular artists, describing their working methods and showing their preliminary sketches.

Calderon, W. Frank. *Animal Painting and Anatomy.* London: Seeley Service & Co. Ltd., 1936. Republished by Dover in 1975. Emphasis on skeletal and muscular anatomy, comparing familiar domesticated animals.

Canemaker, John. *Paper Dreams: The Art and Artists of Disney Storyboards.* New York: Hyperion, 1999.

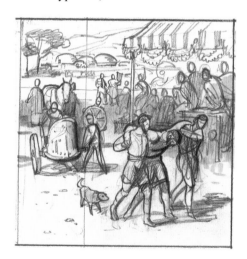

Carter, Alice A. *The Art of National Geographic: A Century of Illustration.* Washington, DC: National Geographic, 1999.

Cole, Rex Vicat. *Perspective.* London: Seeley, Service & Co., Ltd., 1921. Republished as *Perspective for Artists* by Dover in 1976. Thorough coverage of vanishing points, ellipses, shadows, and architectural details, illustrated with explanatory diagrams, observational sketches, and famous paintings.

Collier, John. *A Manual of Oil Painting.* London: Cassell and Company, 1886. A

prominent painter of imaginative realism in Victorian Britain.

Davies, Kristian. *The Orientalists: Western Artists in Arabia, the Sahara, Persia and India.* New York: Laynfaroh, 2005. Beautifully reproduced and well-chosen works, described by an art historian who knows the region and its history.

Delaware Art Museum. *Howard Pyle: Diversity in Depth.* Wilmington, DE: Delaware Art Museum, 1973. A slim exhibition catalog with black-and-white reproductions encompassing Pyle's career. What is most valuable is the 1904 transcripts from Howard Pyle's Monday night composition lectures.

DiFate, Vincent. *Infinite Worlds: The Fantastic Visions of Science Fiction Art.* New York: The Wonderland Press, 1997.

Dunn, Harvey. *An Evening in the Classroom.* Privately printed at the instigation of Mario Cooper, 1934. Dunn was a student of Pyle and himself a notable teacher from the Golden Age of American illustration.

The Famous Artists Schools. *The Famous Artists Course.* Westport, CT, 1954. The top American illustrators of the 1950s, including Al Dorne, Norman Rockwell, and Al Parker, joined forces to create this comprehensive correspondence course. The lesson plan takes the student through the practical methods for developing narrative illustrations. Topics include animal and figure drawing, composition, drapery, research, photography, and painting methods. I prefer the edition from the mid-1950s.

Faragasso, Jack. *The Student's Guide to Painting.* Westport, CT: North Light Publishers, 1979. A systematic approach to color, value, form, light, and edges.

Fenner, Cathy, and Arnie Fenner, Eds. *Spectrum 1-15: The Best in Contemporary Fantastic Art.* Nevada City, CA: Underwood Books, 2008. Juried annual collection of fantasy and science fiction

art drawn from books, magazines, advertising, dimensional, and concept art.

Grant, John, and Elizabeth Humphrey. *The Chesley Awards for Science Fiction and Fantasy Art.* London: Artists' and Photographers' Press Ltd., 2003. Over three hundred color illustrations of winners of the Chesley Awards, which were established in 1985 to honor fantastic art.

Guptill, Arthur L. *Norman Rockwell, Illustrator.* New York: Watson-Guptill Publishing, 1946. Illustrated biography written during Rockwell's lifetime, with an appendix describing Rockwell's creative and technical procedure.

Halsey, Ashley, Jr. *Illustrating for the Saturday Evening Post.* Boston: Arlington House, 1946. More than sixty short features about mid-twentieth century American illustrators and their inspiration.

Hamilton, James. *Arthur Rackham.* New York: Arcade Publishing, 1990.

Hedgpeth, Don, and Walt Reed. *The Art of Tom Lovell: An Invitation to History.* Trumbull, CT: The Greenwich Workshop, 1993. Mostly his western and Civil War subjects. A final chapter discusses his illustration career.

Henning, Fritz. *The Basis of Successful Art: Concept and Composition.* Cincinnati: North Light Publisher, 1983. Written by a son of illustrator Albin Henning, the emphasis is on planning the design of a picture through preliminary sketches.

The Imagineers. *Walt Disney Imagineering: A Behind the Dreams Look at Making the Magic Real.* New York: Hyperion, 1996. An insiders' account of how Disneyland and Disneyworld were designed.

Jenisch, Josh. *The Art of the Video Game.* Philadelphia: Quirk Books, 2008. Visual development including weapons, vehicles, effects, and environments.

Kane, Brian M. *James Bama: American Realist.* Santa Cruz, CA: Flesk Publications, 2006. Bama's photorealistic oil paintings of western, horror, historical, and romantic subjects are paired with photo reference and printed proofs.

Karolevitz, Robert. *Where Your Heart Is: The Story of Harvey Dunn.* Aberdeen, SD: North Plains Press, 1970.

Lee, Stan, and John Buscema. *How to Draw Comics the Marvel Way.* New York: Simon and Schuster, 1978. Useful advice on drawing figures from the imagination and on effective staging to achieve more drama and interest.

Loomis, Andrew. *Creative Illustration.* New York: Bonanza Books, 1947. Practical analysis of the art of storytelling illustration. Topics include line, tone, color, telling the story, creating ideas, painting methods, and fields of illustration.

———. *Figure Drawing for All It's Worth.* New York: The Viking Press, 1943.

Lucas, E. V. *Life and Work of Edwin Austin Abbey, R.A.* 2 vols. New York: Charles Scribner's Sons, 1921. The standard biographical work, with two hundred reproductions, and excerpts from his correspondence.

Ludwig, Coy. *Maxfield Parrish.* New York: Watson-Guptill Publications, 1973. A survey of his illustrations, murals, and easel painting, along with a description of his use of maquettes and posed models.

Marling, Karal Ann. *Designing Disney's Theme Parks: The Architecture of Reassurance.* New York: Flammarion, 1997.

Milner, John. *The Studios of Paris: The Capital of Art in the Late Nineteenth Century.* New Haven, CT, and London: Yale University Press, 1988. Overview of the art scene in Paris during the Salon era.

Mucha, Alphonse. *Lectures on Art.* A supplement to *The Graphic Work of Alphonse Mucha.* London: Academy Editions, 1975. Mucha's ideas on harmony, composition, and graphic design.

Norton, Dora Miriam. *Freehand Perspective and Sketching: Principles and Methods of Expression in the Pictorial Representation of Common Objects, Interiors, Buildings, and Landscapes.* Brooklyn, NY: Published by the Author, 1914.

Parkhurst, Daniel Burleigh. *The Painter in Oil: A Complete Treatise on the Principles and Technique Necessary to the Painting of Pictures in Oil Colors.* Boston: Lee and Shepard Publishers, 1903. A student of Bouguereau discusses materials, aesthetics, principles of design, and subject matter.

Pearce, Cyril. *Composition: An Analysis of the Principles of Pictorial Design.* London: B. T. Batsford, Ltd., 1927. Topics include tone, gradation, perspective, recession, and color.

Peck, Stephen Rogers. *Atlas of Human Anatomy for the Artist.* New York: Oxford University Press, 1951. Reference book for skeletal and muscular anatomy.

Perlman, Bennard B. *The Golden Age of American Illustration: F. R. Gruger and His Circle.* Westport, CT: North Light Publishers, 1978.

Pitz, Henry C. *The Brandywine Tradition.* New York: Weathervane Books, 1968. The story of Howard Pyle, his students, and the Wyeth family.

———. *Howard Pyle: Writer, Illustrator, Founder of the Brandywine School.* New York: Bramhall House, 1965.

Poore, Henri Rankin. *Pictorial Composition.* New York: The Baker and Taylor Co., 1903. Influential treatise covering the steelyard balance principle, entrance and exit, circular eye flow, and the aesthetics of reserve and breadth.

Reed, Walt. *The Illustrator in America 1860–2000*. New York: The Society of Illustrators, 2001. Full-color illustrated survey, decade by decade, of the history of American illustration.

Richter, Jean Paul. *The Literary Works of Leonardo da Vinci*. London: Sampson Low, Marston, Searle and Rivington, 1883. Republished as *The Notebooks of Leonardo da Vinci* by Dover in 1970.

———. *My Adventures as an Illustrator*. New York: Doubleday, 1960. Republished by Harry N. Abrams, Inc., in 1988. Colorful and amusing anecdotes.

Rockwell, Norman. *Rockwell on Rockwell: How I Make a Picture*. New York: Watson-Guptill Publications, 1979. Rockwell's master course in illustration, prepared for the Famous Artists School in 1949 at the peak of his career, covers the picture idea, models, detail, poses, props, the charcoal drawing, the color sketch, and the final painting. Other Famous Artists School instructors, including Austin Briggs, Peter Helck, Robert Fawcett, Al Parker, and Harold Von Schmidt, also produced master courses, but they are very hard to find.

Ruskin, John. *The Works of John Ruskin*. Edited by E. T. Cook and A. Wedderburn. 39 vols. London: George Allen, 1903–1919. In old-fashioned but eloquent prose, Ruskin advocates close observation of nature and the moral dimension of art.

Schau, Michael. *J. C. Leyendecker*. New York: Watson-Guptill Publications, 1974.

Sellin, David. *American Art in the Making: Preparatory Studies for Masterpieces of American Painting, 1800–1900*. Washington, DC: Smithsonian Institution Press, 1976. Exhibition catalog with black-and-white reproductions of sketches, painted studies, and photographs created during the preparation of landscapes and genre paintings.

Solomon, Solomon J. *The Practice of Oil Painting and of Drawing As Associated With It*. Philadelphia: Seeley, Service and Co. Ltd., 1910.

Speed, Harold. *The Practice and Science of Drawing*. London: Seeley, Service and Co. Ltd., 1917. Republished by Dover in 1972. Concepts of line, rhythm, and unity apply both to charcoal drawing and to monochrome painting.

———. *The Science and Practice of Oil Painting*. London: Chapman and Hall, 1924. Republished by Dover as *Oil Painting Techniques and Materials*. Continues the training from the previous volume, covering technique, tone, color, painting from life, and an appreciation of old masters.

Stamp, Gavin. *The Great Perspectivists*. New York and London: Rizzoli International Publications, 1982. Fine early examples of the art of architectural rendering.

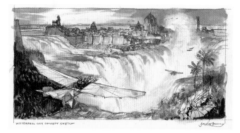

Thomas, Frank, and Ollie Johnston. *Disney Animation: The Illusion of Life*. New York: Abbeville Press, 1981. Two of Disney's Nine Old Men dug through the archives and downloaded their knowledge of the art of hand-drawn animation.

Trippi, Peter. *J. W. Waterhouse*. London: Phaidon Press Limited, 2004.

Vanderpoel, John H. *The Human Figure*. New York: Sterling Publishing Company, 1923 and 1935. Republished by Dover in 1958.

Watson, Ernest. *Forty Illustrators and How They Work*. New York: Watson-Guptill Publications, 1946. Short profiles based on studio visits and interviews with the likes of Dean Cornwell, Harvey Dunn, John Gannam, and N. C. Wyeth.

Weinberg, H. Barbara. *The Lure of Paris: Nineteenth-Century American Painters and Their French Teachers*. New York: Abbeville Press Publishers, 1991. Well-illustrated and well-researched description of what was taught in the ateliers of Gérôme, Cabanel, Bonnat, and Carolus-Duran.

MUSEUM COLLECTIONS

The following museums have an especially good selection of nineteenth-century academic realism or Golden Age illustration, and their collections are usually on display, not locked in basements.

Brandywine River Museum, Chadds Ford, Pennsylvania
Dahesh Museum, New York, New York
Delaware Art Museum, Wilmington, Delaware
Farnsworth Art Museum and Wyeth Center, Rockland, Maine
Gilcrease Museum, Tulsa, Oklahoma
Guildhall Art Gallery, London, England
Haggin Museum, Stockton, California
Lady Lever Gallery, Port Sunlight, England
Maison d'Ailleurs, Yverdon, Switzerland
Metropolitan Museum, New York, New York
Mucha Museum, Prague, Czech Republic
Musée d'Orsay, Paris, France
National Cowboy and Western Heritage Museum, Oklahoma City, Oklahoma
National Museum of American Illustration, Newport, Rhode Island
National Museum of Wildlife Art, Jackson Hole, Wyoming
National Portrait Gallery, London, England
New Britain Museum, New Britain, Connecticut
Norman Rockwell Museum, Stockbridge, Massachusetts
Rockwell Museum of Western Art, Corning, New York
Russian Museum, St. Petersburg, Russia
State Tretyakov Gallery, Moscow, Russia
Sterling and Francine Clark Art Institute, Williamstown, Massachusetts
Tate Britain, London, England
Victoria and Albert Museum, London, England
Wallace Collection, London, England
The Walters Art Museum, Baltimore, Maryland

WORKS BY AND ABOUT JAMES GURNEY

BOOKS

The Artist's Guide to Sketching (with coauthor Thomas Kinkade). New York: Watson-Guptill, 1982.

Dinotopia: A Land Apart from Time. Atlanta: Turner Publishing, 1992. Republished by HarperCollins in 1998.

Dinotopia: The World Beneath. Atlanta: Turner Publishing, 1995. Republished by HarperCollins in 1998.

Dinotopia: First Flight. New York: HarperCollins, 1999.

Dinotopia: Journey to Chandara. Kansas City, MO: Andrews McMeel Publishing, 2007.

James Gurney: The World of Dinosaurs, by Michael K. Brett-Surman and Thomas R. Holtz, Jr. Shelton, CT: Greenwich Workshop Press, 1998

SELECTED ARTICLES

Gurney, James, "Recreating History for National Geographic," *Step-By-Step Graphics.* Volume 6, Number 7, 1990.

Bensimhon, Miriam, "Living with Dinosaurs: Inside the Mind of a Man Who Makes Fantasy Seem Real," *Life.* October 1992.

Jackson, Donald Dale, "Dinotopia: The Magical World of James Gurney," cover feature, *Smithsonian.* September 1995.

Gurney, James, "Asher B. Durand: Plein-Air Pioneer," *Plein Air.* April 2005.

Zeit, Tom, "Fine Art of Fantasy," *The Artist's Magazine.* February 2006.

Parks, John A., "Fact and Fantasy: The Paintings of James Gurney," cover feature, *American Artist.* November 2006.

NATIONAL GEOGRAPHIC ASSIGNMENTS

"Jason's Voyage: In Search of the Golden Fleece." September 1985.

"Humboldt's Way." September 1985.

"Central American Map." April 1986.

"The Quest for Ulysses." August 1986.

"Sealed in Time: Ice Entombs an Eskimo Family for Five Centuries." June 1987.

"The Prodigious Soybean." July 1987.

"Wool—Fabric of History." May 1988.

"The Eternal Etruscans." June 1988.

"Discovering the New World's Richest Unlooted Tomb." October 1988.

"Attic Scene, NGS Centennial." February 1989.

"Did Neanderthals Speak?" October 1989.

"Kingdom of Kush." November 1990.

"Uncovering Patagonia's Lost World." December 1997.

"Battle of Hampton Roads." March 2006.

U.S. POSTAGE STAMP ART

Settling of Ohio, Northwest Territory, 1788. Postal card, 1988.

The World of Dinosaurs. Fifteen-stamp pane, 1997.

Sickle Cell Awareness. Commemorative stamp, 2004.

PAPERBACK COVERS

The books are listed with the title, the author's last name, and the publication date.

ACE/BERKLEY

The Tartarus Incident. Greenleaf, 1983.

Annals of Klepsis. Lafferty, 1983.

Starrigger. DeChancie, 1983.

Procurator. Mitchell, 1984.

The Pandora Stone. Greenleaf, 1984.

The Digging Leviathan. Blaylock, 1984.

The Alejandra Variations. Cook, 1984.

Phoenix Without Ashes. Bryant and Ellison, unpublished.

The Steps of the Sun. Tevis, 1985.

The Man Who Never Missed. Perry, 1985.

The Architect of Sleep. Boyett, 1986.

Phaid the Gambler. Farren, 1986.

The Forever Man. Dickson, 1986.

The New Barbarians. Mitchell, 1986.

Citizen Phaid. Farren, 1987.

Paradox Alley. DeChancie, 1987.

Starjacked! Greenleaf, 1987.

The Winged Assassin. Cooke, 1987.

Glory Lane. Foster, 1987.

The Argonaut Affair. Hawke, 1987.

Never the Twain. Mitchell, 1987.

Maori. Foster, 1988.

Castle Perilous. DeChancie, 1988.

The Fleet. Drake & Fawcett, ed., 1988.

Realm of the Gods. Cooke, 1988.

The Last Coin. Blaylock, 1988.

The Fleet: Counterattack. Drake and Fawcett, eds., 1988.

The Fleet: Breakthrough. Drake and Fawcett, eds., 1989.

On Stranger Tides. Powers, 1989.

Castle for Rent. DeChancie, 1989.

Castle Kidnapped. DeChancie, 1989.

Quozl. Foster, 1989.

Cry Republic. Mitchell, 1989.

The Stress of Her Regard. Powers, 1989.

Cowboy Feng's Space Bar and Grille. Brust, 1989.

The Fleet: Sworn Allies. Drake and Fawcett, eds. 1990.

Cyberway. Foster, 1990.

The Fleet: Total War. Drake and Fawcett, eds. 1990.

BAEN BOOKS

The Zanzibar Cat. Russ, 1984.

Aubade for Gamelan. Willett, 1984.

DAW BOOKS

Salvage and Destroy. Llewellyn, 1984.

The Jagged Orbit. Brunner, 1984.

Imaro II: the Quest for Cush. Saunders, 1984.

Forty Thousand in Gehenna. Cherryh, 1984.

City of Sorcery. Bradley, 1984.

Armor. Steakley, 1984.

The Serpent. Gaskell, 1984.

The Dragon. Gaskell, 1984.

Witches of Kregen. Prescot, 1985.

Atlan. Gaskell, 1985.

The City. Gaskell, 1985.

The Song of Homana. Roberson, 1985.

Warrior Woman. Bradley, 1985.

Imaro III: The Trail of Bohu. Saunders, 1985.

Sentience. Adams, 1986.
Some Summer Lands. Gaskell, 1986.
Word-Bringer. Llewellyn, 1986.

FANTASY AND SCIENCE FICTION MAGAZINE
"Hurricane Claude." Schenck, April 1983.
"Five Mercies." Conner, March 1984.
"The Man Who Painted the Dragon Griaule." Shepard, December 1984.
"Maureen Birnbaum." Effinger, February 1986.

"Face Value." Fowler, November 1986.
"The Color of Neanderthal Eyes." James Tiptree, Jr., May 1988.
"The Ends of the Earth." Shepard, March 1989.
"Down on the Truck Farm." Easton, March 1990.

HARPERCOLLINS BOOKS
Dinotopia Lost. Foster, 1996.
Hand of Dinotopia. Foster, 1999.

TOR BOOKS
Out of the Sun. Bova, 1984.
Homecoming. Dalmas, 1984.
The Yngling. Dalmas, 1984.

WARNER BOOKS
Rogue Moon. Budyrs, 1986.
Michaelmas. Budrys, 1986.
Who? Budrys, 1986.
Journey to Fusang. Sanders, 1988.

ACKNOWLEDGMENTS

Much of the content of this book grew from an exchange of ideas with the community on my blog GurneyJourney.blogspot.com. I would like to express my appreciation to all of the readers and commentators for their feedback and encouragement. I would also like to thank my wife, Jeanette, for her steadfast faith and support.

I am grateful to the following, who contributed either to this book or to the individual works inside it: **Editors:** Caty Neis and Dorothy O'Brien; **Designers:** Tim Lynch, Holly Camerlinck, Christi Hoffman, Tamara Haus and Lynn Wine; **Art Directors:** J. Robert Teringo, Howard E. Paine, Carl Herrman, Christopher Klein, Gene Mydlowski, and Joe Peczi; **Photographers:** Art Evans and Tobey Sanford; **Artists:** Armand Cabrera, Mark Elliott, Erik Tiemens, Frank Costantino, Ernesto Bradford, Dave Krentz, Bill Stout, Tony McVey, and Mike Trcic, Robert Gould, Jacob Collins; **Models:** James Warhola, Gary Alexander, Cindy Dill, Don Kallop, Tyson Neil, Dana Scarano, Harry Turra, Danika, Megan, Leanna, Emma, Genevieve, Hazel Ann, Liam, Owen, and Thomas; **Scientists/Historians:** Colan Ratliff, John Quarstein, Jack Horner, Mark Norell, Rodolfo Coria, and Greg Edwards; **Curators:** Mike Breza, Patrick Gyger, and Stephanie Plunkett; **Teachers:** Alice Carter, Steven Kloepfer, Dennis Nolan, Charles Pyle, David Starrett, Sam Clayberger, Ted Youngkin and Odile Chilton; **Companies:** Busch Entertainment, Columbia Pictures, Eyetools, Inc., Hasbro Toys, Jim Henson's Creature Shop, Moresca, National Geographic Society, Nintendo, Inc.

IMAGE CREDITS

ABOUT THE AUTHOR

James Gurney is the author and illustrator of the *New York Times* best-selling *Dinotopia: A Land Apart from Time*, which has been translated into eighteen languages in thirty-two countries. He has illustrated for *National Geographic* and the U.S. Postal Service, and he has won three gold medals from the Spectrum Fantastic Art. His work has been featured in one-man exhibitions at the Smithsonian Institution, the Norman Rockwell Museum, and the U.S. embassies in Switzerland and Yemen.

Gurney's daily blog, GurneyJourney.blogspot.com, is one of the top ten art blogs worldwide, with an average of 2,000 daily readers. Gurney has lectured at many art schools, including Ringling College of Art and Design, Rhode Island School of Design, Academy of Art University, and Grand Central Academy of Art. He has been invited to teach seminars to creative professionals at DreamWorks Animation SKG, Blue Sky Studios, and Lucasfilm, Ltd.

He lives with his wife, Jeanette, in the Hudson Valley of New York State.

INDEX

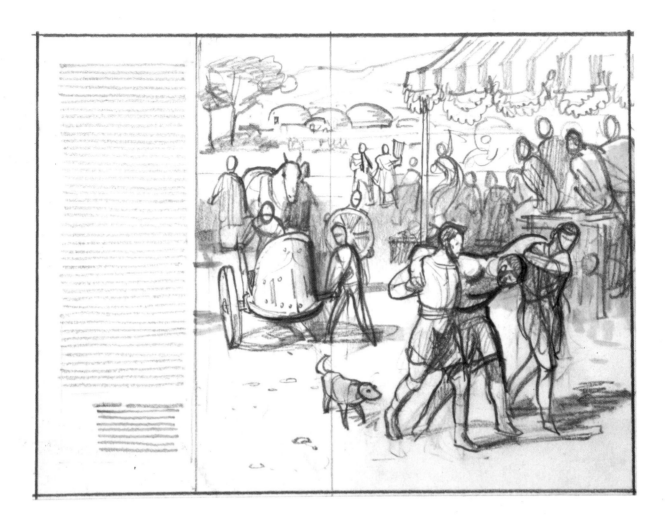

"James Gurney knows more about the methods of illustration and painting and
the history of picturemaking than just about anyone I know. He is unceasingly
generous with his wealth of fascinating facts and insights into the how-to of
painting. I read his blog every day and I always learn something new."

—Jacob Collins
founder of the Water Street Atelier,
the Grand Central Academy of Art,
and the Hudson River Fellowship

"This volume, the result of a lifetime of hard work and study, is destined to become one of
the most esteemed references for this generation of artists. It is an invaluable distillation of
information and a warmly personal guide to the pursuit of excellence as taught by a master."

—William Stout

"James Gurney's masterful artistry and deep understanding of technical and
conceptual concerns are evident in this extraordinary volume, an essential
reference for any artist seeking to bring narrative imagery to life."

—Stephanie Haboush Plunkett
chief curator, Norman Rockwell Museum